JONATHAN CAPE
PAPERBACK
JCP 14

THE DRAWINGS OF LEONARDO DA VINCI

The Drawings
of Leonardo da Vinci

With an Introduction and Notes by

A. E. POPHAM

JONATHAN CAPE
THIRTY BEDFORD SQUARE LONDON

FIRST PUBLISHED 1946
THIS PAPERBACK EDITION 1964

Printed in the United States of America

Dedicated
to the
Librarian and Staff
of the
National Library of Wales
Aberystwyth

CONTENTS

THE
DRAWINGS
OF
Leonardo
da Vinci

INTRODUCTION

This volume includes practically all the drawings which have any interest for the student of Leonardo as a painter or sculptor, which have an æsthetic and not a purely scientific or mechanical interest, as well as a small selection of drawings of the latter sort. The manuscripts are full of sketches, the greater part of them diagrammatic but occasionally, in MS. B in particular, of positive interest and beauty, apart from the text which they explain. It would be possible to make a very agreeable and entertaining collection of snippets from these, as in fact was done by J. P. Richter to illustrate his excerpts from Leonardo's manuscripts. Few of these, however, have any relation to Leonardo's works in painting; an occasional scrawl may be of importance for the reconstruction or dating of some work; it is rarely the sort of drawing which will stand alone. I have in all cases reproduced the whole of the sheet and avoided the practice of making excerpts, which seems to me often misleading and confusing.

The survival over a period of 500 years of objects so frail as drawings can only be attributable to a whole series of fortunate chances. In the first place the artist who drew them must exhibit what in the lesser man posterity will judge to have been vanity, in the greater a justified conviction of the importance of his achievements. If the presence of this conviction, which indeed is rarely absent in the self-conscious artist of the Italian Renaissance, is essential for the survival of drawings, there is another less obvious prerequisite for their preservation in any quantity: That is a passion for hoarding on the part of the artist. Leonardo clearly had this passion and, unmethodical as he was, hated to destroy any scrap of paper marked by his pen or pencil. We can be certain that the gaps in the series of Leonardo drawings are not due to any systematic weeding out by him. The gaps, and they are unfortunately numerous and important in spite of the enormous mass of material from Leonardo's hand which has been pre-

I

served, are due to other causes. No doubt the passion for indiscriminate hoarding was not fully developed or easily practised until the more settled conditions of his employment in Milan at about the age of thirty, so that a comparatively larger proportion of his early drawings is missing. Then there is the question of the purpose for which drawings have been made and the use to which they have been put. The relatively small number which survive for Leonardo's more famous compositions is a striking and unfortunate fact. Among these the slight and rapid preliminary sketches for compositions are more numerous than elaborate studies of detail. For the *Battle of Anghiari*, for example, there are about eight small composition sketches and only three larger studies of heads. Such large studies were intended and used by the artist to assist him in painting details on the wall or on the panel. They were exposed to much greater risks of loss and damage in the course of their use, to being splashed with oil or pigment, to being lost or stolen. If these risks in the case of a businesslike artisan were considerable, in the case of a wayward genius like Leonardo they were much increased. Few of his commissions were ever completed; some involved him in disputes or even litigation with his patrons; in others he released himself from engagements by a more or less precipitate flight, which may well have involved the loss of the type of study we have been discussing.

In spite of these *lacunae* a larger number of Leonardo's drawings of all sorts survives than of any other great Italian artist of the fifteenth century. Let us glance at their history.

There are two great collections of Leonardo's drawings: in the Ambrosiana Library at Milan and in the Royal Library at Windsor Castle. Both have the same history up to 1603.[1]

Leonardo bequeathed to his friend and pupil Francesco Melzi 'each and all of the books of which the said Testator is at present possessed, together with the other instruments and portraits which belonged to his art and calling as a painter.' After the artist's death on May 2, 1519, Melzi, who had accompanied him to France, returned to Milan, taking with him the books and drawings in question. These remained in Melzi's

[1] The most accurate account of the history of the Leonardo manuscripts and drawings is in the new edition of Richter, vol. II, p. 393 ff.

possession until his death in 1570 and were seen in 1566 by Vasari, who speaks of the reverent care with which they were preserved. They passed through many vicissitudes after Melzi's death, but the most important of them came into the possession of the sculptor Pompeo Leoni (*b*. about 1533; *d*. 1608), including those in the Ambrosiana and at Windsor. Leoni made an attempt to arrange the drawings and bound them in two albums. One of these, known from its size as the Codice Atlantico, survives in the form which Leoni gave it; the contents of the other at Windsor were removed at the end of the last century and most of the drawings separately mounted. The binding of the Codice Atlantico is lettered DISEGNI DI MACHINE ET DELLE ARTI SECRETI ET ALTRE COSE DI LEONARDO DA VINCI RACOLTI DA POMPEO LEONI; that from which the Windsor drawings have been removed DISEGNI DI LEONARDO DA VINCI RESTAVRATI DA POMPEO LEONI. The two albums were then made up, probably at the same time, by Pompeo Leoni, from the scattered and unconnected sheets of drawings and manuscripts, or perhaps in some cases manuscripts were dismembered to find their place in these two albums. Leoni attempted to arrange the drawings and leaves of manuscript according to subject, but this attempt not unnaturally failed in view of their extraordinarily varied contents. In the Codice Atlantico, which contains some 1700 sheets with drawings or notes by Leonardo, many which belong together are separated by nearly the whole thickness of the album.

But to return to the history of the two albums after Pompeo Leoni's death. The Codice Atlantico passed to Leoni's son-in-law, Polidoro Calchi, who sold it in 1625 to Count Galeazzo Arconati. The latter presented it in 1637 to the Ambrosiana Library, where it has remained until today except for an excursion to Paris in Napoleon's time.

The history of the second volume cannot be traced with the same continuity as that of the Codice Atlantico. It was apparently taken to Spain by Pompeo Leoni, when he returned there from Italy in 1591 and after his death was acquired by a certain Don Juan de Espina, from whom it passed to the Earl of Arundel. This is proved by the fact that a number of drawings now at Windsor were etched by Hollar, three of them

with the inscription 'Ex collectione Arundeliana.'[1] Exactly when and how they left Lord Arundel's collection and entered that of the King has never been determined. They were in the Royal Collection as early as 1690, when Queen Mary showed them to Constantijn Huygens.[2] They are mentioned in a manuscript inventory of prints and drawings 'in the Buroe of His Majesty's Great Closet at Kensington,' drawn up after (but only shortly after) 1735, and are reported to have been discovered by Richard Dalton, the King's librarian, at the bottom of a chest at Kensington Palace. As has been said, all the drawings were removed from Leoni's album in the nineteenth century and mounted separately, except a certain number of anatomical drawings which have been bound as volumes (see below, p. 59). All the drawings from the album have numbers written on them in an old hand, perhaps Leoni's, but these numbers are not continuous and no one has succeeded in making sense of them. The sheets in the Codice Atlantico are numbered in the same way and this numbering does not correspond to their order in the album.

The provenance of the comparatively small number of drawings in collections other than Windsor and the Ambrosiana is not known. That they were not detached from the Windsor album seems certain from the fact that they do not bear the numeration just referred to. They were probably drawings which either were not taken by Leonardo with him to France and never came into Melzi's possession, or scattered drawings which left the Melzi collection after Francesco Melzi's death in 1570 and before the acquisition of the greater number of them by Pompeo Leoni. It is significant that much the larger number of drawings both at Windsor and in the Codice Atlantico date from the Milanese period,

[1] On the other hand Lucas Vorsterman, who is known to have been in England only between 1624 and 1630, made copies of at least two drawings now at Windsor (*Head of an Old Man with Braided Hair* No. 12,499 and *Profile Head of a Man with a Short Beard* No. 12,555 *recto* and *verso*, one of which he signed; both are in the British Museum). Vorsterman does not state that they were in the Arundel collection at that time, but they cannot have been still in Spain.

[2] The identification of the Leoni volume with one mentioned by Huygens as having been purchased by him in 1690, proposed by Clark in the introduction to his catalogue, has been shown to be wrong (*Burlington Magazine*, LXIX, p. 135). The purchase of this book of pseudo-Leonardo drawings was the occasion of Queen Mary II showing Huygens the genuine Leonardos in the Royal Collection in 1690 and this is the earliest reference to them.

while a majority of the drawings of the first Florentine period are in other collections. A few of these widely scattered drawings bear collectors' marks of the seventeenth and eighteenth century: Sir Peter Lely owned two drawings for the *Adoration* and a profile of a later date; Jonathan Richardson the elder acquired these and some others, and General Guise collected the important sheets now in the Library at Christ Church, Oxford, before 1765. Sir Thomas Lawrence at the beginning of the nineteenth century possessed about fifteen genuine drawings.

The history of Leonardo's manuscripts does not concern us here so closely, though a few reproductions from MSS. B and H are given. It is sufficient to say that the majority of the manuscripts, thirteen in number, were given by Count Arconati at the same time as the Codice Atlantico to the Ambrosiana at Milan. They were sent to Paris in 1796 at the orders of Napoleon and while the Codice Atlantico was afterwards returned, the other manuscripts A, B, C, D, E, F, G, H, I, K, L, M, remained in the Library of the Institut de France. Another manuscript which belonged, like the Windsor drawings, to the Earl of Arundel is in the British Museum, and others are in the Victoria and Albert Museum, the Trivulzio collection (now belonging to the city of Milan), the Earl of Leicester's collection (now in the Pierpont Morgan Library), and the Royal Library at Turin.

As might be supposed from the universal scope of his researches, Leonardo was something of an innovator in the technical methods of drawing as well as of painting. He is credited by Lomazzo [1] with the invention of pastel and, if nothing in this technique from his hand survives, pastel is first found in drawings by Leonardo's pupils and this seems to confirm Lomazzo's claim. He was very probably the first artist to use red chalk, a characteristic medium of the High Renaissance. Vasari speaks of his method of drawing draperies with the brush on fine linen, heightened with white, but this was a system and technique evolved by Verrocchio and current in his workshop, rather than an invention of the youthful Leonardo. Leonardo showed preferences for particular methods

[1] *Trattato della Pittura*, 1584, p. 193.

of drawing at different times. In his youth in Florence in Verrocchio's workshop and later, he employed metal-point on a prepared surface and pen and ink, the latter over a preliminary sketch drawn with the stylus or with lead-point, which is often visible alongside the pen and ink. Occasionally a drawing with the lead-point was not inked in, as in the lower sketch in the British Museum sheet of the *Maiden with the Unicorn* (plate 27) or the Ashmolean *Holy Family* (plate 17). Leonardo's use of the pen in his earliest years is at times very summary, betraying the eagerness with which he hurried to put down his impressions. The Uffizi landscape of 1473 (plate 253) is an example. In spite of the impression of formality which the drawing gives at first sight, the individual parts are sketched with great rapidity and in the shading the pen has hardly left the paper. The same speed, violence and indifference to neatness is visible in the series of drawings for the *Madonna with the Cat* (plates 11 to 14), the large *Madonna and Child* in the Louvre (plate 25), and the sheet at Windsor (plate 23), though in the last the main group is surrounded by heads more delicately drawn. This more careful and delicate style is apparent in the study of the sleeve of the angel for the Uffizi *Annunciation* (plate 8A). It seems that Leonardo naturally drew with extreme precision and neatness at this early stage; it was only when hurrying to complete a landscape or working out a compositional theme that his line became untidy and violent.

Silver-point is a medium which not only allows of, but exacts, extraordinary daintiness of touch. It has never been used with greater delicacy or precision than in the elaborate drawing of a warrior in the British Museum (plate 129). This is one of the few drawings made by Leonardo as a show piece; it almost gives the impression of a diploma-drawing, had such things been current in Florentine *bottegas*. It is on a buff ground, which Leonardo seems to have affected at the time when he was working on the *Adoration of the Magi*. It shares with the drawings of horses and horsemen illustrated on plates 59, 60B, 63B, 64 and 65, not only the same type of ground, but the delicate luminous quality which distinguishes these. I would date it on these grounds nearer 1480 than 1470, though its connection with Verrocchio's relief has inclined critics to the

earlier dating. Other silver-point drawings of the period of the *Adoration* or earlier are on the most diverse coloured grounds and vary in handling from the elaborately finished drapery study on a dark red ground in the Corsini Gallery (plate 1), the technique of which resembles, while it far surpasses, that of Leonardo's fellow-pupil, Lorenzo di Credi; to the rather wavering line of the Oxford drawing (plate 51) on a delicate pink ground. Other colours of grounds employed are a violent orange (plates 56 and 58), purple (plate 55), and a pinkish buff, which latter is most commonly used in the studies for the *Adoration*. At this period he begins the practice, comparatively rare among Florentine artists, of reinforcing the outlines of his silver-point drawings with pen and ink. Examples of this, which becomes rather the rule than the exception, are the study for the *Benois Madonna* in the British Museum (plate 15), the allegory in the same collection (plate 104), and many drawings of horses and horsemen for the *Adoration*. The extraordinary variety both in the handling of the silver-point and in the colour of the grounds becomes less marked after Leonardo's removal to Milan in 1481-82. The ground most usually employed in the drawings for the Sforza horse is a deep blue, as in plates 67 to 69, 72, 73 and 77, and with this tendency to standardize the colour of the ground goes a greater homogeneity in the way in which the instrument is handled. The lines of shading drawn from left to right downwards are exactly parallel and regular and tend to be more widely spaced than before. The depth and plasticity which Leonardo contrives to convey with this apparently rather inelastic system is remarkable, as in the exquisite study for the head of the angel in the *Virgin of the Rocks* (plate 157) or the series of studies for the *Cavallo*, culminating in the horse in profile with its wonderful rendering of glossy skin and powerful neck (plate 77). The latest drawings for the Sforza horse, which must date from 1493, in which year the model was exhibited, are also the latest series of drawings in which Leonardo employed silver-point. After this date he seems to have practically abandoned it, though two drawings, the apostle at Vienna (plate 164) and the head of Christ *portacroce* at Venice (plate 171B), are isolated examples of its use slightly later, about 1495 or 1496 (if the apostle is in fact for the *Last Supper*).

Even before 1481 or 1482 Leonardo seems to have employed red chalk as a medium for drawing (plates 21 and 52A), though its use has not elsewhere been noted much before the end of the century. By 1492-94 he used it consistently for writing and drawing in his small notebooks, e.g. in the Forster MS. III in the Victoria and Albert Museum and in MS. H in the Institut de France (plate 81), and some of his most beautiful studies of heads for the *Last Supper* (plates 166, 167) and for the *Battle of Anghiari* (plate 199) are in this medium. Leonardo continued to use red chalk, as in the famous landscape (plate 261) of about 1499, until nearly the end of his life, as in the self-portrait at Turin (plate 154) and the allegory at Windsor (plate 124). Though the date of neither of these is certain, they are probably between 1510 and 1512. About the year 1511 he used it in a special way, on a prepared pink-coloured ground, such as was intended or could be used for silver-point. In this medium are some of the beautiful drawings of mountain ranges (plate 285A and B) and some anatomical drawings (plate 235); their date is fixed by an inscription on one drawing which, if not autograph, is copied from such an inscription.

Black chalk is however the most characteristic medium of his late period. Though it was not unusual in Verrocchio's workshop, we find it only very occasionally in Leonardo's early drawings. Some of the studies for the *Last Supper* (plates 163, 165) are in black chalk and we find it used in conjunction with white chalk for studies of drapery (plate 169) in a way first employed to its full effect by Leonardo for bringing out the texture and quality of material and the play of light on it. Leonardo exhibits the highest virtuosity in the use of this method in the drapery studies for the *Virgin and Child with St. Anne* (plates 186, 188), in which he also employs black paint to heighten the effect. In the studies for the Trivulzio monument (1508-11) he returns to black chalk alone and here it is used on rather a rough paper almost with the effect of fine stippling. But in spite of the absence of definition there is no lack of design or structure in such drawings as the horseman (plate 102). Most of those apocalyptic visions of his last years, the series of deluges, are also in black chalk.

But through all these years pen and ink remained the most usual and natural medium of expression, especially when, as is so often the case, Leonardo had notes and explanations to add. He does write in red chalk in the manuscripts already referred to but practically never in black chalk, which is too indefinite a medium for legible writing. The character of his pen-work changes at different periods. I have already attempted to describe the rather untidy effect of the pen-work in Leonardo's earliest Florentine drawings. The untidiness disappears at Milan and is replaced by shading executed with extraordinary neatness and precision in evenly placed parallel strokes running down from left to right as in the silver-point drawings of the same period. This regular, formal style of pen-work reached its culmination in the drawings of skulls dated 1489 (plates 217 to 220). The shading with straight downward strokes continues essentially the same till the period of the *Battle of Anghiari*, 1503. In the small pen and ink studies for this we find Leonardo beginning to model the horses with strokes which follow the curves of their bodies, and in the large sheet at Turin with studies of a standing warrior (plate 197) the forms are modelled not only with strokes which curve but with quite an elaborate system of cross-hatching. This in more or less elaborate form becomes Leonardo's regular method. It is conspicuous in the pen and ink studies for the *Leda*, the *Trivulzio Monument* (1508-11), anatomical MS. A (1510) (plates 243, 245), and anatomical MS. C II (1513) (plates 249 and 252). The last-named drawings, which were either drawn by Leonardo at Rome or at Florence on his way to Rome are on blue paper (*carta azzura*) which he uses now for the first time. The character and quality of the paper indeed afford some clue as to the date of the drawings; the use of this blue paper is one, and there is a coarse material, something of the colour and consistency of some packing paper, which he used apparently about the same date or later. Two of the drawings for masques (plates 119, 120) and the head of an old man (plate 155) are on a paper of this type. The regularity of the strokes curving round the objects also tends to disappear and to be replaced by a much more untidy, but nevertheless still vital and expressive arrangement of lines.

These remarks on the subject of Leonardo's methods of drawing are

only intended as a rough indication. His technique all his life varied enormously, not only with the instruments he employed but also with the object and purpose of the drawing and the time available. There is, however, one respect in which he seems to have been constant, and that is in drawing, as well as in writing, with the left hand. Contemporary evidence is not conclusive on this point. Antonio de Beatis, who visited Leonardo at Amboise in 1517, says that 'on account of a certain paralysis having seized him in the right hand one cannot expect more fine things from him,' implying that it was with the right hand that he had habitually worked. The drawings, however, in which the strokes run down from left to right and the writing, which runs from right to left, make it quite clear that Leonardo was left-handed. This left-handedness may have been due to an accident to his right hand suffered in childhood and de Beatis' account of the paralysis may reflect an imperfectly understood or remembered reference to such an occurrence, but there is no other reason why it should not have been natural. It seems likely that Leonardo always drew, wrote and presumably painted with the left hand because it was natural to him. On the rare occasions when he wrote from left to right in the ordinary way he did so generally in order that the writing should be easily legible to others, as in the place-names on many of the maps. But this left to right writing was probably also written with the left hand. There appears to be no instance of a genuine drawing which can be shown to have been drawn by Leonardo with his right hand.

I

DRAPERY STUDIES
AND EARLY MADONNAS

Writing of Leonardo's early life in Florence, Vasari says, 'He would make clay models of figures, draping them with soft rags dipped in plaster, and would then draw them patiently on thin sheets of cambric or linen, in black and white, with the point of the brush. He did these admirably, as may be seen by specimens in my book of designs.' [1] Examples of such drawings on linen with traditional attributions to Leonardo have come down to us. Whether any of these are the specimens described by Vasari as having formed part of his own collection cannot now be ascertained. Nor can it be regarded as certain that any one of these is actually by Leonardo's hand. The practice must have been one current in Verrocchio's *bottega*—perhaps in others—and drawings of this character certainly by other painters, Fra Bartolommeo and Sogliani for example,[2] are known. The medium is an impersonal one and the artist's individual outlook is apparent rather in the arrangement of the draperies on the model than in the actual handling. Nevertheless there is a prima-facie case for attributing to Leonardo a number of such studies, of which I reproduce a selection on plates 2 to 7. The best known and most generally accepted is the cast of drapery for a seated figure in the Louvre at Paris (plate 2). Curiously enough, this is the only one among these studies which has actually been used in a picture—but the picture is by Domenico Ghirlandajo (*Madonna and Child with Saints and Angels* in the Uffizi),[3] not by

[1] Vasari ed. Milanesi IV, p. 20.
[2] Fra Bartolommeo, British Museum, 1895-9-15-487, reproduced Vasari Society, 2nd series, XIII (1932), No. 6; Sogliani, British Museum, 1895-9-15-488. Degenhart, *Münchner Jahrbuch* XI (1936) p. 226, on the strength of the British Museum Fra Bartolommeo, attributes the whole series of drapery studies to the last-named artist.
[3] Van Marle XIII, Fig. 28.

Leonardo. To infer that the drapery study was also by Ghirlandajo would be wrong. The drawing is so clearly Verrocchiesque in character, so distinct from Ghirlandajo's draperies of the period when the Uffizi panel was painted, that it can hardly be his. And it accords well enough with the draperies which we find in early pictures now generally accepted as Leonardo's, those of the angels in the *Baptism* in the Uffizi and of the Madonna in the *Annunciation* in the same gallery. Indeed it has been thought to be an actual preparatory study for this same figure. It is in fact tantalizingly near, but does not in any way correspond. If it was so intended Leonardo must have consciously discarded it and from what we know of his character and methods of work this is by no means improbable. Another study of drapery also in the Louvre (plate 3) it is tempting to connect with the angel in the same *Annunciation*—the action is clearly that of such an angel—but here again the actual folds are quite different from those in the painting. And there are two other studies of drapery for the same or a similar figure (not here illustrated; in the Uffizi, B.B. 1014A, and in the collection of the Comtesse de Béhague, B.B. 1071B) and neither of these corresponds with the picture. Again we must assume that Leonardo made those elaborate studies with the Uffizi picture definitely in view and found all three unsatisfactory, or that he set himself the task of studying the drapery of a figure in this position, and Vasari's words would seem to imply such a practice. Again, as I have said, none, or one, or two out of the three may be by Leonardo. Without having the series side by side it is almost impossible to detect the minute differences of style which may distinguish them.

Little more need be said about the remaining drapery studies reproduced on plates 4 to 7. The standing figure of a bearded man with his arms crossed suggests a king in an *Adoration of the Magi* (or compare the figures on the right of Botticelli's Uffizi *Adoration* or of Leonardo's own, plate 30). The kneeling woman in the British Museum (plate 5) is clearly a Virgin Annunciate, as in the small Louvre *Annunciation*, whether this be by Leonardo or not. The two almost identical casts of drapery for a seated figure in the Béhague collection and in the Uffizi

respectively might also be for a seated Virgin in an *Annunciation* or a *Coronation* (plates 6 and 7).

There remains a drawing (plate 1) which though its purpose is equally uncertain, is indubitably by Leonardo himself. It is the beautiful silver-point study on a brilliant wine-red surface of the kneeling Virgin. The drapery is a marvel of precise and sensitive draughtsmanship. It has the extreme delicacy of Lorenzo di Credi without his niggling quality and shows in fact that artist's *point de départ* in the fellow pupil who influenced him so strongly. And apart from its infinite superiority it is drawn by a left-handed artist. It has been claimed to be a combined study for the Madonna and the angel in the small Louvre *Annunciation* [1]—the upper part of the figure being that of a Madonna while the drapery is very close indeed to that of the angel in reverse. But if the small *Annunciation* is in fact by Credi, such a subtle piece of plagiarism would be quite consistent with his character. Indeed a comparison between the so similar drapery of the angel in the picture and the drawing emphasizes the Credi-like quality of the former.

Finally among all this surmise and uncertainty there is one solid and definite fact, a pen and ink study in the library at Christ Church for the sleeve of the angel in the Uffizi *Annunciation* (plate 8A). This remains one of the very few drawings of Leonardo's early period which can be brought into unequivocal relation with a picture.

On a sheet in the Uffizi (plate 127) with sketches of profiles Leonardo writes (the sheet is torn) '. . . *bre 1478 inchominciai le 2 Vergini Marie.*' '[Between September and December] 1478 I began the 2 Virgin Maries.' What were those two pictures? There are two existing paintings of the Virgin and Child which are now generally accepted as in substance at any rate by Leonardo and which certainly precede in point of date the *Adoration of the Kings* in the Uffizi. These are the so-called *Benois Madonna* in the Hermitage at Leningrad and the *Madonna with the Vase of Flowers* in the Alte Pinakothek at Munich. But in addition to these there are a number of drawings which indicate that Leonardo was at work about the same period on other compositions of the Virgin and Child, one of which

[1] A. E. Popp, *Leonardo da Vinci Zeichnungen*, Munich, 1928, p. 34.

included a cat.[1] It is impossible to be certain to which of these three or more compositions Leonardo refers, but we can confidently assign them to about the same period.

Most numerous are the studies for the *Madonna with the Cat* (plates 8B to 14). The possibilities of the interlocking curves in this composition obviously fascinated Leonardo and he experimented widely. First of all he seems to have conceived the component figures of the group, the Mother, the Child and the cat, quite separately. Of this comparatively noncoherent version the study in the Uffizi (plate 10) is the most finished version. Here the Child, almost wrestling with the unfortunate cat, was drawn first; the table on which He is seated and the Madonna herself were added later; there is no essential link binding her to the Child. On the *recto* of a sheet in the British Museum (plate 11) it is still the Child and its relation to the cat which Leonardo is studying, though the Madonna makes her appearance twice, once, on the left, as an obvious supernumerary, but in the study at the top of the sheet her relationship to the Child is closer and more satisfactory. On the *recto* and *verso* of another sheet, also in the British Museum, Leonardo continues his studies of the Child and cat and the cat alone (plates 12, 13). Here, except in one case where the cat is responding gratefully to stroking, the Infant Christ holds the animal tightly in both arms, to its obvious discomfort. A drawing in the Bonnat collection (plate 14) presents a new conception of the whole group; the Infant is seated on His Mother's lap and the cat stretches up from the level of the seat and places its forepaws on the Infant's leg. What seems to me the final version, or at any rate the latest which we have, is represented by two small scraps, one in the collection of Mrs. A. H. Pollen (plate 8B) and another drawn on both sides in the British Museum. Here the group is conceived with the unity and plasticity of a piece of sculpture in the round. First of all (plate 9A) the Virgin holds the Infant and the cat on her left knee; then Leonardo traced the composition through to the back, reversing the arrangement, and experimented

[1] Adolfo Venturi in *L'Arte* XLII (1939), p. 217, publishes a picture of this subject which was at the Milan Leonardo Exhibition of 1939, as the painting by Leonardo himself. Emil Möller in a notice in *Pantheon* XIII (1940), p. 48, has shown that this miserable production is no more than a pastiche of the *Benois Madonna*.

with the position of the Virgin's head and accentuated the plasticity of the group with a rich brown wash. Finally in the little sketch in Mrs. Pollen's collection he fixed the position of the Virgin's head as inclined to the left; otherwise he made but little alteration. These final versions inevitably recall the *Virgin and Child with St. Anne* of Leonardo's maturity (see plates 174 ff.). There is a similar if more complicated problem to be solved, the relations of three figures closely united in one group and their compensatory reactions. In the *Virgin and Child with the Cat* we see the germ of the elaborate *contraposto* of the later work.

In the British Museum is another sheet drawn on both sides with four studies of a Madonna and Child (plates 15 and 16). One of these studies, that on the right at the top in plate 16, corresponds pretty exactly with the picture already named in the Hermitage. It is clearly a study for it, while the sketch on the left in which the Madonna is represented without clothing is a variant. The sketch on the *verso* has the same theme of the Child and the flower, but here His Mother holds it at arm's length and He stretches out His hand for it.

On the *recto* of the British Museum sketch (plate 16) besides the two Madonnas in pen and ink is a third, hardly visible in the reproduction, drawn in faint lead-point. Here the motive is different; the Virgin leans down to the left, her face in profile, while the Child takes the breast. There is an almost equally faint drawing of a similar Madonna suckling the Child on a sheet in the Louvre with studies for the *Adoration of the Magi* (plate 44). Clark [1] has ingeniously related these insignificant scrawls to a composition known as the *Madonna Litta* in the Hermitage at Leningrad and a passage in the list of works which Leonardo drew up probably soon after his arrival in Milan in 1482, '*una nosstra donna finita*' '*un altra qu(a)si che n proffilo*,' 'another almost finished in profile.' The little British Museum sketch corresponds well enough with the picture, except that it represents the Virgin seated, in the same position as in the studies for the *Benois Madonna*, while in the picture she is apparently standing. Besides the beautiful head of the Virgin in the Louvre (plate 19) which has long been recognized as a study for the *Madonna Litta* (or the original from which

[1] Kenneth Clark, *The Madonna in Profile*, in *Burlington Magazine* LXII (1933), p. 136.

it is copied), Clark also believes that a sheet at Windsor with studies of a baby and parts of babies (plate 21) is also a study for the same picture, while another very similar sheet in silver-point (plate 20) he connects with the *Benois Madonna*. There can be no doubt whatever of the close relation between these two last sheets; they must surely have been studied from the same model at about the same time. These however are also in my opinion closely linked with a sheet of studies bound up in the Arundel Codex in the British Museum.[1] At first sight this sheet appears only to contain studies of the head of a baby suckling, a baby's right foot twice repeated and a baby's left hand. The foot and hand are for the Infant Christ in the Louvre *Madonna of the Rocks*. If the sheet is held up at an acute angle to a strong light it will however be seen that it is covered with sketches made with the stylus on the prepared surface. The *mise-en-page* assumes exactly the character of the two Windsor drawings. A number of these almost invisible studies are also for the *Virgin of the Rocks*, but not all. Nor has the clearly visible head of a child suckling anything to do with it. It is tempting to connect it either with the *Madonna Litta* or another Madonna to be discussed immediately. It corresponds most closely with the head of the Child in a Holy Family formerly in the Benson collection which is illustrated by Suida as embodying a Leonardo drawing.[2]

A large sheet at Windsor with drawings on both sides (plates 23, 24) has as its main theme on the *recto* a composition of the Virgin kneeling on the ground in a landscape with the Child at her breast, while the Infant St. John approaches from the right. It seems a familiar theme and its presentation almost hackneyed. It is only when we realize that the pictures which it recalls are pictures by Raphael and Fra Bartolommeo and that the pyramidal arrangement of the group is a typical formula of the High Renaissance that its significance becomes apparent. It is extraordinary that Leonardo about 1480 should have evolved this composition; having evolved it, it is almost more extraordinary that he did not follow it up and that it did not receive its typical and classical expression until the *Esterhazy Madonna*

[1] Reproduced in the Commissione Vinciana publication of the Arundel Codex, fol. 253 *verso* and 256 *recto*.

[2] W. Suida, *Leonardo und sein Kreis*, Munich, 1928, p. 34.

and the *Belle Jardinière* of Raphael about 1507. That this sketch of Leonardo's did not merely remain a sketch but was advanced at least to the stage of a cartoon is certain from the existence of a picture by Andrea da Salerno in the Naples Gallery, which closely follows the lines of the drawing. The rest of the sheet is covered with specimens of those profiles, which were Leonardo's instinctive expression with the pen and the *verso* has a number of more elaborate and more varied examples of the same type. Another sheet at Windsor (plate 22) has a whole series of sketches made from the life of the head and bust, or more frequently the bust alone, of a woman. The emphasis laid on a head and shoulders in the position of that in the Madonna just discussed makes it probable that this sheet was done in connection with it.

A drawing which in scale and character approaches and in grandeur surpasses the Windsor *Madonna and Child with St. John,* is the *Madonna and Child with a Bowl of Fruit* in the Louvre (plate 25). This composition was never as far as we know brought further; its motive is nearly that of the *Benois Madonna* and it may in fact have been a first idea for this. The head of the Virgin is very near to that in the Uffizi *Adoration of the Magi* (plate 33) and in date it cannot by much precede this work.

Of Madonnas of this early period there remains to be discussed what is hardly more than the shadow of a sketch at Oxford (plate 17). Insignificant as a drawing—it is merely a preliminary scrawl in lead-point which Leonardo never completed in pen and ink—it nevertheless has something of the prophetic importance attached to the large Windsor sheet. It also anticipates a compositional theme of the High Renaissance, the Madonna and Child with the Infant St. John introduced and supported by an angel (compare the drawings by Fra Bartolommeo in the British Museum, B.B. 405 and 406). On the *verso* of this sheet (not reproduced) are some rough studies of arches in perspective which may well have been made in preparation for the background of the *Adoration of the Magi* in the Uffizi.

A few other drawings of this early period, though they do not represent Madonnas, may find a place in this section. The study of hands at Windsor (plate 18) is perhaps misleadingly but certainly, I think, effectively, reproduced opposite the head for the *Madonna Litta.* Though they

are two of Leonardo's most beautiful early drawings they have nothing else to connect them. The hands have been plausibly identified as those of the Lady, probably Ginevra de' Benci, in the Liechtenstein Gallery. The bottom of the picture, as can be seen from the incompleteness of the device painted on the back of the panel, has been cut off. It must originally have been a half-length portrait. What appears to be a pastiche of the Liechtenstein picture in its original condition, in the collection of Mr. de Wolfe Brixey, has the hands in a position similar to that of the drawing. The minute caricature on the left is almost identical with one on the British Museum studies for the *Benois Madonna* (plate 16).

The gruesome drawing of the hanged conspirator Bernardo di Bandino Baroncelli (plate 26) is important as a certain chronological point. Baroncelli was executed on December 29, 1479. This with the landscape drawing in the Uffizi dated August 5, 1473 (plate 253) and the sheet with two heads in the same collection (plate 127) already referred to constitute the *points de départ* for a chronology of Leonardo's early drawings.

On the *verso* of a drawing for the *Madonna with the Cat* already mentioned is the sketch for a composition of a maiden with a unicorn (plate 27), the traditional emblem of purity. There is an alternative version of the composition in lead-point below, which is hardly visible in the reproduction and another, which appears to be the latest, at Oxford (plate 28B). The purpose and final form of this design is not known; the picture in the Lanckoronski collection which Suida reproduces as derived from the lead-point sketch on the sheet in the British Museum has only the vaguest connection with it. On the other hand an engraving by Agostino Veneziano dated 1516 (Bartsch XIV, p. 288, No. 379) substantially reproduces the Oxford drawing, though the background is different and the positions of the girl's and the unicorn's heads are slightly altered. Can we assume that Agostino Veneziano had before him Leonardo's final version? It seems likely, though what form this final version took, whether painting or drawing, must remain a mystery.

The two small studies in the British Museum (plates 28A and 29B) of a woman carrying a child and a kneeling angel cannot be definitely connected with any other work of Leonardo's. In its spontaneity and charm

the first recalls the drawings of the girl with the unicorn and also the Oxford lead-point sketch of the *Holy Family* (plate 17), which has a similar drawing of a scroll, quite unconnected with the main drawing. The angel, kneeling among bulrushes, can only be intended for an angel in a *Baptism*, though it is hard to see how it can be connected with the famous Verrocchio panel of the subject as suggested by Campbell Dodgson.

The placing of the minute sketch below with its violent *contraposto* anticipates drawings of a much later date (compare the sheet in the British Museum, plate 175, with studies for the *St. Anne* of about 1498); it also recalls the studies for a *St. Mary Magdalene* reproduced beside it. A three-quarter length of this saint must be a rarity in Italian art but it is not an unusual subject in the circle of Quentin Matsys, who notoriously borrowed from Leonardo.[1] But no picture of this school known to me resembles the present drawing except in the vaguest way. Still there can be no doubt that the drawing is by Leonardo and that it dates from his early Florentine period.

[1] E.g. the picture in the Kaiser Friedrich Museum by the so-called Master of the Mansi Magdalene. In an article in the *Repertorium für Kunstwissenschaft*, XLV (1924), p. 114, B. Haendcke finds a connection between the *Mona Lisa* and Rogier van der Weyden's *Mary Magdalene* in the Bracque triptych in the Louvre of about 1451. This connection does not appear to me very obvious nor does it extend to the present drawing.

II

ADORATIONS

In January, 1478, Leonardo received the commission to paint an altarpiece for the chapel of St. Bernard in the Signoria (Palazzo Vecchio) at Florence; in March, 1481, the monks of San Donato a Scopeto commissioned him to paint a picture for their high altar; in neither case is the subject of the picture recorded, but the unfinished panel of the *Adoration of the Magi* in the Uffizi is generally assumed to be the work ordered by the monks of San Donato. This identification is rendered very probable from the fact that Filippino Lippi, who was commissioned to paint an altarpiece for the same fraternity in substitution for that which Leonardo had never completed, was to be paid by a third part of a property in Valdelsa—that is, in exactly the same manner as Leonardo was to have been paid. Filippino's picture, now in the Uffizi, has almost exactly the same dimensions as Leonardo's and represents the *Adoration of the Magi*.

A word of explanation is necessary for the inclusion, in a volume of Leonardo's drawings, of details from a painting on panel, this same *Adoration of the Magi* in the Uffizi (plates 30-38). But this painting was never carried beyond the stage of a monochrome brush drawing. It is not inherently different from a cartoon or a large drawing and, if a precedent were needed to justify its appearance among the drawings proper, this is afforded by the Olschki publication of the Uffizi drawings, where it also finds a place.

A group of drawings (plates 39-41) are clearly studies for an Adoration, not of the Kings, but of the Shepherds. It has been suggested—but there is nothing to support, as there is nothing against, the suggestion—that the picture ordered for the Palazzo Vecchio was an *Adoration of the Shepherds*. In any case Leonardo must at about the same period have been working on two compositions or, what seems to me equally probable, must

have been commissioned to paint an *Adoration of the Shepherds,* gone some way with this and then persuaded his patrons that an *Adoration of the Kings* would be a more sumptuous picture and afford him greater scope. But, though the two pictures may have merged into one another, a distinction can be drawn between the studies for the *Adoration of the Shepherds* and those for the *Adoration of the Kings* (the drawings of horses and animals for the two compositions are treated separately below).

We first of all have the study in the Musée Bonnat at Bayonne (plate 39) where the scene is represented in the traditional Florentine manner. The Infant Christ lies on the ground in the centre while the Virgin kneels in adoration behind Him. There are however two innovations, the central position of the Virgin (who hitherto had knelt on one side balanced by a kneeling St. Joseph), and the presence of the Infant St. John, who seems to have been popular in Verrocchio's workshop as an assistant and play-fellow of the Infant Christ (they are to be found together in a *Nativity* in a drawing by Francesco di Simone in the Ecole des Beaux-Arts at Paris). St. Joseph is seated on the left in conversation with a shepherd, a group which we shall see developed later in the *Adoration of the Kings.*

In a second drawing in the Accademia at Venice (plate 40A) only the left-hand side of the composition is presented. This is similar to the Bonnat sketch except that the infant Baptist seems to have been discarded—he was drawn in metal-point in the first sketch but not subsequently inked in —and a wreath of flying angels appears above the Virgin's head. (One is reminded by the violence of their movements of Leonardo's own criticism of an *Annunciation* supposed to be aimed at Botticelli: *Trattato della Pittura,* ch. 105.) The presence of these angels, which do not reappear, suggests the influence of Hugo van der Goes' great altarpiece of the *Adoration of the Shepherds,* painted for the Church of the Hospital of Sta. Maria Nuova between about 1473 and 1475. In previous Nativities the angels had knelt on the ground beside St. Joseph and the Virgin. Nor do I find the centrally placed Virgin occurring in Florentine art before this date.[1]

[1] Fritz Knapp, *Hugo van der Goes Portinari—Altar und sein Einfluss aut Leonardo da Vinci,* etc. in *Mitteilungen des kunsthistorischen Instituts in Florenz,* II (1917), p. 194 ff.

A third drawing, also at Venice (plate 40B) shows studies for a kneeling shepherd, for one of the hovering angels and for the Infant Christ and John the Baptist.

Another study in the Hamburg Kunsthalle (plate 41), which repeats with variations the group of St. Joseph in conversation with a shepherd and studies of the Infant Christ, completes the drawings which can definitely be connected with an *Adoration of the Shepherds* except for those of animals, which will be dealt with in their appropriate place.

For the Uffizi *Adoration of the Kings* a whole series of homogeneous studies exist (again the drawings of animals are treated separately). First of all there is the large composition sketch in the Louvre (plate 42), which must mark a fairly advanced stage in the evolution of the picture, though it was in many respects modified. This is on the whole a straightforward conventionally balanced composition, set out on the paper with a clarity and precision which anticipates the classicism of Raphael. There are already notes of strangeness, which are to find their full romantic emphasis in the picture—the prominent building in the background with its double stairs and the almost hysterical eagerness with which the adorers on the right fling themselves forward. The old 'philosopher' who stands on the edge of the picture to the left is here on the right and his attitude is less impassive as he shades his eyes with his hand. The staff he holds and the absence of any other prominently placed venerable personage suggests that he is here intended for St. Joseph.

The second study (plate 53) is the perspective drawing for the background, an elaborate and conscientious piece of scientific perspective on top of which (or partly on top, other parts seem to have been drawn first) shadowy figures of men and animals walk and talk or rest, curvet and prance. It is partly no doubt an accident of its technique which gives this drawing the same romantic *Stimmung* which marks the picture, but that it shares with the picture and some other drawings of horsemen this peculiar quality is undeniable.

In spite of its elaboration the Uffizi perspective was not used for the picture. Leonardo must have realized that it was too elaborate and that its manifold incidents were too numerous and too distracting to be possible

as a background. One imagines him with almost childish eagerness working out and making studies of all these incidents, a microcosm of the world, and then realizing the ineptitude of overelaboration and ruthlessly curtailing. Later he learnt how to restrain this exuberance, which we find so entrancing, and in the *Last Supper* confined his ideas within the most rigidly classical formula.

All other studies for the *Adoration* are studies of detail. They are mostly of the same character and style and drawn on the same paper and may, as Thiis suggested,[1] have formed part of a sketchbook, but without a minute and elaborate study of the originals which are widely scattered, it would be impossible to say which was connected with which. To assume, as Thiis does, that all without material exception belonged, is quite unwarranted. Again it would be difficult to say in many cases whether the studies were for the *Adoration of the Shepherds* or the *Adoration of the Kings.* The sheet in the Ecole des Beaux-Arts (plate 48) has studies for the figure, which is to become the so-called philosopher in the picture. As we have seen, he seems in the Louvre sketch to have been a St. Joseph; he still carries the staff in one of the studies in the Ecole des Beaux-Arts and in one of two studies on the same sheet in the British Museum (plate 49). Here he is draped and his attitude begins more nearly to resemble that of the philosopher. Another group on the Paris sheet (plate 48), that of the man with his hand on the shoulder of another, seems to be for a pair of disputants, who are to be vaguely distinguished in the Uffizi perspective sketch (plate 53) on the parapet at the top of the first flight of stairs. This last pair reappears in a drawing in the Bonnat collection at Bayonne (plate 45). The two designs for a decorative terminal, the man hammering in a nail, the two *putti,* one of whom carries a crab, and the kneeling lady have no necessary connection with the picture. Another study in the Wallraf-Richartz Museum at Cologne (plate 47) has studies for more important actors in the sacred drama, the kings on the right or their immediate retinue. On the back of this sheet—an unexpected collocation—is a careful, lifelike study of two crabs. Can there be a connection between these studies and

[1] Jens Thiis, *Leonardo da Vinci,* London, n.d. Appendix I, p. 247. This book contains the most elaborate analysis of the picture and the drawings for it.

23

the crab-carrying infant on the Bonnat drawing? It seems possible, though the crabs appear from their style to have been drawn at a later date.

Another sheet in the Louvre (plates 43 and 44) has drawings on both sides. On the *verso* the studies are for figures similar to those on the Cologne sheet, except that they include the easily identifiable figure of the crawling King. The *recto* of this sheet seems at first sight to have little connection with our *Adoration*. The group of figures in conversation at a table would obviously be identified as apostles in a Last Supper and the figure below, pointing at a plate, would be that of Our Lord. But observe how the figures at table continue and expand the motive of the pair in conversation above and this pair again is connected with the pair of talkers on plates 48 and 49. Two other sketches at Windsor, one in red chalk (plate 52A), the other in silver-point on a pale pink ground (plate 52B), are further certainly secular variations on the same theme. Leonardo seems to have gone on elaborating this subject of men arguing until finally he realized that the group had in it the elements of a *Last Supper* and begun to work it out as such, with perhaps a premonition of his most famous composition of 16 years later. His work indeed is full of such anticipations of his maturer, or reminiscences of his earlier, work and certain motives, the twirls and twists of hair and water, the complicated curves of horses in motion, run like a theme through all his work.

The drawing in the British Museum (plate 46) is another work which does not obviously connect, except in style, with the Uffizi *Adoration*. But again the two figures in conversation recall those of the Paris drawing and eventually the arguers on the parapet. The figure blowing a trumpet into the ear of another has been claimed for the *Adoration* on the ground that there are trumpeters in the background of the first sketch in the Louvre (plate 42), but this explanation seems to me farfetched. Surely we have here an allegory or part of an allegory, like that on the *verso* of the other British Museum drawing with studies for the *Adoration* (see plate 104). Indeed on one of the allegorical drawings at Christ Church (plate 106) there is a minute sketch of exactly the same motive.

A sheet of studies in silver-point in the Ashmolean Museum at Oxford (plate 51) has details of machinery (which I have failed to explain or con-

nect with other of Leonardo's mechanical work), and three figures which Berenson interprets as apostles in a composition of Christ washing the apostles' feet. It may be so, but the figure on the left has a certain connection in its pose with the man seated in the conversation group on the Bonnat drawing (plate 45) and the motive of the man shading his eyes, which Berenson says is only appropriate to a St. Peter in a Washing of the Disciples' Feet, appears not only in the picture of the *Adoration* itself but, as we have seen, in one of the studies for it (plates 48, 49).

Finally there is a sheet in the Uffizi (plate 50) which among various notes and studies includes that of a draped figure seen from the back wearing a conical hat. It gives one the impression of being the study for a king in an *Adoration*, but it differs from any in the Uffizi painting and has almost the look of being derived from some northern engraving or picture. The notes about machinery have no connection, but there is one *'questo e il modo del chalare degli uccelli,'* which shows that Leonardo was already interested in the problem of flight.

III

HORSES AND OTHER ANIMALS

Vasari tells us that Leonardo loved all animals and especially, he implies, horses. He prepared, according to Lomazzo, a work on the anatomy and proportions of the horse; but this was destroyed during the troubles of the French occupation of Milan in 1499. No definite work of this kind has come down to us, but a large number of studies of horses from all periods of Leonardo's activity have been preserved. The majority of these are at Windsor.

To the unaccustomed eye drawings of horses seem to vary less than drawings of human beings and, though the type of animal portrayed by Leonardo changes considerably, these differences have not always been recognized by critics, who have tended to connect any drawing of a horse, not obviously otherwise attached, with the commission for the Sforza monument.[1]

The first documented work in which horses appear is the *Adoration of the Magi* in the Uffizi, already mentioned. Here are to be found horses standing, walking, curvetting, prancing, rearing, seen from the front, the back and the side (see plates 30 to 38). It might almost be regarded as an illustrated treatise on the movements of the horse. The horses of the *Adoration* are far from being realistic animals, nor are they the animals of Roman sculpture. They seem nearest to the horse of Donatello's Gattamelata monument. They are distinguished from Leonardo's later horses by the smallness of their heads; they have very wide foreheads which narrow down to where the nostrils begin; the muzzles are wide and almost circular in shape. These horses behave in a wild, romantic way, in contrast to the

[1] Müller-Walde in his articles in the *Berlin Jahrbuch* (Vol. XVIII (1897), p. 92 ff., and Vol. XX (1899), p. 81 ff.) was the first to distinguish clearly between the studies for the Sforza and Trivulzio monuments, and Sir Kenneth Clark in his catalogue of the drawings at Windsor has expanded and clarified these conclusions. I can only here summarize the latter's conclusions.

stereotyped action of classical sculpture. Already the rhythm of their movements is twisting and complicated and foreshadows the frantic action of the horses in the *Battle of Anghiari,* drawn nearly twenty years later. But for all its violent and crowded incident the picture has a poetical quality, which envelops every part and differentiates it from any work previously conceived and painted. This indescribable dream-like quality extends to the drawings of horses and horsemen connected with the picture. Their technique, faint silver-point on a pinkish-buff ground, reinforced here and there with pen and ink, in the way it is employed is unique in Leonardo's work and must show a conscious attempt to convey an attitude of mind (plates 59, 60B, 64 and 65). There is one more precise and matter-of-fact drawing (plate 67), which corresponds more or less exactly with an animal in the foreground of the picture.

But before planning the *Adoration of the Magi,* which as we have seen was probably commissioned in March, 1481, Leonardo seems to have been engaged on an *Adoration of the Shepherds* (see above p. 20). Its form can only be reconstructed from a group of drawings, among them drawings of horses and domestic animals. The studies of asses and of an ox (plate 54) can obviously only have been appropriate to a Nativity and there are other studies from nature of grazing and stationary horses and parts of horses, which are connected in style, technique and paper with this and probably formed part of the preparation for the same composition (plates 55 to 58). They are in sharp contrast to the prancing animals of the *Adoration of the Magi.* But on plates 58 and 59, combined with the homely animals appropriate to an *Adoration of the Shepherds,* we find galloping horses and a horseman with the action of a St. George attacking the dragon (plate 58). So Leonardo seems to have been working at the same time on three separate compositions, an *Adoration of the Shepherds,* an *Epiphany* and a *St. George and the Dragon.* One of the drawings we have already mentioned as being a study for the *Epiphany* and the horseman which is almost textually introduced into the picture is actually a St. George fighting the dragon (plate 60B). Another drawing near in style to the studies for the two *Adorations* is the sheet with dragons (plate 62), no doubt also intended for a St. George. It seems impossible to disentangle

these three almost contemporary compositions, only one of which, as far as we know, was advanced beyond the stage of preliminary drawings.

What is perhaps the earliest drawing of animals by Leonardo is, however, unconnected with any of these three compositions. It is the extraordinarily fresh and natural sketch of a dog and two cats in the British Museum (plate 63A). The latter may have been done in connection with the *Madonna with the Cat* (see above p. 14) and the sheet probably dates from 1478-80. Another minute sketch of a unicorn purifying a pool of water with its horn at Oxford (plate 60A) seems to me most probably to date from the same early period and to be connected with the allegorical drawings of a *Maiden with a Unicorn* (plates 27 and 28B).

When Leonardo went to Milan at the end of 1481 or in 1482 he professed himself ready to undertake work on the bronze horse, commemorating Lodovico Sforza's father Francesco. It is even probable, from an autograph passage in the Codice Atlantico (fol. 323 v.-a), that he was invited to Milan by Lodovico with the express purpose of carrying out this work. No drawings for it, however, according to Clark, can be dated earlier than between 1485 and 1489. In Leonardo's earliest conception Francesco Sforza is represented on a horse rearing over a prostrate foe (plate 68 and another drawing at Windsor, No. 12,357 which is not illustrated). This idea seems to have been too ambitious, to have presented insurmountable difficulties to its realization in bronze and to have been abandoned. In 1489 Lodovico was described by the Florentine agent at Milan as being doubtful about Leonardo's capacity and to be enquiring for artists in Florence more capable of carrying out the work.

The result of these enquiries is not known but, from the fact that Leonardo notes on April 23, 1490, '*ricominciai il cavallo,*' it seems obvious that he was re-entrusted with the commission, if indeed he had ever been formally deprived of it. In this second conception the rearing horse was apparently abandoned and a sedately pacing horse substituted. Leonardo seems to have begun, as his wont was, from the beginning with an intensive study from nature, and there are a large number of drawings, nearly all at Windsor, which bear witness to the thoroughness of his preparations. There are studies of the whole horse seen in profile (plates 69, 77) and

from other points of view (plate 70), numerous studies of separate parts (plates 71, 73, 74 and 75) and measured drawings of the whole horse (plate 72) and of its foreleg (plate 76). The final form which the horse took is probably represented in a hardly visible small sketch in the bottom right-hand corner of plate 70. The model in clay or plaster which Leonardo finally produced in 1493 was destroyed by the French soldiers at the time of their occupation of Milan in 1499. It was never cast in bronze. The metal destined for this had been diverted to warlike purposes and all that remains to justify the contemporary fame of Leonardo's colossal 'cavallo' is this beautiful series of drawings.

Leonardo had fled from Milan on the fall of his patron, Lodovico Sforza, in December, 1499. By April of the following year he was in Florence and in October, 1503, began work on the cartoon for the decoration of the Great Hall in the Palazzo Vecchio, with which he had been entrusted by the government of the Republic. He chose for his subject—or was given as his subject—an incident in the battle of Anghiari between the Florentines and the troops of Filippo Maria Visconti of Milan. The theme, a struggle between horsemen for the possession of a standard, gave Leonardo full scope for the exhibition of that unrivalled knowledge of the horse's anatomy which we have seen him acquiring. Considering the importance of the commission and Leonardo's methods, it is surprising that so comparatively few drawings of horses made in connection with the cartoon are known. The greater number of the drawings which we have are small composition sketches or impressions of the action of single figures, which will be discussed later.

There are, however, two wildly careering horses with tossing heads at Windsor which cannot be for any other composition (plate 84). They are clearly for the horse on the right in the cartoon, though the position of the neck, with the violently flung-back head, which Leonardo is studying in these two drawings has been completely abandoned in the cartoon. Something like it, however, is to be found on an early sketch for the whole composition at Venice (plate 194). It is a motive which had occupied Leonardo as early as the *Adoration of the Magi*. The horse in the distance just to the right of the tree (see plate 37) swerves away with his head

and neck in something the same manner and the drawing at Oxford (plate 60B) reproduces this movement. Indeed this horseman and the one whom he attacks form together the central motive of the *Battle of Anghiari* in a less concentrated form. The same horse appears again with its neck still thrown back but its head now curved inward on plate 85. On the same sheet are studies of the heads of a man and of a lion showing how the rage of battle unites men with beasts in a common ferocity. On the *verso* (plate 83), in the middle of a series of notes on astronomy, is the head of a horse which corresponds exactly with that finally adopted in the cartoon (for the horse on the right).

Though chronologically a certain number of drawings intervene between the studies for the Sforza monument, the *Battle of Anghiari* and the Trivulzio monument, and though the plates are arranged in what I believe to be the approximate chronological order, it will be more convenient to proceed to the drawings for the Trivulzio monument, the fourth great work in which the horse figured prominently.

An autograph sheet in the Codice Atlantico (fol. 179 v.-a) gives estimates for the cost of an elaborate monument to Gian Giacomo Trivulzio, the condottiere general, who overthrew Leonardo's former patron, Lodovico il Moro, in 1499. The exact date when this monument was projected is not known, as the sheet in the Codice Atlantico is undated and there is no other reference to it in contemporary sources. It must date from after Leonardo's return to Milan in 1506, probably after his second return in 1508. Trivulzio founded a mortuary chapel for his family in 1511 and it may well have been in connection with this that the monument was projected. It was a funeral monument, as the specification is headed *'Sepulcro di Messer Giovanni Jacomo da Trevulzo.'* It was to consist of a bronze horse and rider, a marble base with eight columns and eight sculptured figures, together with a recumbent figure of the marshal accompanied by six harpies with candelabra.

On a sheet at Windsor (plate 90) there are four small and rapid sketches which are clearly for a monument of this type. The style of the drawing, the handwriting and the paper are all of a sort not employed by Leonardo when he was at work on the Sforza monument in the 'nineties.

They are clearly studies for the work estimated for in the sheet of the Codice Atlantico.

Again we find Leonardo starting off on an ambitious scale; again the steed is to be prancing over a fallen foe. The theme of the horseman, with and without the pedestal, is worked out more elaborately in another drawing at Windsor (plate 91). We see the artist experimenting with various positions for the rider, who in this monument, after the experience with the *Battle of Anghiari,* is regarded as integrally related to the horse, not as a mere appanage as in the Sforza monument. In the small sketch at the bottom on the left, the sarcophagus is to be distinguished in an arched opening under the statue (though no recumbent effigy is indicated) and four free columns at the angles with Michelangelesque captives.

The exact sequence of the drawings for the Trivulzio monument (plates 90 to 102) seems to me almost impossible to determine. I reproduce them in the order which Clark assigns to them (except that plate 89 should follow plate 94). Their style leaves no doubt that they belong together and are connected with the monument, but they fall into two main groups. In the first of these the horseman is prancing over a fallen foe (plates 90, 91, 101, 102); in the second he is walking (plates 92-100). These two groups are, however, linked together by the fact that the walking horse appears together with the prancing horse on plate 101, and that a minute sketch of a prancing horse appears alongside the walking horses on plate 100. The horsemen on plates 91 to 93 are represented in contemporary armour; on plates 97, 99, 100, 101 and 102 they are either nude or in more or less classical costume. Leonardo clearly had three types of horsemen in mind: that of Verrocchio's Colleoni, apparent in plates 92 and 93, his own wildly careering horseman in the *Battle of Anghiari* (plates 91 and 101), and a much more classical type, which it has been supposed he derived from a lost equestrian statue at Pavia known as the *Regisole* (plates 89, 97 to 100 and the walking horse in plate 101). The technique of the drawing on plate 102, with its misty but masterly indication of volume and the compactness of its design, must be the latest of the series. The comparison which has been made between its technique and that of the aged Michelangelo is just and significant.

Drawings by Leonardo of animals other than horses are few in number and the range of species small (if we except the minute hieroglyphics like those illustrated on plate 115). We have seen some of dogs and cats (plate 63A) and of a unicorn (plate 60A) from his early period, and I might add the camel in the perspective sketch for the Uffizi *Adoration* (plate 53). Of fantastic animals I have already illustrated a sheet with dragons from the same period (plate 62). There is a dragon of a much later date (plate 88), somewhere in the period of the *Battle of Anghiari,* which looks as if it had been drawn for a masquerade. In spite of Leonardo's well-known precepts on how to construct a dragon from the actual parts of other real animals—one can distinguish here the exactness with which the ram's horns are imitated—the general effect recalls the traditional Chinese-looking dragon who devours St. Margaret's clothes in Flemish Books of Hours. In the same category are the heads of monsters illustrated on plate 80, though these, if unpleasant, are quite certainly original inventions. They may date from about the same period as the delightful studies of a cart horse and details of harness and of a cart from MS. H in the Bibliothèque de l'Institut, Paris (plate 81; about 1493-94).

Some careful studies of a bear, a bear's head and the paws of a dog or wolf (plates 78 and 79), all of the same date, which have lately come to light, are not easy to place. Leonardo was interested in bears at different times: in the preliminary composition sketch for the *Adoration of the Magi* in the Louvre (plate 42) there is what appears to be a scene of bear baiting in the background. The colour of the silver-point ground in plates 78 and 79 is the same as that employed in some of the drawings of horsemen for the *Adoration* and the lightly sketched nude, which appears under the drawing of the bear, has more or less the position of the seated Virgin in the *Adoration;* further, the handling of the silver-point seems to me most closely to resemble that of the drawing of a dog and two cats in the British Museum (plate 63A). The connection between the drawings of paws and those of a dissected bear's foot (plates 225 and 226) dateable about 1490-3, which I suggested in a note in the *Burlington Magazine,* cannot be maintained in view of the fact that these are not the paws of a bear but of a dog or wolf, as has been pointed out to me. In the small

allegorical drawing in the Louvre (plate 110A) of about 1494 a bear also appears and its head is not unlike that in plate 78A (there is an even closer resemblance to the animal in the engraving of the subject by the 'Master of the Beheading of St. John the Baptist,' which may be based on a more elaborate drawing by Leonardo than the small one in the Louvre). There is also an admirable pen and ink sketch of a bear in the Codice Atlantico (fol. 98, r.-a), but this appears to be considerably later. It is particularly difficult to date silver-point drawings made, as are these, directly from nature, but I think the probabilities seem to be in favour of their belonging to Leonardo's earlier Florentine period.

IV

ALLEGORIES AND MASQUERADES

As official painter to the court of Milan Leonardo would naturally be called on to glorify the person and justify the policy of his patron in every available way. Whether Leonardo's adulation was as fulsome and at the same time as punctual as the ideal courtier's should be is doubtful —we have seen the failure of one of the schemes entrusted to him for perpetuating the glory of the regime, the ill-fated *'cavallo.'* But he was certainly busy, in conjunction with the sycophantic poets of the court, Bellincioni and Paolo Geronimo del Fiesco, in devising complicated allegories to explain away the treacheries and to stress the virtues of the tyrant. One of these in the Library of Christ Church, Oxford (plate 105) has been interpreted with great probability as referring to a particular incident in Lodovico Sforza's career, his execution of Cecco Simonetta, the minister of Bona of Savoy and her son, Lodovico's nephew, Gian Galeazzo. This event actually took place in 1480, when we know Leonardo was still in Florence, but the episode may well have been regarded as of sufficient importance as a warning to others to have been recalled some time later. There is a sketch on the *verso* of this sheet and drawings on the back and front of another sheet at Christ Church, with allegories of a similar type. In the first (plate 106) Fame or Virtue attacks Envy; on the *recto* of the second sheet are two further allegories of Envy and on the *verso* (plate 107) still another allegory of Envy and one of Pleasure and Pain. The style of all these drawings, with their tense and rapid lines, obviously approaches very near to that of the studies for the *Adoration of the Magi* and such a sketch as the girl holding a child in the British Museum (plate 28A). They must belong to a time very little remote from these sketches of the Florentine period. But we have seen studies for the *Madonna Litta* become merged in studies for the *Madonna of the Rocks* and we cannot

34

expect to find any hard and fast division between the style of drawings made in Florence in 1481 and those of, say, a few months later, which happen to have been drawn in Milan. The style of Leonardo's Milanese period is not a definitely limited and definable style: It is a gradual development of Leonardo's personality.

It is necessary to bear this in mind in reference to an allegory of the same type as those we have been considering on the *recto* of a sheet, the *verso* of which (plate 49) contains, as we have seen, studies for the *Adoration*. This composition (plate 104) has as its subject Fortune holding in her arms a child who tries to extinguish the flaming torch with which Death, supported by Envy and Ingratitude, tries to consume a tree (Fame?); Pride and Ignorance look on from the left. The style, allowing for the fact that the drawing is in silver-point, partly gone over with pen and ink, is exactly that of the two Oxford sheets. These three drawings form in fact an absolutely homogeneous group and the type of the allegory of the British Museum drawing is so similar to those associated with Lodovico Sforza, that we are tempted to think it also has reference to the Milanese court. On the other hand there is no perceptible difference in handling between it and the sketches for the *Adoration* on the *recto*, so that one is left with the conclusion that one side was drawn in Florence and the other in Milan the following week.

Another famous and beautiful drawing in the British Museum (plate 103), though its rather mysterious subject, generally explained as Victory placing a shield on a trophy, has little in common with the literary allegory of plates 104 to 108, is stylistically very close. Is it late Florentine or early Milanese? Again the question must be left open. The suggestion recently made [1] that the parts drawn with the point of the brush in bistre are eighteenth-century additions is to me quite unconvincing. The character of this drawing is eminently Leonardesque.

A rather singular little drawing at Hamburg (plate 110B) must belong to Leonardo's first Florentine period. It represents Phyllis riding on the back of Aristotle, one of those subjects dear to medieval cynicism, typifying the subjugation of intellect by love. It belongs to the same cycle

[1] Edgar Wind, *Old Master Drawings*, XIII (1939), p. 49.

of stories as that of Virgil in the basket and Samson and Delilah. Leonardo's notes on the back, '*Compagnje volupta dispiacere amore gielosia felicita invidia fortuna penitencia,*' suggest a train of thought similar to that of the Oxford and British Museum drawings.

A second group of literary allegories (plates 109, 110A, 111) belongs to a somewhat later date. These are characterized by their small size, the extraordinary delicacy of their pen-work and the delicate play of light on their surfaces. One of them, the *Allegory of the Lizard Signifying Truth* at New York (plate 111) has on the *verso* sketches for a masque of *Danae and Jupiter,* which was composed by Baldassare Taccone and was performed in the house of Giovanni Francesco Sanseverino on January 31, 1496. This gives a *terminus ante quem* for the drawing, as the slight sketches on the *verso* are likely to have been done after the more finished composition on the *recto*. The text is one of those medieval bestiary stories, many of which are to be found copied in MS. H in the Institut de France dating from between 1492 and 1494. In exactly the same style is the little roundel in the Bonnat collection (plate 109B), which seems to represent Lodovico Sforza il Moro unmasking Envy. More carefully finished are the roundel in the collection of Miss Clarke (plate 109A) representing the ermine as the symbol of purity (again explained by a passage in MS. H) and the animals fighting and a man with a burning glass in the Louvre (plate 110A), the exact meaning of which is obscure.

These small allegories, some of them contained in circles, are really of much the same character as various designs for emblems, almost certainly also done for the Sforza court. In one (plate 113) we see variations of the same subject; the mask of Falsehood being melted in the rays of the sun of Truth; sometimes the mask is by itself, sometimes it is held up in front of naked Truth by a winged figure, and generally it is enclosed in a circle or an oval. Simpler emblems are those illustrated on plate 114, where the plough, the mariner's compass and the windproof lamp, have obvious allegorical significance, however inappropriate to the tortuous policy of the Sforzas they may seem. There is another sketch of the lamp emblem in MS. M in the Institut de France, of which the date is approximately 1498, so that the drawings are likely to belong to that year. There

is also a sheet at Windsor with much less finished sketches for the same emblems, of exactly the same type as those illustrated on plate 113. Doubtless the curious apocalyptic vision on plate 112, which has not been explained, is of the same period.

What seems to us a rather childish indulgence on Leonardo's part—unless it can be explained by the exigencies of court employment—is the composition of pictographs, like that illustrated on plate 115. Words are represented by animals or objects, often with the addition of letters to complete them. Thus 'o' followed by a pear 'pera' = 'opera' and so forth. There seems to be no sequence in the thought and few consecutive sentences, but the shorthand in which the objects are represented is delightful and significant—witness the two running girls for 'venture.' This and similar sheets and fragments at Windsor seem to date from some time after 1490. Some of the charming little scrawls (plate 116A and B) may also be fragments of pictographs, but in the absence of a key as provided on the sheet illustrated, it is difficult to say. The mysterious allegory represented on plate 116C, in which all sorts of objects, but with a preponderance of hardware, are rained down from the clouds, may have reference to the occupations and professions to which men are allotted by Fate. There is an heraldic lion on the clouds and the inscription 'on this side Adam and on that side Eve' appears quite irrelevant.

A beautiful series of designs at Windsor for costumes in a masque (plates 118 to 122) represents Leonardo's court activities at Milan at a much later date, after the fall of the Sforzas and the occupation of the city by the French. It is on stylistic grounds that Clark assigns them to a period about 1513, and this evidence for their later date is quite convincing. The attempt to connect them with a masque performed in 1491 (only referred to incidentally by Leonardo) is a typical example of that absence of critical sense which, without reference to the style of the work, seeks to connect it with a document. The style and the paper of these drawings is that of the later drawings for the Trivulzio monument. We are given no inkling of the subject of the masque, nor indeed is there any certainty that all five drawings are for the same masque, but they share

37

a delicate poetic quality, which would make them adequate illustrations to Milton's Comus.

Perhaps the extraordinary figure of an elephant-headed man riding on horseback and playing on his trunk as on a flute (plate 124) is also the design for a figure in a masque, as has been suggested. It seems to me more probable that it is an allegory. It looks almost like the parody of a drawing by Dürer in the Victoria and Albert Museum, representing a man on horseback playing the bagpipes, but this may be pure coincidence.

Whether the pointing lady in a landscape (plate 123) is actually the design for a masque, like plates 118 to 122, must remain doubtful. If its form and scale suggest a connection with these, the quality of its inspiration and its ethereal charm seem to place it beyond the confines of any objective reality. The flavour of the *quattrocento* which it retains is the reminiscence of an ageing man; it represents the sum of that romantic feeling which underlies Leonardo's works as a painter and a draughtsman, but which the scientist so ruthlessly suppresses. It may be one of the very latest of his drawings done during his retirement at Amboise.

A sketch of almost equally compelling but less mysterious charm is that of the dancing women in the Venice Academy (plate 126). This has been associated with the Windsor drawing as well as with the drawing for the *Nativity* at Venice (plate 40A), showing a difference of nearly forty years in the estimate of its date formed by different critics. Its style shows that it belongs to a period not earlier than the *Battle of Anghiari* and though its rhythm also recalls that of the British Museum drawing of *Victory Placing a Shield on a Trophy* (plate 103), this must be an example of Leonardo's recapturing the mood of an earlier period of his career. We have seen other examples, not merely of reminiscence, but of almost textual repetition in his work.

Finally we have the elaborately finished political allegory at Windsor (plate 125), which doubtless contains some allusion to the papacy of Julius II, though it has never been exactly interpreted. If Julius II is intended (the tree in the boat is that of the de la Rovere arms), it must date from before that Pope's death in 1513.

V

PROFILES AND GROTESQUES

Very early in his career as an artist Leonardo formed the habit, an almost unconscious habit, of tracing on the paper the contrasted profiles of a stern warrior and of a pretty youth. No doubt these types corresponded to some deep-seated longing of Leonardo's; perhaps he thought of himself in the character of Caesar laying a conquered world at the feet of his lover, the beautiful youth. Both types persist almost to the end, modified from time to time. The warrior has a tendency to become older and less fiercely dominant; the youth loses his *quattrocento* charm and almost imperceptibly assumes the sensual outlines of a real lover who is probably Salai.[1] Neither of these types is particularly original; both in fact reflect ideals current in Verrocchio's workshop. The profile of the charming youth on the sheet at Windsor (plate 24), which dates probably from before 1480, is a near relation of the Tobias in the picture from Verrocchio's *bottega* in the National Gallery and of the marble relief of Alexander in the Straus collection in New York, while the warrior bears an unmistakable resemblance to the stern-featured Colleoni.

These are the most constant of Leonardo's types. But one of them, the warrior, by the exaggeration or distortion of a feature, ceases to have anything of nobility and becomes a caricature. He is in fact the connecting link between the normal and the abnormal, between the sublime and the ridiculous, as if Leonardo were mockingly distorting the unattained ideal of his youth. The caricatures themselves, in their multiform difformity, can hardly be classified. The greater number are clearly inventions of Leonardo's, experiments in the distortion or exaggeration of particular parts

[1] For an account of all that is known of Salai's life see Emil Möller, *Salai und Leonardo da Vinci* in the *Vienna Jahrbuch,* Neue Folge, II (1928), p. 139 ff. Möller's hypotheses about which drawings represent Salai, and still more which pictures and drawings are by Salai, seem insufficiently grounded.

of the human face. They do not give the impression of being those studies from real types which Vasari tells us Leonardo delighted in making.

The profile of a warrior in the British Museum (plate 129) has been regarded as one of the earliest of Leonardo's drawings and dated from before the time when he left Verrocchio's workshop, where he remained till 1476. But, in spite of its dependence on Verrocchio, the perfection of the drawing, its character and technique, seem to me to indicate a date about 1480. It is, in fact, as has been convincingly shown, a copy or rather an adaptation of a relief (in bronze, according to Vasari) representing Darius. This was the work of Verrocchio and was sent by Lorenzo the Magnificent to Matthias Corvinus, King of Hungary. A companion representing Alexander the Great has been identified as the marble relief in the Straus collection in New York.[1] That of Darius is lost but its form must be accurately preserved in terracotta reliefs of the Della Robbia workshop, like that in the Kaiser Friedrich Museum, Berlin. The British Museum drawing corresponds with this except for some important differences in the ornamental armour. These two reliefs probably in fact form the basis of the contrasted types which, we have mentioned, run through Leonardo's work. One can almost take it for granted that he made a corresponding drawing of the Alexander.

The same type as in the British Museum drawing with the downslanting mouth, the strongly-marked aquiline nose and the scowling brows appears on the sheet in the Uffizi dated 1478 (plate 127), on which Leonardo notes that he has begun the two Virgin Maries. But here the warrior has aged and the distortion of his toothless jaws verges on caricature.

Again we find him younger and more ill-tempered in an obviously very early drawing in the Uffizi (plate 130A); older and with thickly curling hair on a fragment in New York (plate 140c), which must date from about 1485-90, and still older, milder and more philosophic in the middle of a large sheet at Windsor (plate 132), dating from about 1489. He appears elderly and bald but forceful enough in the red chalk drawing in the British Museum dating from about 1490 (plate 140B). Later varia-

[1] Leo Planiscig, *Andrea del Verrocchios Alexander-relief* in *Vienna Jahrbuch*, Neue Folge, VII (1933), p. 89 ff. See also Sir E. Maclagan in *Burlington Magazine*, XXXIX (1921), p. 131.

tions of the same type are to be found in a full face at Windsor (plate 142), where he has obviously assumed the character of a Roman Emperor. This must date from about 1498-9, to judge from a profile drawn in a very similar way in the British Museum (plate 144). This is on the back of a sheet with a composition sketch for a *Madonna and Child with St. Anne* (plate 175), which is in fact traced through and impinges on the profile. The warrior's head appears again in a profile at Windsor (plate 139A) and a three-quarter face in the Louvre (plate 139B), which must date from about the time of the *Battle of Anghiari*, 1503. In the Louvre drawing, though he is old and toothless he is more stern and terrible than ever. A similar but rather younger and certainly milder head, with closely curling hair, at Windsor (plate 148) seems to date from about 1510, while the latest of the series and also the oldest, is the toothless man seen full face (plate 150), which is also at Windsor. The style of this is like that of the latest drawing for the Trivulzio monument (plate 102) and the landscapes on a red ground and must be dated about 1510 or 1511.

On a sheet in the Uffizi (plate 141) we find the two types, fierce old warrior and epicene youth, actually facing one another, so that the contrast was definitely present in Leonardo's mind, but the old man's chin has assumed a prominence which makes him definitely unpleasant. The contrast is between youth and repulsive age, not between youth and a forceful and dignified old age. The youth here and on plates 143 and 147 represents a type almost identical with the charming Florentine of plates 24 and 131A, but there are differences. The mass of hair closely curled in ringlets and the extraordinarily straight Grecian nose distinguish him. Clark has remarked that most artists sooner or later find the incarnation of their ideal type: This youth, so impossibly Leonardesque, is probably in fact Salai, who entered Leonardo's service in 1490 aged about 10, and whose propensity to steal and whose greed caused endless trouble in the household.

There is no regular female counterpart of the pretty youth in Leonardo's repertoire of profiles. The girl who appears on the sheet at Windsor so often referred to (plate 24) is identical, except for figure and coiffure and the absence of enthusiasm with which it is drawn, with the boy on the same sheet, but from this time women almost entirely disappear.

Their presence must be accounted for by some definite commission—as in the drawings for masqueraders' costumes (plates 122, 123)—and the profile illustrated on plate 152 may indeed have some connection with the same masque. It certainly dates from about the same year, 1513.

In contrast to these types are the actual portrait drawings, which are unfortunately all too scarce. One of the most beautiful and best-known is the profile of a young woman at Windsor (plate 128). It is difficult to form an accurate idea of the date of silver-point drawings from the life. The hairdressing of this lady seems Florentine rather than Milanese, but on the other hand the handling is more direct, simpler and more masterly than that of other silver-points of the Florentine period, for example, horses for the *Adoration,* which we have already discussed. It may then date from Leonardo's Milanese period and the lady may have been a visiting Florentine, if the headdress is impossible for Milan. Another admirable silver-point profile drawn from the life is that of a solemn man with a Roman nose also at Windsor (plate 130B). This can be more confidently, but still not certainly, assigned to the period before 1481.

As early as 1478 we have seen Leonardo beginning to modify his ideal type in the direction of caricature, even if one cannot say that the boundary dividing portraiture from caricature has actually been passed. In a famous sheet at Windsor, the most elaborate and finished of the type which has come down to us (plate 133), dating from about 1490, this step has definitely been taken. The bald old man, crowned with the oak-leaves, is the caricature of a Roman general, gentle as the satire is. He is a modification into the ridiculous of the same warrior type, while the heads which face to left and right, apparently those of women, are almost monstrosities. Whether they were conceived by Leonardo as illustrations of the passions, as eighteenth-century writers like Mariette believed, is doubtful. Certainly in some of them, like the grotesque betrothal (plate 135) at Windsor, the satiric intention is explicit as it is, in an even more obvious and traditional form, in the youth marrying an old hag for money, a drawing which is lost but is known from a copy by Hoefnagel and an etching by Hollar. This is a type of satire present in all popular art and no less in Florence where we can find something analogous among such engravings

42

as the *Bambocciata* (Hind, *Catalogue* B, III, 2) and some of the decorative engravings known as the Otto prints (especially Hind, *Catalogue* A, IV, 14; A, IV, 22 and A, IV, 23). One is apt to think of Leonardo as the inventor of the type of caricature we are discussing, but it is clearly a universal *genre*, which a certain kink in Leonardo's nature induced him to develop.

The drawings reproduced (plates 133 to 138, 145, 146) give a fair sample of this unpleasant side of Leonardo's art culminating in the almost life-size head at Christ Church (plate 146), which is probably among the latest of the caricatures. It has been suggested with some probability that this is the drawing of Scaramuccia, King of the Gypsies, to which Vasari refers as in his own collection of drawings. Is this drawing the representation of an actual human or subhuman creature? It may be, but this type with enormous slobbering lips recurs in at least two other drawings, the whole-length figure of a man holding a scroll at Windsor (plate 145), on the sheet with five heads at Windsor already mentioned (plate 133), and on that of the woman in plate 136B. The common denominator of most of the types is, however, as Clark has pointed out, their toothlessness and the various malformations of the jaw consequent on this. In some (plates 134B and 137A) the chins project upwards and nearly hit the noses; in others they protrude horizontally to an impossible distance (plates 136A and 138A). In nearly all cases the upper lip tends to disappear.

There remain three drawings of bearded old men which are in no sense caricatures. One is the magnificent self-portrait at Turin (plate 154). The apparently advanced age of the subject would seem to indicate that it was drawn in France between 1513 and 1516; the precision and character of the line on the other hand suggest an earlier period. Here there is no touch of the *quattrocentro* left; one is reminded of Raphael's portrait of Julius II. A second drawing (plate 156) is the profile turned to the right of an old man with his hair in braided pigtails, which is also traditionally regarded as a portrait of the artist by himself. Clark suggests that it might be the study for a doctor in a composition of *Christ Disputing with the Doctors*. It is probable that Leonardo painted such a picture for Isabella d'Este about 1504 and that this is reflected in the painting by Luini

in the National Gallery. Finally there is the magnificent profile (plate 155), of which again the purpose is obscure, but which must date from the artist's very latest years as the rough paper and the (for Leonardo) almost impressionistic style, as of a late Titian, indicate.

VI

COMPOSITIONS

The first documented information of Leonardo's activities in Milan is the contract signed in conjunction with Evangelista and Ambrogio Preda in 1483, for the picture which took shape as the *Virgin of the Rocks* and is now in the Louvre. It was completed at least as early as 1490. It is not necessary here to go into the complicated story of this picture, the lawsuits resulting from it, and the replica of it finished in 1508 (the National Gallery version), especially as only three drawings can be brought into relation with the two versions. The first of these is the beautiful head of a girl at Turin (plate 157) which is the study used for the angel's head in the Louvre version; the second is the sheet in the Arundel MS. in the British Museum, referred to on p. 16, which is most of it so faint as to be unsuitable for reproduction; the third is the study of drapery for a figure kneeling to the left (plate 158), about the purpose and date of which a great diversity of opinion has reigned. Its technique clearly precludes an early date, even as early as the Louvre *Virgin of the Rocks,* and it is only in the general position of the figure that it corresponds with the angel of that picture. But it does correspond fairly closely with the drapery of the same figure in the London version and probably shows, as Richter, Bodmer and Clark have pointed out, that Leonardo himself prepared and revised this version, though the execution was finally left to a pupil.

Two other sheets (plates 159 and 160) show Leonardo at work on a composition closely related to the *Virgin of the Rocks* in which the Madonna kneels, facing the spectator, stretching out one or both arms in a gesture of wonder and reverence before the newborn Child, Who lies at her feet and is, in one case, also adored by the Infant St. John. The position of the Virgin and the gesture of her left hand hovering above the head of the Infant Christ in two of the sketches in the New York sheet,

45

her right arm extending her cloak in the manner of a *'Madonna della Misericordia'* are inevitably reminiscent of the *Virgin of the Rocks* and she probably represents an earlier stage in the latter composition. As Clark has pointed out the architectural sketches on the Windsor sheet (plate 160) are connected with work on Milan Cathedral, with which Leonardo was busy about 1485. A number of pictures, notably one in the collection of Mr. H. Harris, reproduce more or less nearly the New York sketches, so that it is possible that Leonardo developed the composition to the stage of a cartoon.

The surviving drawings for the *Last Supper,* on which the artist was at work about 1495-7, are more numerous. We have already observed a first casual and tentative approach to the subject on a sheet in the Louvre (plate 44), which also contains studies for the *Adoration of the Magi* and must date from about 1481. Apart from this, which obviously has no substantial connection with the *Cenacolo* in Santa Maria delle Grazie at Milan, there are two composition sketches, a series of studies of heads, one of hands and one of a sleeve (plates 161 to 169) which can be more or less definitely related to this commission.

The two composition sketches (plates 161, 162) both represent an early stage in the working out of the theme. St. John is represented lying in Jesus' lap or stretched over the table according to the Gospel of St. John, and Judas is seated alone on the near side: His isolation was a time-honoured iconographical convention, which obviated the need for any psychological imagination in portraying him. It was obviously some time before Leonardo realized that it would be possible for him to depart from this compositionally clumsy convention and make Judas identifiable by his attitude and his expression. In both these versions also the Gospel followed is that of St. John, in which Jesus reaches a sup to Judas. The fresco, as is well known, represents the moment when, according to St. Matthew and St. Mark, Jesus exclaims, 'Verily I say unto you, that one of you shall betray me.' The sketch at Windsor (plate 161) is no more than a rapid scrawl for roughly indicating the position and proportion of the figures in relation to the architecture, details of which are included as well as geometrical figures and calculations irrelevant to our purpose. But it is instinct

46

with vigour and movement and shows an almost Rembrandtesque economy of means. In a more elaborate red chalk drawing at Venice (plate 162) (the four apostles at the bottom are to be thought of as continuing to the left) this vivacity has been lost, so much so that many have regarded it as a copy or forgery.[1] But this is hardly possible; the writing is Leonardo's, the strokes are characteristic and left-handed.

The arrangement of the apostles at table, except for the position of St. John and of Judas, corresponds approximately with that of the fresco, and they are named, but there is little of the dramatic intensity and nothing of the classical unity which distinguishes the great work itself.

A half-length figure at Vienna (plate 164) is generally, but for no very cogent reason, held to be a study for St. Peter (he is the apostle in the fresco who stretches over behind Judas). He is a fierce, didactic, indignant old man, but does not lack nobility. If it is for the figure of St. Peter in the *Last Supper* it must represent a stage intermediate between the Venice composition sketch and the final version. All the other studies are at Windsor. Unlike the Vienna drawing they are beardless, though in the fresco all except St. Philip are represented bearded. Perhaps the most impressive, certainly the one most obviously a study for the fresco is the Judas (plate 166), who is represented not as a weak or contemptible traitor, but as a powerful villain with strongly developed, almost Michelangelesque neck muscles. Certainly the most beautiful is the St. James the Greater (plate 167), with his delicately poised head and his tense expression—a head of apparently classical simplicity but with a personal quality, a head that Raphael might have conceived in its broad lines, but that only Leonardo could have drawn exactly so. The head of St. Philip (plate 165), no doubt drawn from the same model as the St. James, is almost equally beautiful, but its appeal is more sentimental and less subtle. The St. Bartholomew (plate 168), if it really is for the apostle on the extreme left, approaches too nearly to one of Leonardo's stock types to be interesting. Finally there is a study of clasped hands for those of St. John (plate 163) and a beautifully finished study for the sleeve of St. Peter (plate 169), both also at Windsor.

[1] A more probable explanation is that it is a copy *by* Leonardo of an earlier composition.

Plate 171A has usually been regarded as for the Infant Christ in the *Virgin of the Rocks*. The child is indeed extremely similar, but why is it cut off by a horizontal line below the bust in a way which is unexampled among Leonardo's studies? Clark has connected it with another drawing, like the first at Windsor, which represents the back and chest of a baby without the head and cut off below the chest in a similar way. His theory is that it is a drawing for a terracotta bust of the Infant Christ and such a bust is mentioned by Lomazzo.[1] The style of these drawings points to a date about 1497.

A drawing of the head of Christ (plate 171B) must be for a Christ carrying the Cross, a composition which is reflected in Venetian art but of which this is the only positive evidence that it derives from Leonardo. It is not an attractive drawing and somehow recalls the unpleasant characteristics of the so-called study for St. Peter at Vienna (plate 164). It must date from about the time of the *Last Supper*.

In December, 1499, Leonardo left Milan and apparently went from there to Mantua. Here he drew or painted a portrait of Isabella d'Este which must have looked something like plate 172. This certainly represents Isabella and is a life-size cartoon which has been pricked through and used for a painting. There are various versions of this portrait, at Oxford, in the Uffizi and elsewhere, but none is as good as that illustrated, in the Louvre. Of the authenticity of this it is difficult to speak; in its present state one cannot say that it represents much of the master's handiwork. Isabella seems to have been fascinated by Leonardo and was anxious to obtain other pictures from him. She presumably succeeded in getting him to paint an Infant Christ (see plate 207), but from the correspondence it is doubtful whether he produced anything else for her or even coloured her portrait, a point mentioned in the letter. Her envoy in Florence, Fra Pietro da Nuvolaria, was instructed to procure pictures from Leonardo and as a fortunate result gave an account of him and his activities during March

[1] *Anch'io mi trovo una testicciola di terra, di un Christo, mentre ch'era fanciullo, di propria mano di Leonardo Avinci, nella quale si vede la semplicità, & purità del fanciullo, accompagnata da un certoche, che dimostra sapienza, intelletto, & maestà & l'aria che pure è di fanciullo tenero, & pare haver' del vecchio, savio, cosa veramente eccellente. Trattato dell' Arte de la Pittura*, Milan, 1584, p. 127.

and April, 1501, in a letter which has been preserved. Among the paintings which he describes is one for Florimond Robertet, representing the Madonna with the Child Who plays with a yarn-winder. Of this composition, though the original is lost, numerous copies are in existence and it is possible to connect with it a beautiful study at Windsor of a woman's bust (plate 173).

Leonardo must have been occupied with a composition, or series of compositions, of the Virgin and Child with St. Anne, from shortly before his departure from Milan in 1499, possibly almost up to the time of his death. The Burlington House Cartoon and the Louvre picture of the subject are both well known. It has been argued that Leonardo produced a third version which survives only in description in the letter of Fra Pietro da Nuvolaria just mentioned, and in the feeble and very un-Leonardesque painting by Andrea del Brescianino in the Kaiser Friedrich Museum at Berlin. This would have been the version spoken of by Vasari, 'which not only filled all artists with wonder, but, when it was finished men and women young and old, continued for two days to crowd into the room where it was exhibited, as if attending a solemn festival: and all were astonished at its excellence.' But, in fact, contemporary descriptions of compositions can be too carefully read, right and left are relative, not standard terms, and Nuvolaria's description accords closely enough with the composition of the Louvre picture. One can assume it was the cartoon from which this was evolved.[1] The Burlington House Cartoon (plates 176-180) is said by Fra Sebastiano Resta,[2] who may have had some authority for this statement, to have been the cartoon of St. Anne ordered by Louis XII (who came to the throne in 1498) before 1500 from Leonardo, while the latter was still in the service of Lodovico il Moro in Milan. Such a date is possible, even probable, on grounds of style if this statement has reference, as it almost certainly does, to the Burlington House Cartoon. Resta adds that Leonardo never sent the cartoon to Louis XII, but afterwards did a second more finished one in his own (Resta's) possession. (This was actually a

[1] See L. H. Heydenreich, *Gazette des Beaux-Arts*, X (1933), p. 205 ff.
[2] *Lettere Pittoriche*, III (1759), p. 326. The fullest account of the cartoon is by the late Sir Herbert Cook in the *Gazette des Beaux-Arts*, XVIII (1897), p. 371 ff.

copy of the Louvre picture or its cartoon and was in the Esterhazy collection in Budapest.)

The Burlington House Cartoon is one of the few large works which come direct from Leonardo's hand. So many of the paintings, the *Last Supper*, the *Virgin of the Rocks*, the *Battle of Anghiari* are lost, or ruined by repaint or obscured by dirt and varnish. Here we have the inestimable benefit of the authentic touch and of all the elements, except colour, which go to make up Leonardo's charm. The problem which he set himself to resolve here was one which had, as we have seen, occupied him at the very beginning of his career in the *Virgin and the Cat*—the relation in depth of three almost interlaced bodies. This, his first solution, must have seemed to him too monotonously vertical and the collocation of the two pairs of heads may have struck him as unhappy. In the next version, on which he was, we believe, working in 1501, the contrasts in position between the figures is very much more complicated, though actually the individual forms show less of that twisting *contraposto*, which is generally so characteristic.

The most interesting drawing connected with the Burlington House Cartoon is that in the British Museum (plate 175), in which the main group has, but only after a struggle which has made it almost indecipherable, assumed pretty nearly the form of the cartoon, though in the smaller sketches below Leonardo, still dissatisfied with the position of the legs, has sought to clarify this.

The large drawing Leonardo traced through to the back of the sheet (plate 144) with the object of further elaborating the subject. This reversed tracing seems to have formed the basis of a drawing of similar type in the Louvre (plate 174B) in which the difficulties and experiments have been so numerous, that the drawing which finally emerged is almost unintelligible. Nevertheless it is basically no more than a reversed version of the Burlington House Cartoon, while at the same time it contains some of the elements of the Louvre picture. A further development in which the lamb is introduced for the first time is to be found in a drawing in the Venice Academy (plate 174A). Here the movement, which in the Paris drawing tended to the left and has as its object the Infant Christ, is now transferred to the opposite side, or rather it begins in the centre and makes

a detour through the Virgin down to the lamb on the right. This curious animal incidentally assumes almost exactly the position and indeed the physical appearance, bar the horn, of the unicorn in a much earlier drawing (plate 27). The only drawing remaining which can be associated with the Burlington House Cartoon is the pen and ink sketch at Windsor (plate 181), which is apparently for the Infant St. John. The position is by no means the same, though there is a resemblance, but the type of child and the tightly curled hair are unmistakably similar.

All the remaining studies are studies of detail for the Louvre version and nearly all are at Windsor. There is the beautiful drawing of the head of St. Anne (plate 182) and another head (plate 183) which Clark claims is for the head of St. Anne as it appears in the Brescianino picture mentioned above. It is not directly for any of the heads in either the London or the Paris version. As it stands the face has been ruined by a restorer; it is primarily a study of the kerchief covering the head, the work on which is intact. This is of exactly the same character as the drawing for the sleeve of St. Anne. It might be for the head of the Virgin as realized in the Paris sketch (plate 174B). For the Infant Christ there are a number of studies on a well-known sheet at Venice (plate 185) and another slight one at Windsor (plate 184A) and there is the elaborate and beautiful drawing for the Virgin's sleeve (plate 184B). Finally there are the two studies for the unfinished (or ruined) drapery of the Virgin, at Windsor (plate 186) and in the Louvre (plate 188) and the similar study for the drapery round St. Anne's legs (plate 187).

A drawing in black chalk at Windsor (plate 190) has a study of a nude youth seated in profile to the right and, below, the sketch of an infant holding a lamb. The subject of this last suggests a connection with the Louvre picture, and this has been supposed of a sheet with three similar studies formerly at Weimar.[1] But the position of the Child, Who appears to be seated on the ground, can hardly be reconciled with His position in the Louvre picture or any of the studies for it. Nor can the seated youth

[1] Reproduced or partly reproduced in W. von Seidlitz, *Leonardo da Vinci*, Berlin, 1909, vol. I, p. 80.

be connected with any existing composition of Leonardo's. But the drawing must date from about this period.

A remarkable drawing of the head of a bearded man in three different positions (plate 189), which reminds one of Van Dyck's painting of Charles I made for Bernini, used to be described as studies of an Armenian. The Christ-like features have now been identified as those of Cesare Borgia. Leonardo must have drawn the portrait when he was in the duke's service as a military engineer in 1502.

I have already in the section on horses (p. 29) necessarily touched on Leonardo's great composition of the *Battle of Anghiari,* which survives, or partly survives, only in copies. The lines of the great central group, the battle for the standard itself, are well known, particularly from the copy by Rubens and from some earlier paintings and engravings.[1] A certain number of the drawings can be related to this well-defined central group, others not. Some of these last are probably more or less irrelevant jottings by Leonardo, others may be connected with a part of the composition which was never advanced beyond the stage of a cartoon. There can be no doubt that the actual battle for the standard was the only portion of the design painted by Leonardo on the wall. Let us deal with the drawings for this first. On a small sheet at Venice (plate 193B) the terrific interlocked group of horsemen galloping past has already taken shape. We see the horse on the right, which is attacked with tooth and hoof by another and the horseman on the left with the pole of the standard on his shoulder. But the two groups are not so closely knit together and there is room for a standing foot soldier between them; in the picture only the pair locked in deadly combat on the ground appeared under the horses' bellies. For this foot soldier, who thrusts upwards with his lance at the central figure of the group, there is a separate study on a larger scale below. In the background on the right is a bridge, which was an important element in the story of the battle. On another small sheet at Venice there is a similar little composition sketch (plate 194) which probably precedes in point of date that first

[1] K. F. Suter. The earliest copy of Leonardo da Vinci's *Battle of Anghiari, Burlington,* LV (1929), p. 181; the same, *Burlington,* LVI (1930), p. 257; for yet another copy by Rubens, see *Burlington,* LXXVI (1940), p. 194.

mentioned. The attitude of the horseman on the extreme left with the lance behind his back is already as in the cartoon. It was clearly an attitude which particularly pleased Leonardo and which early became fixed. But here the groups are widely separated and great play is made of the billowing folds of the standard between them. Below are studies of foot soldiers fighting, which have no apparent connection with the portion of the composition which we know. Another minute sheet at Venice has three studies for the two men beneath the horses' bellies, one poniarding the other (plate 192A). They are marvels of expressiveness in miniature. The remaining studies are the famous sheets at Budapest for the head of the warrior brandishing his sword above his head (plate 198) and for the youth on the right (plate 199). It is these two magnificent heads which give the most vivid idea of what the original cartoon must have been like. A third sheet at Venice (plate 196) is very closely related to a subsidiary head on the Budapest sheet (plate 198) to which it is in reverse. It may have been intended for that of the warrior in the centre between the man brandishing a sword and the man in profile.

The drawings which are not obviously studies for the battle for the standard itself may represent ideas jettisoned by Leonardo in the course of the work, or they may be studies for parts of the composition, which was developed as far as the cartoon. The wall of the great hall of the Palazzo Vecchio was divided into three parts by windows; it has been suggested that the central part was occupied by the struggle for the standard and that some of the unidentified sketches may represent ideas for the other two spaces to left and right. A certain support is given to this by contemporary copies. A well-known sketch by Raphael at Oxford, for example, from the *Battle of the Standard* as we already know it, also contains a slight but unmistakable copy of the horse seen from the back on plate 201. Perhaps the latter drawing reproduces the right-hand half of the composition with the supports moving up to take part in the melee. On another sheet at Turin (plate 197) the most finished study is that of a nude warrior with sword in hand. Below is a smaller study of a man brandishing a battle axe or a two-handed sword above his head and lower still a galloping horseman *ventre à terre*, a rider and another horse. The nude warrior is copied,

as has been remarked by Müller-Walde, by Raphael in the *Judgment of Solomon* of the *Stanza della Segnatura*. It is likely that Raphael also sketched it from the cartoon rather than from this drawing itself. The minute galloping horseman reappears on two sketches at Venice (plate 191) and Windsor (plate 200) and on one in the British Museum (plate 193A). A drawing by Michelangelo, who was working on his cartoon in the great hall at the same time as Leonardo, includes the same horse and rider galloping to the right. It is assumed that this sketch is a copy of the left-hand portion of Leonardo's cartoon. The little sketches of horsemen and foot soldiers at Venice (plate 192B) may be for this half of the composition or may represent an early phase of the central design. It seems that the horseman on the extreme right at the bottom of the British Museum drawing already mentioned (plate 193A) may be the earliest conception of the warrior hauling at the pole of the standard. On the *verso* of this same drawing is a slight sketch in black chalk of a foot soldier (not reproduced) which corresponds with a figure in the bottom sketch of the Venice sheet (plate 192B).

A sheet at Windsor drawn on both sides (plates 202, 203) is of interest from more than one point of view. It contains a number of studies of rearing and galloping horses which if not directly studies for the *Battle of Anghiari*, are at any rate of the same character as those already discussed. It however brings us into contact at the same time with another work, an angel which Vasari describes as having belonged to Cosimo de'Medici and of which copies survive. This figure in black chalk is indeed a copy by a pupil but it has been corrected in pen and ink by Leonardo himself. The sheet also contains the important note by Leonardo, *'Fanne un picholo di cera lūgho un dito'* 'Make a little one of it in wax a finger long,' referring most probably to the horses, and confirms a statement by Vasari as well as explaining the existence of a number of small bronzes of prancing horses. Of the same type and date is another Windsor sheet (plate 195) with three studies of horses fighting and what appears to be a man getting onto the bank out of the water rather in the manner of Michelangelo's bathers.

This exhausts the drawings which are mainly or entirely studies for the *Battle of Anghiari,* but little fighting horsemen crop up on many sheets in

the Codice Atlantico and the other manuscripts, and show Leonardo's continued preoccupation, in the middle of other studies, with the cartoon. One such is illustrated on plate 237, a sheet of anatomical studies at Windsor.

There remains one remarkable drawing (plate 204) which seems to be a sort of nightmare recollection of the *Battle of Anghiari*. Monstrous horses curvet and prance and fall huddled up in the centre; against them gallops another horse on the back of which is a howdah, filled with men; a host of minute horsemen follow this monstrous vision and fight and skirmish in the foreground. What are these amazing animals and what is it all about? Some, if not all, are intended for elephants, but it is odd that Leonardo, who had been in Mantua, did not remember the real elephants of Mantegna's *Triumph of Caesar* or even the elephant on the medal of Isotta da Rimini, and evolve a more lifelike animal. It just shows that even the greatest artist cannot invent that unique creature. The drawing has been variously interpreted; from an allegorical attack on war to an elephant hunt. It is most likely Leonardo's conception of a classical battle with elephants, but it is linked in feeling and in technique with the drawings of deluges (see especially plate 290) and must belong to a later period than the drawings for the cartoon we have been considering; Clark dates it about 1511.

There is one drawing at Windsor (plate 205), which seems to record a design spoken of by Vasari as made for Leonardo's friend Antonio Segni. This was a Neptune in his 'chariot drawn by sea-horses, with fantastic creatures, dolphins and winds; and several most beautiful heads of sea gods,' and is clearly an elaborate finished drawing, probably of the type of the allegory illustrated on plate 125. The study is a preliminary one and includes only the figure of Neptune himself and four sea-horses with those wildly tossing heads familiar from the Anghiari studies. For all its vigour and the wild movement of the horses it has a certain classical regularity, which suggests derivation from an ancient gem. It is the earliest of a series of representations of the subject beginning with Marcantonio's *Quos Ego*. Over the drawing Leonardo has written *'a bassa i chavalli,'* 'lower the horses.' This instruction has, it is ingeniously supposed, been carried out on another sheet at Windsor (plate 206) in which a nude man stands in

the attitude of Michelangelo's *David* while a horse (or horses) lies at his feet. The man here is indeed higher than the horse as compared with the other drawing. But the relation between the man and the horse is obscure and it does not seem to be a sea-horse. The interesting thing about the figure is that it is a sketch by one great artist after another's work. Leonardo, as is well known, was appointed to a committee to consider a position for Michelangelo's *David* at the beginning of 1504 and this drawing is likely to date from then. The Neptune would be of approximately the same time, as Segni left Florence for Rome in 1504.

Two drawings at Windsor (plates 207A, 207B) of a sleeve and of the front of a dress have been convincingly related by Clark to a lost picture of *Christ Blessing*. This composition is preserved in an etching by Hollar and in more than one painting, and is presumably that commissioned by Isabella d'Este on May 14, 1504.

A composition on which Leonardo was engaged during or shortly after the Anghiari cartoon is that of *Leda*. Of this also there were at least two different versions, though whether either of them was actually carried by Leonardo beyond the stage of a cartoon is doubtful. In one Leda was represented half kneeling, as in the small composition sketches on plate 212 and the larger and more elaborate drawing on plate 208. The horse on the former is clearly for that on the right in the *Battle of Anghiari* and shows that Leonardo must have been working simultaneously on the two compositions. The *Leda* shows the same interest in *contraposto* that we find in some of the drawings for the *St. Anne*. The two small drawings should particularly be compared with those on the British Museum sheet (plate 175). The scale, the technique and the twisting movement are identical. There is a picture ascribed to Gianpetrino at Schloss Neuwied, which corresponds fairly closely in design with the smaller of the two sketches on plate 212, in which Leda holds one of the children to her breast, and seems to imply that Leonardo had at least completed a cartoon, perhaps a picture, as a model for the copyist. But a second composition less violent in its contortion, in which Leda stands facing the spectator and stretches her right arm across her body to the swan which is on the right, was the final and better known conception, as is shown by the numerous existing copies and

adaptations. A version supposed to have been painted by Leonardo himself is recorded at Fontainebleau in the seventeenth, but had disappeared by the end of the eighteenth, century. A cartoon must have been in existence before 1508 for Raphael, who left Florence about that time, made a copy of it (now at Windsor). The picture—if Leonardo actually painted the subject—was probably not completed till after his return to Milan in 1508, for the existing versions of it are mostly by Milanese artists. It would seem that the picture was modified or completed then by the inclusion of the two sets of twins issuing from the eggs, and these clearly show a connection with Leonardo's anatomical studies of the foetus in the womb (plate 248) probably dating from about 1512; so that the *Leda,* like most of Leonardo's compositions, seems to have dragged on.

There are a number of studies made directly for the standing *Leda* and probably dating from the earlier phase of its composition about 1504-6, apart from the drawings of plants (plates 270 to 278), which were probably made in connection with it. There is an insignificant sketch of the pose on a sheet at Windsor (No. 12,642, not reproduced) which also contains anatomical studies, and two similar ones in the Codice Atlantico (f. 156r.). The most important, however, are the four sheets at Windsor (plates 209A, 209B, 210, 211), with studies of Leda's coiffure, which a note on one (plate 209A) proves to have been a detachable wig. The model finally adopted in the cartoon seems to have been that of the larger head on plate 210, for it is almost exactly reproduced in one of the painted versions, probably by Cesare da Sesto, at Wilton House.

VII

ANATOMICAL DRAWINGS AND DRAWINGS OF THE NUDE

The stage in his career at which Leonardo began to devote himself seriously to the study of anatomy is not exactly known. No surviving anatomical drawings can be assigned to a period earlier than about 1487, and the earliest actually to be dated are some sheets with drawings of skulls (plates 217 to 220) in Anatomical MS. B, one of which is inscribed by Leonardo with the day of the month, April 5, and the year, 1489, in which it was drawn.

There are also traditions handed down by the Anonimo Gaddiano and Vasari about Leonardo's activities as an anatomist, which are no doubt substantially accurate and which carry with them some implications as to date. The Anonimo [1] says that Leonardo made many drawings of anatomy in the Hospital of Sta. Maria Nuova in Florence. This must have been at some period after his return to his native city in 1500 and probably before 1506. Vasari,[2] in the second edition of his Lives (1568), speaks of Leonardo's association with the anatomist Marcantonio della Torre. The latter was appointed teacher of anatomy at the University of Pavia in or about 1506 and died in 1512, so that Leonardo's work in collaboration with him must have taken place between 1508 (the date of Leonardo's return to Milan) and 1512.

Leonardo also dated some of his anatomical MSS. That known as Anatomical MS. A at Windsor (plates 243 to 246) has the note 'in the spring of this year, 1510, I hope to have completed all this branch of anatomy.' One of the series of miscellaneous sheets known as Anatomical

[1] *Il Codice Magliabecchiano,* ed. Carl Frey, Berlin, 1892, p. 112. This is confirmed by a passage in Anatomical MS. B, fol. 10v, in which Leonardo describes an autopsy which he carried out in the hospital on an old man 100 years old (MacCurdy, I., p. 125).

[2] Vasari, ed. Milanesi, IV, p. 34.

MS. B, also at Windsor, has, as we have seen, the date 1489, but this date only applies to a small part of this manuscript. In the similarly miscellaneous collection, Anatomical MS. C, there is the date January 9, 1513, which applies to twenty sheets, and marks the last definite date we possess for Leonardo's activities as an anatomical draughtsman.[1]

We have the contemporary evidence of Antonio de Beatis, who visited Leonardo at the Castle of Cloux on October 10, 1517, as secretary to Cardinal Louis of Aragon, about the anatomical drawings, which is worth quoting in full: 'This gentleman [Leonardo] has compiled a particular treatise of anatomy, with the demonstration in draft not only of the members, but also of the muscles, nerves, veins, joints, intestines, and of whatever can be reasoned about in the bodies both of men and women, in a way that has never yet been done by any other person. All which we have seen with our own eyes; and he said that he had already dissected more than thirty bodies, both men and women of all ages.'

Leonardo certainly projected a didactic treatise on anatomy, which was obviously to consist chiefly of illustrations with explanatory text. It is very unlikely that it was ever completed or even that any part of it was prepared for publication. Anatomical MS. A seems to contain the elements of this projected work, but it is far from being arranged in any consistent order. Leonardo also prepared no less than three drafts for an introduction to the work, in two of which he lays down the order to be followed.[2]

Leonardo's anatomical writings and drawings were, as we have seen, taken by him to France, where they were examined by de Beatis. They were inherited with the rest of Leonardo's drawings by Melzi, and were seen by Vasari in Melzi's possession in 1566. Their subsequent history need not be repeated here. They are now all, with very few exceptions, in the Royal Library at Windsor Castle.

Their arrangement and the manner of their publication is confusing and may be summarized here. Anatomical MS. A, numbered at Windsor 19,000 to 19,017, was published in facsimile at Paris in 1898 by T. Sabach-

[1] In a draft of a letter in the Codice Atlantico (Richter, No. 1353), undated, but written in Rome, Leonardo speaks of having been hindered from practising anatomy there, apparently by order of the Pope. This was in 1514-16.

[2] Richter, Nos. 796-798.

nikoff and Giovanni Piumati. It is bound as a book, comprises, as already stated, the elements of the projected treatise on anatomy, and is dated 1510.

Anatomical MS. B consists of sheets of various dates, of which some five belong to 1489, but the greater number probably to 1502-6. It is numbered 19,018 to 19,059 and was published in facsimile by Sabachnikoff and Piumati at Turin in 1901.

Anatomical MS. C comprises all those drawings at Windsor of various dates not previously published by Sabachnikoff and Piumati. They have the numbers at Windsor 19,060 to 19,152, and were published in admirable facsimile in six volumes by C. L. Vangensten, A. Fonahn and H. Hopstock at Oslo, 1911 to 1916. The sheets are bound in the order of this publication, except that it includes other anatomical drawings which are mounted separately and have numbers in the 12,000's at Windsor. (Plates 216, 223, 227-229, 230, 231, 232, 241, 247, 250 are taken from such drawings.)

It is of course impossible for any but a professed anatomist to pass judgment on the significance of Leonardo's work in this field. The acuteness of his observation and the extraordinary accuracy with which he recorded what he had dissected, was far in advance of anything previously done, and he is credited with some discoveries which were not published for one or two hundred years after his death as the result of independent research, for none of his work was ever published or became available to his successors even to a limited extent.

What we are here concerned with is not the scientific interest of his work but its importance in Leonardo's development as a draughtsman. It would appear at first sight a simple matter to deal with the anatomical drawings, strictly so-called, alone, but this is not the case. A number of the drawings of nudes, or parts of nudes, were made in connection with the studies in anatomy; in some cases it is not even clear whether a drawing actually represents the limbs in their perfect state or partially stripped (écorché) to show the muscles (e.g., plate 239). And further, most of these drawings have been included as anatomical drawings in the publication of the so-called Anatomical MS. C. Some of the drawings again are studies illustrating the proportions of the human figure, rather than its

structure or anatomy, for instance those reproduced on plates 215, 216 and 224.

A small number of drawings of the nude, however, clearly have no direct anatomical interest. Such is the study of a youthful nude (plate 213A), apparently for a St. John the Baptist in the desert, which is of the type of the very numerous drawings by Florentine artists of the *quattrocento*, like those of Filippino Lippi and those attributd to Davide Ghirlandajo. Like them it is drawn with the silver-point on a coloured ground and heightened with white, and must date from the very beginning of Leonardo's career, about 1476. No picture for which it might have been a preparation is known. Another slightly later nude is the figure of St. Sebastian at Hamburg (plate 213B), the style and penwork of which points clearly to the period of the *Adoration of the Magi*, about 1481.[1]

To the earliest drawings, which can strictly be called anatomical, belongs the sheet with drawings of a man's legs, the leg-bones with the sinews and a similar drawing of a right arm (plate 214). It is on a blue-green prepared surface used by Leonardo about 1487 and there are eight other sheets of the same character at Windsor. An interesting point about it, discovered by Clark, is that it was copied by Dürer in a sketch-book now at Dresden, though not directly, as the copy is reversed. It would seem that someone either copied or engraved some of the drawings in this series and that Dürer obtained these. There are also examples of other definite copies by Dürer. The similarity between the German artist's studies in the proportion of the human figure and in anatomy and those of Leonardo are obvious; even a certain similarity in their attainments and their approach to art has been observed, but even now that we know that Dürer actually copied Leonardo, the exact scope and extent of their relations to one another has still to be explained.

The famous drawing at Venice (plate 215) of a nude man in a circle illustrates Vitruvius's code of human proportions, and a translation of the text of Vitruvius in Leonardo's hand has been subjoined. The drawing has the appearance of having been made for reproduction by the woodcutter

[1] A picture by Marco d'Oggiono in the Kaiser Friedrich Museum, Berlin, related to this drawing, is published by Suida, op. cit., Abb. 88.

and a figure in a similar position was in fact used in Fra Giocondo's edition of Vitruvius, first published at Venice in 1511. The drawing, however, dates from a much earlier period, about 1485-90, and was certainly not designed for this work. Another sketch, dealing with the proportions of the head and face and illustrated on plate 216, is of the same period. It shows that Leonardo was at this time seriously engaged in a study of the proportions of the human figure. There are other drawings at Windsor, Nos. 12,606 and 12,607, and 19,130 to 19,133 (of which one, No. 19,132, is reproduced on plate 224), which show a similar interest and there are many passages in the *Trattato della Pittura,* to which these drawings could be related. The two elaborate but unfinished silver-point drawings, illustrated on plates 222 and 223, might in their nature be regarded as preparatory studies for paintings. One of them, however, (plate 223) appears in substantially the same form as an illustration to the *Trattato,*[1] to explain the shortening of the body on the side on which the weight rests and the other sheet was probably drawn to illustrate a similar problem. Both drawings are dated by Clark about 1490-1 from the resemblance in style and technique which they bear to drawings for the Sforza horse (e.g. plate 77).

The drawings of skulls dated 1489 (plates 217 to 220) have already been referred to. Strictly anatomical as their intention is, the extraordinary delicacy of observation and appreciation of surface quality with which they are drawn raise them from the level of anatomical diagrams to that of works of art. Though this is indeed true of a large proportion of Leonardo's scientific drawings, it is here patently obvious, and they must rank with such studies as the angel's head at Turin and some of the studies of horses of this period as masterpieces of modelling and texture.

Almost equally beautiful and among the most elaborately finished of Leonardo's anatomical studies are the dissections of the paws of bears, of which two (plates 225 and 226) are illustrated. These are drawn in silver-point on a blue prepared surface heightened with white, and add to the delicacy of their drawing a singular charm of colour. In the introductory

[1] Lionardo da Vinci, *Das Buch von der Malerei, nach dem Codex Vaticanus (Urbinas)* 1270. Herausg. von Heinrich Ludwig, Vienna, 1882, p. 212. The Codex Urbinas is a copy, or rather a manuscript edition, made about the middle of the sixteenth century, of Leonardo's writings on art. The diagrams illustrating it are certainly faithful copies of Leonardo's own sketches.

plan for his projected work on anatomy Leonardo writes, 'Then I will dis-
course of the hands of each animal to show in what they vary; as in the
bear, which has the ligatures of the toes joined above the instep.'[1] No
doubt these drawings were made to illustrate this comparison, though the
draft introduction dates from some years later, about 1504-9, at the time
when Leonardo was most intensively occupied with anatomy. The drawings
were oddly described by Vangensten, Fonahn and Hopstock as the dissec-
tion of the feet of a monster, but were later identified by Prof. William
Wright as representing 'the hind foot of a plantigrade carnivorous animal
—probably a bear.'[2]

A type of drawing which may, for lack of a better title, be included
under 'Drawings of the Nude,' is illustrated on plates 228 and 229. These
are studies of men at work, ploughing and digging and carrying earth. The
earliest of them (plate 228), from the similarity of the handling of the
red chalk to sketches in MS. H, must be of the same date as this, about
1492-4 (compare the drawings of a horse and cart illustrated on plate 81).
Sketches of the same character (plate 229B) seem to be later, about 1503.
There are similar little figures on the *verso* of the same sheet and on the
back and front of two other sheets at Windsor (Nos. 12,645 and 12,646),
all drawn in black chalk so faint as to be unsuitable for reproduction. The
example illustrated has been partly inked in, if not by Leonardo himself, by
someone who has preserved the action and the spirit of the tiny figures.
The drawings of two nudes and of a woman washing clothes (plate 229A)
is clearly of the same type and sketches on the *verso* are similar in subject.

A few other anatomical drawings can from their style be dated before
the period of Leonardo's main preoccupation with the subject from about
1504 onwards, like the unpleasant and, I believe, inaccurate diagram illus-
trating the structure of the cranium and the eye socket (plate 227) which
dates from about 1500. To this latter period, when he was working on the
cartoon for the *Battle of Anghiari*, belong a whole series of studies, part
strictly anatomical, part drawings of the male nude made apparently to
illustrate anatomical theories (plates 230 to 237). The presence on one

[1] Richter, No. 822.
[2] *Burlington Magazine*, **XXXIV** (1919), p. 203.

(plate 237) of a minute drawing of a battle of horsemen and foot soldiers is conclusive evidence for the date of this and others of similar style. Another (plate 236) of the legs of a man lunging, in spite of the anatomical inscription, may be a direct study for one of the figures in the cartoon. The position of the legs corresponds to that of the soldier holding a shield above his head on plate 237 and less exactly to one in the little sketch at Venice illustrated on plate 192B. A number of drawings show a figure standing with his legs apart and arms slightly raised from the sides, seen frontally (plate 231, 238) or from the back (plate 233). Another figure in the same position (plate 232) has the heart, lungs and main arteries drawn on it, showing the close connection between the nudes of this type and the work on anatomy. Others (plates 234 and 239) are drawings of the leg or legs and lower half of the body of a man in exactly the same position and another drawing (plate 242), the style of which points to a later date (the period of the studies for the Trivulzio monument) shows Leonardo still occupied on a man in the same position. The constant repetition of that attitude must imply that it was the position, or one of the positions, which Leonardo had selected for his anatomical man. Another study which recurs is that of the lower half of a man to above the waist seen in exact profile, of which the earliest is that on plate 222, already referred to. Another, which Clark assigns to about the same period as this but which appears to me later, about 1504, is illustrated on plate 221; and others are the drawing in the British Museum (plate 235) of about 1504 and that at Windsor with the little sketch of a battle already mentioned (plate 237).

A sheet with three studies of the lower part of a man (plate 230), but in positions differing from the standard types we have been discussing, dates also from about 1504. It also shows drawings of the leg bones and muscles of a man and of a dog and is interesting as exemplifying Leonardo's use of comparative anatomy, which we have seen in the quotation to the introduction to his projected anatomical work.

Anatomical MS. A, of which five pages (plates 243 to 246 and 251) are here illustrated, has already been referred to as being dated 1510. It deals mainly, as will be seen from the specimens, with the muscles of the shoulder, arm, neck, face and legs, and has a continuity and consistency

lacking in most of the anatomical works. At least the drawings are mostly to the same scale and similarly arranged on the page, though their order does not, it is said, follow any logical plan.

Leonardo was concerned with the problems of conception and generation at various periods from about 1494 onwards, but more intensively in 1510 or rather later. The drawing of the foetus in the womb (plate 248) and the dissection of the main organs of a woman (plate 247) date from this period. He is certainly the first artist to have dissected and drawn the unborn child and, as we have seen, these studies seem to have some connection with the painting of the Leda and the twins issuing from the eggs which she produced. Not that it is necessary to explain any of Leonardo's scientific work by reference to his painting, for though the original impetus may have been artistic, it was pursued for its own sake.

The latest of the anatomical drawings are those in MS. C II, which is dated January 9, 1513. They are drawn on natural blue paper (*carta azzura*), a product of Venetian origin, which is here employed by Leonardo for the first time. Some, like plate 252 of the tendons of the neck, are more summary than the earlier drawings, but others like the drawings of the heart on plate 249 have an extraordinary precision and delicacy of modelling, with a style of cross hatching which recalls Breughel.

VIII

LANDSCAPES, FLOWERS AND WATER, MAPS

We found in the case of Leonardo's study of the human form difficulty in drawing a line between the strictly anatomical and the purely artistic. The same difficulty arises in his studies of the earth, its waters and its vegetation. The original motive for recording these is obviously the keen appreciation of their beauty expressed in such passages of romantic description as that in the *Trattato della Pittura*, 'beautiful and delightful places with limpid waters through which the green bed of the stream can be seen and the play of the waves rolling through meadows and over pebbles, mingling with blades of grass and with playful fishes and similar subtle detail.'[1] To this attitude of enjoyment and representation succeeded, as always with Leonardo, a mood of inquiry and, having inquired, of explanation. For he feels it his duty to express in words, reinforced if possible by diagrams, the principles which he has discovered about the structure and appearance of things. The scientist in Leonardo is always treading on the heels of the artist. It does not follow that his scientific studies made his drawings less artistically attractive, where the subject in itself admitted of it, but it did induce him to make hundreds of diagrams and write thousands of words, which any but the most bigoted 'Leonardista' could well spare, and distract him from what posterity at any rate has pronounced his real profession, that of an artist. We have on the other hand many exquisite studies, like those of mountain ranges (plate 285) and of trees (plate 262), which owe their origin to scientific curiosity.

Leonardo was not only the author of the first treatise on landscape, incomplete though this is, he was also fortunately the author of more surviving landscape drawings perhaps than any artist of the fifteenth century.

[1] Richter, I., p. 59 (Paragone 24).

Indeed one can recall very few Florentine landscape drawings before those of Fra Bartolommeo, though artists like Baldovinetti and Antonio Pollaiuolo must have made such studies. Leonardo himself criticizes the attitude of Botticelli in the *Trattato*: 'He who does not care for landscapes esteems them a matter involving merely cursory and simple investigations. So does our Botticelli, who says that such studies are vain, since by merely throwing a sponge soaked in different colours at a wall, a spot is formed wherein a lovely landscape might be discerned . . . and this artist painted very poor landscapes.' [1]

It is perhaps significant that Leonardo's first dated drawing is a landscape, the famous sheet of 1473 in the Uffizi (plate 253) drawn when he was 21. The mere fact of the presence of a relevant and precise inscription on a drawing implies either some self-satisfaction on the part of the artist or that it marks some significant point in his career. Most of the other dates on the drawings are in connection with notes scribbled on the paper which have no direct reference to the subject of the drawing. We may, I think, assume that the inscription on the Uffizi landscape betrays a pride in the achievement. In spite of a certain romantic improbability about the rocky hill to the right [2] it is no doubt an actual view, and the castle on the left has been identified with some verisimilitude as that of Montelupo. The broad valley in the distance with the wide, wandering river is certainly the valley of the Arno as it is to be found in the background of many Florentine paintings, notably in those of Antonio Pollaiuolo. The trees are rendered in a convention either of parallel lines or, when more distinct, of blobby circles. Leonardo is already observing the different appearances of foliage on trees in varying lights and at different distances and trying to record these impressions. He was to take up this problem of the representation of trees with extraordinary thoroughness nearly thirty years later, and the advance may be estimated by comparing the schematic drawing of the trees here with that in the studies illustrated on plate 262. The Uffizi drawing has none of the delicacy of most of his later pen drawings or of his con-

[1] *Trattato della Pittura*, 60 (quoted in Richter, I, p. 84).
[2] Its form is reminiscent of the rock in the background of the painting of the *Madonna and Child with Angels* by Verrocchio in the National Gallery.

temporary work in silver-point. It does, however, reveal already an original observer and a powerful artistic personality.

In the rocky gorge at Windsor, reproduced on plate 255, first occur those basaltic formations, series of spikes either detached or, as here, split off but still leaning against the main precipice, which form so characteristic a feature of the background of the *Virgin of the Rocks* and reappear in the *Mona Lisa*. But this drawing is very much earlier, not far removed in date from the Uffizi landscape. Dr. Valentiner[1] has rightly remarked a similarity in the forms of the rocks in this drawing and in those of the picture in the Kaiser Friedrich Museum at Berlin, representing the meeting of the youthful Saviour with the young St. John the Baptist, a picture which he attributes on this and other grounds to Leonardo. The Windsor drawing has not the speed and energy of the Uffizi landscape; indeed it is rather feeble and tentative in handling and the conventional ducks and the reflections of the stones in the pool are frankly incompetent.

There is no landscape drawing existing for the *Virgin of the Rocks* or of that period, and the next glimpse of Leonardo's landscape which we get is on a double page in the Codice Atlantico (plates 258, 259). The drawings seem to represent a series of separate landscape sketches rather than the romantic panorama which at first sight emerges. They were drawn on two sheets on which subsequently Leonardo wrote the famous piece of geographical romancing, in the form of a letter to Diodarius of Syria, on the formation of the Taurus mountains. This text dates probably from about 1499 and the drawings only preceded the writing by a very short space of time and may have been vaguely intended as illustrations to it. Anyhow the landscapes are strange and romantic ones, which recall the mysterious amphitheatre of rock behind the *Mona Lisa's* head. The expanse of water in the foreground in plate 258 (repeated in the background to the right and on plate 259) may perhaps be a whirlpool, though such a phenomenon is not mentioned in the text.

The magnificent red chalk drawing at Windsor (plate 261) of a storm breaking over an Alpine valley, probably records a visit paid by Leonardo to the foothills of the Alps about 1499. It used to be regarded as a study

[1] *Berlin Jahrbuch*, LVI (1935), p. 223.

for the background of the *Mona Lisa,* but the relation to this is not very close and it is clearly the vivid recollection, if not the textual record, of a real storm effect. It is the actual prelude to the cloudbursts and floods of Leonardo's imagination, which he recorded in such drawings as those illustrated on plates 283 and 288. In the same technique and style are the other two mountain landscapes illustrated on plate 260, which must have been made on the same Alpine journey.

The three dainty pen and ink landscapes and the study of trees illustrated on plates 268 and 269 clearly belong together. These panoramas are in character intermediate between the landscapes and the bird's-eye view maps, which we shall have later to consider. They were apparently, like many of the latter, made in view of, or as a relaxation from, schemes for canalizing the Arno which occupied Leonardo in 1503. It may even be that they are details of the plan illustrated on plate 267, part of a scheme for embanking and directing the Arno. The rope ferry (plate 268B) might well be a view of that which appears on the extreme left of the plan and in each of the landscapes (plates 269A and B) a navigable canal alongside a shallow river occurs as in the plan. These three landscapes with their extraordinary delicacy and the exquisite rendering of sunlight on tree and meadow and water are unique in Leonardo's work. They inevitably recall the work of another great landscape draughtsman, Pieter Breughel, who specialized in this type of panoramic landscape. They are very much alike even in detail, but Leonardo has more variety and suppleness—he is experimenting. From the first Breughel's technique is absolutely assured; it is a medium admirable for its purpose, but which could not have been adapted to express the varieties of broken water which run and bubble and foam in Leonardo's little drawing of the ferry. As for the trees, without the unexceptional provenance, one might have thought them the work of a sixteenth- or seventeenth-century Fleming.

A series of four drawings in black chalk or charcoal on white paper, of which two are reproduced (plate 284), were made to illustrate or explain geological formations. They have this in common with the visions of destruction, that they represent former catastrophic upheavals of the earth; they are petrified deluges. The style and technique of the drawing,

black chalk on particularly clear white paper, connect this series with the drawings for the Trivulzio monument, 1508-11.

Actually to the year 1511 must belong a further series of seven drawings at Windsor in red chalk on a red prepared surface, of which three are illustrated on plates 285 and 286. The same technique was used by Leonardo for drawings of the nude, for example that in the British Museum (plate 235) but never with such exquisite effect as in the mountain range (plate 285A). No monochrome reproduction can give any idea of the charm of colour or of the brilliance with which the early sunlight strikes these ranges with its clear beams. A drawing of the series representing a fire (No. 12,416) has the inscriptions (almost certainly copied from an effaced inscription in Leonardo's own hand) 'On the tenth day of December at nine o'clock a.m. fire was set to the place' and 'On the eighteenth of December, 1511, at fifteen hours this second conflagration was made by the Swiss at Milan on the spot called DCXC.' The inscription on plate 285B has reference to the stone of these mountains in varying lights, and suggests a connection with studies of this sort in the manuscript of 1509-10 formerly belonging to the Earl of Leicester. The notes on a drawing of a delta (plate 286), which are very much effaced, have not been deciphered. The drawing itself has suffered also to a certain extent, and lost the crispness of the mountain ranges, but it is a masterly impression of this type of swampy land with which Leonardo had so much to do. It recalls a similar view, done about a hundred years later, a colour etching by Hercules Seghers. Finally the elaborate study of rock stratifications (plate 289) suggests as Clark says 'that Leonardo was turning to the anatomy of the earth, studying its rocks as he had the human bones.' The style of the drawing with its assurance and its elasticity connects this study with the later anatomical drawings of 1513 (compare plates 248, 249).

If the general appearance of the earth in all its manifestations and the scientific explanation of these engrossed Leonardo throughout his life, the particular element which exercised over him the greatest fascination was water. Water played a very important part in his life. A great deal of his energies and his intellect were absorbed in directing and canalizing rivers and in inventing or perfecting hydraulic machinery. But his profes-

sion as a water engineer is not enough to account for what can almost be regarded as an obsession; rather it was a symptom of it. Something in the movement of water, its swirls and eddies, corresponded to some deep-seated twist in his nature. All his life he studied these movements. The writings in which he sought to codify the waves and reduce the eddies to a geometrical system form one of the largest sections of his voluminous writings, and the drawings illustrating these a not inconsiderable part of his graphic work, which culminates in the series of deluges (plates 290-6) at Windsor.

The earliest drawings are those definitely concerned with hydraulic inventions, Archimedes tubes, suction pumps and water wheels of various types, which from their style must date from between 1473 and 1478. One of them in the Codice Atlantico is illustrated in the following section on machinery (plate 297). In the famous letter to Lodovico Sforza in which Leonardo gave a list of his accomplishments, one of these was his ability to conduct water from one place to another, but it was not till some years later, in 1492 (MS. A), that he began seriously to study the movement of water. His first account of a deluge, which became the symbol of this passion and of this study, does not occur till much later.

Plates 279 to 282 are examples, dating from about 1507-9, of Leonardo's studies of the forms assumed by water flowing from a conduit on impact with stationary water or the forms taken by water passing an obstacle. The cinematographic vision which could see, the prodigious memory which could retain and the hand which could record these evanescent and intangible formations are little short of miraculous. These drawings do not however so much convey the impression of water as of some exquisite submarine vegetable growth.

If their value for us is merely that of beautiful patterns, Leonardo's aim was purely scientific, as the text to these drawings shows. They illustrate a projected book on the nature of water, a large part of which is contained in the manuscript formerly at Holkham Hall, but now in the Pierpont Morgan Library, and in the MS. F in the Institut de France, both dating from about 1509-10. How far Leonardo succeeded in elucidating the nature of water I must leave it for others to decide. The bulk of

his writing on this subject, with its attempts to find a formula for the impact of water on water and its endless repetitions, is almost unreadable. It is unlikely that the dignified old man seated under a tree, who appears to be contemplating the intricate patterns of the water opposite him (plate 282), has any real connection with it. It has been supposed, but without adequate reason, that it represents Leonardo himself. The text may be quoted as an example of Leonardo's methods and as revealing a connection in his mind between the forms of water and hair which is not unimportant. 'Observe the motion of the surface of the water which resembles that of hair, which has two motions, of which one depends on the weight of the hair, the other on the direction of the curls; thus the water forms eddying whirlpools, one point of which is due to the impetus of the original current and the other to the incidental motion and return flow.'

Connected in Leonardo's mind still more, one would suppose, embedded in the depth of his consciousness, was the vision or the nightmare of a catastrophic disaster. Though the destructive agency in what is probably the earliest illustration of this dream (plate 288) does not primarily assume the form of water, this is its normal manifestation. Even here, though fire and lightning are in evidence, the solid mass of cloud in the lower vision must contain, and seems to be pouring down, water into the rocky valley below. The sheet might well illustrate the passage in the Codice Atlantico [1] quoted below. There the continuously destructive power of water is contrasted with the temporary ravages of fire, which needs fuel for its continued existence. This drawing may indeed be regarded as the prelude to the series of inundations.

These open with what at first appears to be nothing but a quiet landscape of wooded slopes, rocks and a castle (plate 283). But already on the right the waters are rushing past and through the buildings and behind and above we see in faint black chalk the indication of swirling, tempestuous forms which will in a few moments engulf all that remains. In what is probably the next of the series (plate 290) not only the water but the winds are unleashed. It is the latter agency which has cast down a group of men and horses in the foreground on the right and beaten the trees

[1] Fol. 108, verso b. MacCurdy, vol. II, p. 12.

down to the earth. But in the background monstrous waves, on the crests of which ride the watery gods, are about to finish the destruction. It is the tidal wave which succeeds the hurricane, though this effect is more likely due to the unfinished state of the drawing than to the knowledge on Leonardo's part of such phenomena. On plate 291 the destruction is more complete; man has already been eliminated and the waters swirl around and over the vegetation, which still here and there rises above the waves, while the laden clouds let down from above curious tenacle-like arms of rain. Another (plate 292) is already so stylized that its subject is barely recognizable. It seems to represent the double destruction of a city by inundation and by the collapse upon it of a mass of rock.[1] Leonardo's conception of the deluge becomes more and more stylized. The forms of the water curling down from above and spreading out on impact with the ground in curls like that of hair no doubt seem to him to embody the results of the observations and experiments in the movement of water extending over so many years. But in fact the scientist has in these drawings been totally submerged: It is some inner rhythmic sense which dictates to Leonardo the abstract forms of these visions.

These abstractions are certainly among the latest of Leonardo's drawings and were probably made during his retirement in France after 1517. They represent a very interesting experiment in abstract design hardly repeated in Europe till modern times. Are they of absolute aesthetic value? I should say no, but qualify this negation by adding that anything of Leonardo's had aesthetic significance, direct or indirect. In the matter of deluges one is tempted to think that his power as a draughtsman lagged behind his power as a writer, for this subject stimulated him to passages of real descriptive power. Or is it rather that the subject is one for descriptive writing rather than pictorial representation? Let me conclude with one of Leonardo's often quoted descriptions:

Among irremediable and destructive terrors the inundations caused by rivers in flood should certainly be set before every other

[1] Clark refers to the description of a mountain falling on a town, in the Codice Atlantico, fol. 79a (Richter, No. 610), in connection with this drawing.

dreadful and terrifying movement, nor is it, as some have thought, surpassed by destruction by fire. I find it to be the contrary, for fire consumes that which feeds it, and the movements of water by its wish to descend. The food of the fire is disunited, and the mischief caused by it is disunited and separated, and the fire dies when it lacks food. The slope of the valley is continuous and the mischief done by the destructive course of the river will be continuous until, attended by its valleys, it ends in the sea, the universal base and only resting place of the wandering waters of the river.

But in what terms am I to describe the abominable and awful evils against which no human resource avails? Which lay waste the high mountains with their swelling and exalting waves, cast down the strongest banks, tear up the deep-rooted trees, and with ravening waves laden with mud from crossing the ploughed fields, carry with them the unendurable labours of the wretched weary tillers of the soil, leaving the valleys bare and mean by reason of the poverty which is left there.[1]

Though Leonardo must have made hundreds of studies of plants during his life, only a minute fraction of these survives. There are something like thirteen genuine drawings of flowers, without counting two or three unimportant, and a few more elaborate, sketches in the manuscripts.

If Vasari's account[2] of the Adam and Eve cartoon and the date he assigns to it by implication are correct Leonardo must have spent a considerable part of his youth in Florence studying plant forms. Even if Vasari's story is not true, the foregrounds of Verrocchio's *Baptism*, or that part of it occupied by Leonardo's angels, and of the Uffizi *Annunciation*,

[1] Codice Atlantico, fol. 108, verso b (MacCurdy, vol. II, p. 12).
[2] Vasari, ed. Milanesi, IV, pp. 22, 23. It would seem curious that an unknown Florentine artist should be entrusted with the design of a cartoon to be woven in Flanders as early as 1475-80. It is much more probable that such a commission should have been given to Leonardo after his reputation had been established at the beginning of the sixteenth century. I do not know that there is any example of an Italian artist supplying the cartoon for a tapestry to be woven in Flanders before the *Acts of the Apostles* by Raphael. Tapestry cartoons, Italian and Flemish, were as we know from existing examples, usually in colour, not '*di chiaro e scuro lumeggiato di biacca,*' as stated by Vasari.

as well as the tree in the *Adoration,* imply a pretty elaborate preparation and the lists of works which he apparently drew up shortly after his arrival in Milan includes 'many flowers drawn from the life.' But there is only a single drawing of a flower which can be assigned to this period, the large and elaborately finished study of a lily at Windsor (plate 254). This is in fact not a preliminary study, but a full-size cartoon and the pricked outlines imply that it was used. It cannot, as has been stated, have been employed for the angel's lily in the Uffizi *Annunciation* or for any other picture known to us. Are we to infer that it is the only surviving indication of still another *Annunciation* from Leonardo's Florentine years? The slant of the lily is in the opposite direction to that of the Uffizi one and probably indicates an angel advancing from the right. I think there can be no doubt at all that the drawing is in fact by Leonardo, widely as it differs from the other plant drawings by him. The rather heavy-handed outlines, with their effect of violence and impatience, are paralleled by the lines of the Uffizi landscape of 1473 and still more by those of drawings of engines of war in the Codice Atlantico of the same period or a little later (e.g. fol. 64 *recto*).

The next definitely dateable drawings of plants occur in MS. B of the Institut de France. This manuscript can be assigned to the winter of 1488-9, a time at which Leonardo may still have been working on the *Virgin of the Rocks* commissioned in 1483. The viola illustrated on plate 257, though it is not actually to be found among the flowers painted so lavishly and so exquisitely in the foreground of the Louvre picture, is very similar to that in the centre by the feet of the Infant Christ. This study on fol. 14 *recto* of MS. B and another slighter sketch on fol. 13 *verso* of the same, are drawn with that extraordinary evenness and precision with parallel lines of shading, which is seen in its most elaborate perfection in the drawings of skulls of 1489. In the same style, but carried out with even greater delicacy and with a certain hesitancy, is the sheet of studies at Venice (plate 256). This again has an appearance of kinship with the flowers in the *Virgin of the Rocks,* but again, as far as I can see, no single flower is actually repeated in the picture. Apparently of the same period is the

drawing of a plant on a sheet at Windsor which has already been illustrated in connection with the more prominent drawing of an old man's profile which it contains (plate 132).

The bulk of Leonardo's drawings of plants and flowers are, however, of a much later date. They have convincingly been related by Clark to the cartoon for the *Leda* (see plates 208 to 212). They are all at Windsor and most of them have the appearance of being studies made for a picture rather than definitely botanical studies, with the exception of one (plate 272) which has notes of a scientific character. The pen work of such as are drawn with the pen (plates 270, 272, 273, and 274B), with the greater pliability of its line and its occasional cross-hatching, relates the series to the later drawings for the Anghiari cartoon and those for the Trivulzio monument, while the type and species of the plants definitely point to the *Leda*. Bulrushes such as those on plate 271 occur in the drawing of a kneeling Leda formerly at Weimar (plate 208), and brambles (plate 274A), oak leaves (plate 277) and again rushes are to be found in the version of the picture formerly in the Richeton collection. The feeling for structure and for texture, shown in such studies as the branch of blackberry on plate 275 and the oak leaves on plate 277, are extraordinary and make one regret the disappearance of so many of these and resent the survival of so many drawings of purely mechanical subjects.

The study of tree forms seems to occupy an intermediate position between landscape and botany. In the case of trees Leonardo was in fact less concerned with their growth and structure on the whole than with their appearance. Whole sections of the *Trattato* are taken up with rules for the manner in which more or less distant trees are illuminated and should be represented at different times of the day. As is shown by the inscription on the *verso* of the sheet illustrated on plate 262, these two beautiful drawings were made in connection with such studies in landscape. They must date from about 1498, the time of Leonardo's most exquisite and elaborate red chalk drawings, like the storm in an Alpine valley (plate 261).

Leonardo's work as a cartographer forms a distinct and separate part

of his multifarious activities.[1] Its interest and importance is largely historical, but I have included some examples of maps in this section on the ground of their relationship to landscape proper. The medieval idea of a map was of a vast panorama with the mountains, rivers and cities represented as they appeared, but necessarily hopelessly out of scale. Leonardo in most of his maps followed this tradition and in so far as he followed it his maps have a certain claim to be regarded as landscapes. They have the stylishness which Leonardo could not avoid impressing on anything he drew and an extraordinary charm of colouring, which is unfortunately lost in reproduction, and they appear to be remarkable examples of painstaking and accurate cartography. Still, one of their chief attractions is in what appears to us the *naiveté* of their convention, and this is a quality we hardly associate with Leonardo.

Nevertheless the earliest to which a definite date can be assigned is the plan of Imola (plate 263) and this is claimed to be one of the earliest geometric plans of a town. The bird's-eye view for towns was almost universal till the end of the sixteenth century and indeed persisted till much later. However this may be, the plan must have been drawn in 1502, when Leonardo was serving Cesare Borgia as a military engineer. Borgia was immobilized in Imola by a rebellion of some of his troops in October of that year, and it is no doubt at that time that Leonardo drew not only this plan but the triple portrait of Cesare at Turin (plate 189). The notes refer to various places in the neighbourhood of Imola, their distance and direction from it, no doubt drawn up for strategical reasons.

The beautiful bird's-eye view of the country to the east and south of Arezzo (plate 266), showing Perugia in the top right corner and Siena at the bottom, has been explained by Solmi in reference to the same campaign as that for which the plan of Imola was drawn. It will be observed that lines radiate from Arezzo (at the top to the left) and mark this as the important point. It appears that Borgia's general, Vitellozzo Vitelli, was in command of troops at Foligno which were to come to the aid of

[1] Dr. Eugen Oberhummer, *Leonardo da Vinci and the Art of the Renaissance in its Relations to Geography, Geographical Journal*, XXXIII (1909), p. 540; M. Barrata, *Leonardo da Vinci e la Cartografia*, Voghera, 1912.

the insurgent inhabitants of Arezzo, and that the map has reference to these operations in June, 1502.

Most of the other maps and a number of preliminary sketch maps were drawn in connection with an ambitious and apparently quite impracticable scheme for constructing a canal from above Florence through Prato and Pistoja to rejoin the Arno at Fucecchio or to enter the sea near Pisa, and for related plans for regulating the flow of the Arno above Florence. Plate 265 shows a genuine map of the watershed of the Arno which attains a high degree of accuracy and in which the mountains are indicated not in the medieval way, as actual mole hills, but by shading, in a manner approaching the modern system of contours. The care with which the rivers and streams and the watershed is drawn and the absence of towns or villages show that this was a hydrographic map almost certainly drawn for the canal scheme. The beautiful plan of a weir or series of weirs (plate 267) has already been mentioned in connection with the landscape drawings. Its purpose and position are explained by a smaller scale map of the Arno above Florence, for which it is the detail. Purely practical as is the intention of this drawing it achieves in the original an extraordinary charm of colour and design.

Not so directly connected with the canal scheme is the bird's-eye view of part of the coast of Tuscany with points of strategic importance prominently marked (plate 264). The view includes the valley of the Arno with particular emphasis on the fortified points at the junction of the Arno and the Era. The fortress on the range of hills to the south, with the castle of Volterra in the foreground, are also given prominence. It is to be presumed that this bird's-eye view was drawn in connection with the defense of the canal, especially where it rejoined the Arno near Fucecchio. The most important document regarding a scheme for this canal are the rough sketch-plan at Windsor (No. 12,279), on which its proposed course is marked, and a descriptive note in the Codice Atlantico (Richter No. 1001).

The map or bird's-eye view of the coast of Italy farther south, with Monte Circeo as the prominent headland in the centre (plate 287), must date more than ten years later than those of Tuscany. At least there is

no record of Leonardo's having travelled as far south as this before his residence in Rome in 1515. It probably indicates that he was concerned in the scheme initiated under Leo X for draining the Pontine Marshes. The hand in which the place names are written in this map is not Leonardo's but there is no doubt that the drawing is his, the shading of the mountains being quite characteristic for that period.

It will be observed that the writing on all these maps and plans, except that of Imola, is from left to right, so that it should be legible to others besides Leonardo. They are all elaborately and beautifully finished productions and among the few drawings which Leonardo consciously prepared for other eyes than his own.

IX

MACHINERY AND ARCHITECTURE

In the famous letter presumed to have been addressed, about 1481, to Lodovico Sforza, of which a draft or copy not in Leonardo's handwriting is in the Codice Atlantico, he asks for employment mainly in the capacity of a military engineer. His claims are set forth in the following terms:[1]

> Most illustrious Lord, having now sufficiently seen and considered the proofs of all those who count themselves masters and inventors of instruments of war, and finding that their invention and use of the said instruments does not differ in any respect from those in common practice, I am emboldened without prejudice to any one else to put myself in communication with your excellency, in order to acquaint you with my secrets, thereafter offering myself at your pleasure effectually to demonstrate at any convenient time all those matters which are in part briefly recorded below.
>
> 1. I have plans for bridges, very light and strong and suitable for carrying very easily, with which to pursue and at times defeat the enemy; and others solid and indestructible by fire or assault, easy and convenient to carry away and place in position. And plans for burning and destroying those of the enemy.
>
> 2. When a place is besieged I know how to cut off water from the trenches, and how to construct an infinite number of bridges, mantlets, scaling ladders and other instruments which have to do with the same enterprise.
>
> 3. Also if a place cannot be reduced by the method of bombardment, either through the height of its glacis or the strength of its position,

[1] Translated by MacCurdy, II, p. 552, 3.

I have plans for destroying every fortress or other stronghold unless it has been founded upon rock.

4. I have also plans for making cannon, very convenient and easy of transport, with which to hurl small stones in a manner almost of hail, causing great terror to the enemy from their smoke, and great loss and confusion.

5. Also I have ways of arriving at a certain fixed spot by caverns and secret winding passages, made without any noise, even though it may be necessary to pass underneath trenches or a river.

6. Also I can make armoured cars, safe and unassailable, which will enter the serried ranks of the enemy with their artillery, and there is no company of men at arms so great that they will not break it. And behind these the infantry will be able to follow quite unharmed and without any opposition.

7. Also, if need shall arise, I can make cannon, mortars, and light ordnance, of very beautiful and useful shapes, quite different from those in common use.

8. Where it is not possible to employ cannon, I can supply catapults, mangonels, *trabocchi* and other engines of wonderful efficacy not in general use. In short, as the variety of circumstances shall necessitate, I can supply an infinite number of different engines of attack and defence.

9. And if it should happen that the engagement was at sea, I have plans for constructing many engines most suitable either for attack or defence, and ships which can resist the fire of all the heaviest cannon, and powder and smoke.

The very large number of drawings and notes on military art which have been preserved show that these claims of Leonardo's to competence as a military engineer were based on extended study. It must be confessed, however, that much the larger number of these drawings date from a period subsequent to that of the letter, when he was already settled in Milan. Nevertheless there are some which can be assigned with more or less certainty to the first Florentine period. The drawings on the *verso* of

the sheet dated 1478 (plate 127), with the two heads, represent catapults and winches for engines of war and the detail of a ratchet on the *recto* is for a dart-throwing machine, of which a finished drawing is in the Codice Atlantico (fol. 64 *recto*). A number of other sheets in the same album can, from the style of their writing or drawing, be attributed to the same period.[1] These include a number of studies of cannon and gun-carriages, bridges, the dart-throwing machine, which Leonardo later calls a rhomphea, and devices for repelling assaults by scaling ladders, of which I reproduce an example (plate 298). The view of a canal with weirs and lock gates reproduced on plate 299 may have a military significance but it is more probably an example of civil engineering. The character of the writing and the style of the drawing show that it belongs to the same date as the drawings just described, that is, probably to about 1480. It is difficult to judge how important and novel Leonardo's contrivances are without a profound knowledge of contemporary treatises on the art of war. As far as I can judge from the material available to me [2] most of Leonardo's devices are improvements of existing machines rather than actual inventions, especially at the period of which we are treating. The simple and slightly ludicrous invention for throwing down scaling ladders, and another machine in the form of a sort of horizontal windmill for sweeping assailants off the battlements, seem, however, to be original. In two cases Leonardo has certainly copied earlier drawings, for these drawings are actually included in the Codice Atlantico [3] together with Leonardo's copies. The style of these early drawings of machinery, the convention for representing screws, cog-wheels, etc., clearly derives from that current at the time as exemplified in Valturius and the two manuscripts mentioned

[1] The following is a provisional list: Fol. 9 *recto*-b, 14 *verso*-a, 19 *recto*-a, 19 *recto*-b, 23 *recto*-a, 23 *verso*-a, 26 *verso*-a, 26 *verso*-b, 28 *verso*-b, 32 *verso*-a, 34 *verso*-a, 49 *verso*-b (illustrated), 53 *verso*-a, 56 *recto*-a, 56 *verso*-a, 60 *recto*-b, 372 *verso*-b.

[2] These include Robertus Valturius, *De re Militari,* first edition, Verona, 1472: Italian translation with copies of the woodcuts, Verona, 1483 (Leonardo is known to have used the latter directly or indirectly, see Calvi, op. cit. p. 100 ff.) and two manuscripts on the art of war, hydraulics, etc., illustrated with numerous drawings, in the British Museum. These are Harley 5281 and Add. 34,113, the latter of which largely derives from the first. The treatise by Francesco di Georgio in the Communal Library at Siena, from which I suspect the above manuscripts derive, at any rate in part, is not known to me.

[3] The earlier drawings are fol. 15 *recto*-a, 15 *recto*-b, and Leonardo's copies are fol. 392 *verso* and 387 *verso*-a.

in the note. It is well shown in the sheet with drawings of pumps and Archimedes tubes, reproduced on plate 297. It has been described by Calvi as *'un po' mastodontico'* and contrasts with the extraordinary delicacy of the drawings of the beginning of the Milanese period.

A large number of drawings of military subjects, which correspond with the claims made in the letter to Lodovico Sforza, as has been shown by Müller-Walde,[1] must certainly follow and not precede this letter. Some are drawn with pen and ink and wash, some with the pen and ink only, all are closely connected in style as well as in subject with each other and with similar drawings in MS. B in the Institut de France (see below). Three of them (plates 308-310), which are shaded with washes of light brown and have as their principal subject chariots armed with revolving scythes, must clearly have been drawn within a short time of one another, but I do not think they are necessarily separated by any length of time from others (plates 300 to 307) or from the drawings in MS. B, as has been supposed.[2] The style of the figure drawing, apart from the addition of wash, is the same. On one (plate 308) a partisan on the extreme right is obviously a study for one in a sheet of drawings of halberds and partisans attached to MS. B.[3] The studies for the drawings at Windsor and Turin (plates 309, 310) on a sheet in the Codice Atlantico (plate 311) are strikingly similar to the rapid sketches in MS. B.

Lomazzo[4] states that Leonardo drew for Gentile dei Borri, armourer to Lodovico Sforza, a whole series of men on horseback and on foot, showing the methods by which they could defend themselves, the one from the other. It has been suggested that the drawings we have been discuss-

[1] *Leonardo da Vinci Lebenskizze,* Munich, 1889, p. 159 ff.

[2] Clark (Catalogue, 6. 122, No. 12,653) notes the close connection between these washed drawings and a sheet from the collection of Baron Edmond de Rothschild, now in the Louvre (reproduced *Gazette des Beaux-Arts,* VII (1932), pp. 88, 89). One of the drawings on this sheet represents two horsemen attacking a dragon, which he connects with the dragon fight on the Oxford drawing (plate 60B), and this he maintains points to an early date for the Rothschild drawing and the three drawings of chariots with scythes. But there are things in the Rothschild drawing which anticipate the studies for the *Battle of Anghiari* (the youth on a galloping horse and the horse seen from the back with its off hind-leg raised) as well as recalling the drawings for the *Adoration.* It is unfortunate that it has not been possible to procure a photograph of this interesting drawing for reproduction.

[3] Reproduced, C. Ravaisson-Mollien, *Les Manuscrits de Leonard de Vinci,* Tom. VI, Paris, 1891, MS. 2037, fol. A1 *recto.*

[4] *Trattato dell'Arte de la Pittura,* Milan, 1584, p. 384.

ing form part of this series. But only one of them corresponds in its subject matter exactly with Lomazzo's description, the drawing at Venice (plate 304) of infantry defending themselves against cavalry with lances, over which has been fitted a shield in the form of a half-opened steel umbrella. A sheet in the Ecole des Beaux-Arts in Paris, showing a bomb exploding (plate 301) also has drawings of archers, a swordsman and a crossbowman sheltering behind shields, in some cases attached to their weapons, and these might be brought into connection with the illustrations mentioned by Lomazzo, as well as a similar bowman and a horseman with three lances on a second sheet at Windsor (plate 309). But on the whole the identification of any of these drawings with the work for Gentile dei Borri seems inadmissible.

But to return to Leonardo's letter to Lodovico in reference to these drawings—their character and their number almost imply that Leonardo was making good statements which, at the time they were made, hardly corresponded to the facts, and the contents of MS. B goes to confirm this impression. It is largely taken up with notes and transcriptions relating to the arms of the ancients taken from Valturius' *De re Militari*.

I should think it doubtful whether the bombard in the drawing at Windsor (plate 306) was 'very convenient and easy of transport' (one is in fact mounted on a barge) but it is certainly hurling forth 'small stones in a manner almost of hail,' as in paragraph four of the letter. The circular object, something like a tortoise, on the British Museum sheet (plate 308) may be one of the 'armoured cars, safe and unassailable, which will enter the serried ranks of the enemy, with their artillery, and there is no company of men so great that they will not break it' of paragraph six. It is certainly a forerunner of the modern tank, though its speed and consequent offensive power must have been small. One is reminded of 'bridges very light and strong and suitable for carrying very easily' of paragraph one by the trestle bridge, the construction of which is illustrated on plate 300, but it is hardly the whole bridge which is transportable; it can be constructed of timber found on the spot.

The giant crossbow on the sheet of the Codice Atlantico (plate 302) is no doubt among the 'catapults, mangonels and *trabocchi* (*trébuchets*)

and other engines of wonderful efficacy not now in use' of paragraph eight. Leonardo seems to have concentrated his attention chiefly on the catapult stone or dart thrower of this type actuated by some sort of bow, ingeniously varied and complicated, or in which the motive force was twisted cord.[1] Mangonels and *trébuchets*, in which the motive force is obtained by a weight at one end of a pivoted beam, at the other end of which is a sling containing the missile, are less frequent. One simple form for defending ramparts appears on the right on the sheet of sketches illustrated on plate 311.

An ingenious machine for the continuous discharge of arrows is illustrated on plate 303. It consists of a sort of treadmill in the interior of which are four bows which shoot arrows through an opening as they come opposite this. The bows are reloaded by a man seated on a seat attached to the axle of the wheel. An elaboration of this type of quick-firing machine with no less than fifteen bows is illustrated on fol. 64 *verso*-b of the Codice Atlantico.

Leonardo's claim in paragraph seven of his letter to be able to make 'cannon, mortars and light ordnance of beautiful and useful shapes' is borne out by a large number of drawings in the Codice Atlantico as well as that already referred to, reproduced on plate 306.

The sheet in the Louvre with numerous drawings of arms (plate 307), chiefly halberds and partisans, is connected with the four sheets attached to MS. B. They would seem to be the designs for halberds for the ducal guard; the fantastically involved design of many of them precludes their having been intended for any but ornamental purposes.

The most important pictorially of the drawings of military subjects, which we have been discussing, is certainly the drawing of a Cannon Foundry, at Windsor (plate 305). In fact the interest of the machine for raising cannon, which is illustrated, is subsidiary;[2] it is the mass of naked figures straining at the ropes and winches, the impression of energy con-

[1] Various designs of catapults are in the Codice Atlantico, fol. 31 *recto*-a, 50 *verso*-a, 51 *recto*-a, 51 *verso*-b, 53 *recto*-a, b, 54 *recto*-a, 54 *recto*-b, 54 *verso*-a, 57 *recto*-a, b, 57 *verso*-b.

[2] These shear-legs are in form almost exactly like those illustrated in Valturius' *De re Militari*, Liber X, for raising cannon. There should be four legs, but Leonardo has inadvertently omitted the fourth.

veyed by these toiling men, which makes this drawing an epitome of human effort. It is characteristic of the drawings of military subjects of this period however that they are enlivened and explained by figures full of expressiveness and energy and it is this fact which makes one prefer for illustration such subjects, before the no doubt more valuable and interesting inventions, such as the machine for making files (Codice Atlantico, fol. 6 *recto*-b) or the numerous hydraulic machines of the type illustrated on plate 297.

As an example of the style of Leonardo's later drawings of machinery, I give one from the Codice Atlantico (plate 319) which seems to me to date from the end of the first Milanese period or the beginning of the second Florentine period, about 1500 in fact. It is a machine actuated by a turbine for shaping and tapering bars of iron for building large cannon constructed after the manner of barrels bound with hoops. It is a model of elegance and precision in drawing.

I have already had occasion more than once to mention MS. B in the Institut de France and one leaf of it was illustrated in the section on Landscapes and Flowers (plate 257). It is of great importance in the chronology of the early Milanese period, as part of it can be dated with comparative certainty in the winter of 1488-9.[1] It is certainly the earliest surviving of Leonardo's note-books and also one of the clearest, most systematic and best illustrated. It is one of the thirteen manuscripts in the Institut de France in Paris. MS. 2037 of the Bibliothèque Nationale (now deposited in the Institut) actually formed part of MS. B, but was detached from it in the nineteenth century. There are in addition six leaves with drawings on one side of the sheet only of halberds, partisans, etc., attached to MS. 2037 and presumed to have formed part of the original volume, but only four of these drawings are actually by Leonardo. MS. B and MS. 2037 can therefore be regarded as one. The leaves measure about 23 × 16 cm. and number (for the two separate parts together) 100. A good deal of these 200 pages is taken up with notes on military machines

[1] Girolamo Calvi, *I Manoscritti di Leonardo da Vinci,* Bologna, 1925, p. 81 ff.
Clark (Catalogue of drawings at Windsor, pp. xxi and 122) believes it to have been begun earlier, but does not give his reasons in any detail.

and tactics, some of this derived from Valturius. Another important section is devoted to architecture and there are no less than twenty-one pages with plans and views of domed buildings, of which three are reproduced on plates 312-14.

No building which can with certainty or even probability be credited to Leonardo exists. Leonardo as an architect must be reconstructed from his drawings and from his texts, and the figure so obtained must lack reality. In the letter to Lodovico Sforza he speaks of himself as able to 'give perfect satisfaction and to the equal of any other in architecture and the composition of buildings public and private,' and he is known to have been with Francesco di Giorgio, a member of a commission on the cathedral of Pavia in 1490. He was amongst those who were asked to supply models for the *tiburio* (central lantern) of the Duomo at Milan, but his first model, completed and paid for on January 11, 1488, was apparently rejected, for on May 10, 1490, he was commissioned to prepare a second one, but this he never completed. It is certainly to this period, 1488-89, that the series of drawings of domed churches, in MS. B belong. They have no immediate reference to the *tiburio* of the cathedral, but this work no doubt led up to the study of domes and domed buildings in general. There is no reason to suppose that they were drawn in preparation for any definite or prospective commission. They are all variations on the same theme, a large central dome surrounded by four or more cupolas. Though the varieties of plan and differences of design, which have been carefully analysed by Geymuller [1] are considerable, there is a certain monotony about them. For one thing they are all drawn as seen from the same point of view, from above, and for another Leonardo has failed to convey any impression of size. The agglomeration of bulbous cupolas in the lower drawing, plate 312, on a miniature scale becomes almost ridiculous.

In addition to these studies of domed structures in MS. B there are also plans and drawings for a model city, no doubt equally far from realization, but showing an extraordinarily imaginative and at the same

[1] In Richter, II, p. 19 ff. See also Adolfo Venturi, *Storia dell'Arte Italiana*, XI 1, (1938), ch. 1.

time practicable and modern grasp of the problem. There are a certain number of less ambitious designs, among them that for a stable, illustrated on plate 315, with elaborate instructions and explanations appended. Another sheet (plate 316) has a charming design for a screen with panels of elaborate interlaced designs. This is actually in the Codice Atlantico, but it must date from the same period as MS. B, as is shown by the drawings at the top on the right of methods of roofing garden walls, which correspond to drawings of the same subject in that manuscript.

The sketches of corner towers crowned by cupolas on the sheet at Windsor with the beautiful head of St. James (plate 167) can be fairly exactly dated as belonging to the period of the Last Supper, 1495-7. It seems to embody a scheme for beautifying the rather grim and warlike towers of the Castello at Milan.

An example of Leonardo's architectural drawing of a somewhat later period is the sheet with plans and sketches of a square castle with a round tower at each angle (plate 320). The style of drawing, with the slightly untidy strokes curving to the outline of the buildings and the occasional cross-hatching, is in contrast to the drawings of manuscript B with their neat parallel lines. There are a number of drawings of this character dealing with war or military architecture and these can for the most part be related to the second period of Leonardo's chief activity as military engineer, in the service of Cesare Borgia in 1502. To the same period, or a little later, belongs the design for a square castle on the sheet at Windsor with the sketch of Michelangelo's David (plate 206).[1]

To return to MS. B: It is here that Leonardo first began to study the problem of artificial flight with continuity and there are some thirteen pages with drawings for aeroplanes or parts of aeroplanes of which I reproduce two (plates 317,[2] 318[3]). The one is a diagram of his apparatus showing the ingenuity of his methods for imparting the necessary movements, or the movements he thought necessary, to the wings; the other

[1] According to L. H. Heydenreich, who has made a special study of Leonardo's architecture, this design cannot be earlier than the Roman period, 1514-16 (*Zeitschrift für Kunstgeschichte,* IV (1935), p. 344).

[2] Ivor B. Hart, *The Mechanical Investigations of Leonardo da Vinci.*

[3] R. Giacomelli, in *Journal of the Royal Aeronautical Society,* XXXIV (1930), p. 1016 ff.

(plate 318) shows a man at work generating the power for a quite different type of machine, which seems to be in the nature of a helicopter to be raised by the downward flapping of wings. Leonardo later recognized the inadequacy of the power which a man could artificially generate and turned his attention to soaring, with devices for stabilizing the machine. This was a much more practicable line of approach to the problem of flight, but nevertheless the drawings of this first phase in MS. B are more attractive than the scientifically perhaps more interesting drawings of a later date.

LIST OF DATES IN LEONARDO'S LIFE

1452 15 April. Birth at Vinci near Prato.

1472 Member of the Guild of St. Luke in Florence.

1473 5 August. Date on landscape drawing (plate 253).

1476 8 April and 7 June. Accused of sodomy. Still in Verrocchio's studio '*sta con* Andrea del Verrochio.'

1478 10 January. Picture for the chapel of S. Bernardo in the Palazzo Vecchio ordered from Leonardo by the Signoria.
 September to December. Drawing of two heads. '*Incominciai le due Vergini Marie*' (plate 127).

1479 29 December. Drawing of body of Baroncelli (plate 26).

1481 March. Commissioned by monks of S. Donato a Scopeto to paint altarpiece for their chapel, to be finished within at most thirty months.
 28 September. Still in Florence.

1481–2 Moves to Milan. Undated letter to Lodovico Sforza (Cod. Atlantico, fol. 391 *verso* a).

1483 25 April. Contract for the *Virgin of the Rocks* between the Confraternity of the Conception in Milan and Leonardo da Vinci and Evangelista and Ambrogio Preda.

1487 July to January, 1488. Payments for model of *tiburio* of the Cathedral at Milan.

1489 2 April. Drawings of skulls in Anatomical MS. B. (plate 220).
 22 July. Pietro Alamani, ambassador to Milan of Lorenzo de' Medici, writes that Lodovico il Moro is doubtful of Leonardo's ability to carry out the equestrian statue of Duke Francesco Sforza.

1490 13 January. Designs pagent of *Il Paradiso*.

23 April. Begins MS. C and recommences the Sforza monument.

8 June. Visit as commissioner with Francesco di Giorgio to Duomo at Pavia.

22 July. Salai joins Leonardo.

1493 30 November. The model of the Sforza monument was on exhibition on the occasion of the marriage of Bianca Maria Sforza to the Emperor Maximilian.

1494 MS. H.

1497 29 June. At work in the Refectory of S. Maria delle Grazie (on the *Last Supper*).

1498 MSS. L and M.

1499 26 April. Gift by Lodovico Sforza of vineyard to Leonardo.

December. Leaves Milan after its occupation by the French and before the return of Lodovico Sforza.

1500 February. In Venice.

24 April. In Florence.

1501 8 April. Letter of Pietro da Novellara in Florence to Isabella d'Este in Mantua describing the cartoon for a *Virgin and Child and St. Anne* by Leonardo and portraits by pupils.

14 April. Letter from the same to the same describing Leonardo at work on a composition of a *Madonna with the Yarnwinder* for Florimond Robertet.

1502 18 August. Leonardo appointed architect and military engineer to Cesare Borgia in the Romagna.

1503 18 October. Rejoins Painters' Guild in Florence. Begins work on the cartoon of the *Battle of Anghiari* commissioned by the Florentine Signoria.

1504 25 January. Invited, together with other Florentine artists, by the *operai* of S. Maria del Fiore to give his opinion on the position in which Michelangelo's statue of David should be placed.

1 April. First payments of fifteen gold florins monthly for the

 painting of the *Battle of Anghiari* in the Sala del Gran Consiglio in the Palazzo Vecchio.

 24 May. Accepts commission from Isabella d'Este to paint a youthful Christ.

1505 14 March to 30 April. Payments for scaffolding for the painting of the *Battle of Anghiari.*

1506 30 May. Leonardo given leave of absence by the Signoria from his work in Florence to return to Milan for three months.

 18 August and 16 December. Letters from Charles d'Amboise in Milan to the Signoria of Florence asking for the extension of Leonardo's leave.

1507 26 July (before). Appointed *'Peintre et ingenieur ordinaire'* to Louis XII of France.

 18 September. In Florence.

1508 22 March. Begins Arundel MS. in Florence.

 12 September. In Milan.

1510 Anatomical MS. A (plates 243-6, 251).

1511 18 December. Drawings on red grounded paper (plates 285, 286).

1513 9 January. Anatomical MS. C. II (plate 249).

 24 September. Leonardo leaves Milan with Melzi, Salai, Lorenzo and il Fanfoia.

 October. In Florence.

 1 December. In Rome.

1514 Leonardo in Rome.

 25 September. In Parma.

 9 December. In Milan.

 In Rome as late as August, 1516.

1517 May-June. At Cloux near Amboise.

 10 October. Visit of the Cardinal of Aragon, recorded by the latter's secretary Antonio de Beatis.

1518 19-24 June. At Cloux.

1519 23 April. Leonardo makes his will.

 2 May. Dies.

BOOKS AND ARTICLES
(Used or Referred to in this Work)

a. BOOKS

BELTRAMI, Luca

Il Codice di Leonardo da Vinci della Biblioteca de Principe Trivulzio in Milano.
Milano, 1891.

BERENSON, Bernhard

The Drawings of the Florentine Painters.
Amplified edition.
3 vols. Chicago, 1938.

BODMER, Heinrich

Leonardo: Des Meisters Gemälde und Zeichnungen. (Klassiker der Kunst).
Stuttgart und Berlin, 1931.

CALVI, Girolamo

I manoscritti di Leonardo da Vinci dal punto di vista cronologico storico e biografico.
Bologna, 1925.

CALVI, Girolamo

Il Codice di Leonardo da Vinci della Biblioteca di Lord Leicester in Holkham Hall,
pubblicato sotto gli auspici del R. Istituto lombardo di scienze e lettere (premio Tomasoni).
Cogliati, 1909.

CLARK, Kenneth

A Catalogue of the Drawings of Leonardo da Vinci in the Collection of His Majesty the King at Windsor Castle.
2 vols. Cambridge, 1935.

CLARK, Kenneth

Leonardo da Vinci. An Account of his Development as an Artist.
Cambridge, 1939.

93

CODICE ATLANTICO

Il Codice Atlantico di Leonardo da Vinci nella Biblioteca Ambrosiana di Milano, reprodotto pubblicato dalla R. Accademia dei Lincei ...
Milano, 1894-1904.

COMMISSIONE VINCIANA

I manoscritti e i disegni di Leonardo da Vinci publicati dalla Reale Commissione Vinciana.
Disegni; a cura di Adolfo Venturi.
Fascicolo I, Roma, 1928; Fascicolo II, 1931; Fascicolo III, 1934; Fascicolo IV, 1936.

COMMISSIONE VINCIANA

I manoscritti e i disegni di Leonardo da Vinci.
Vol. I. *Il Codice Arundel* 263. Parte I, Roma, 1923; Parte II, 1927; Parte III, 1928; Parte IV, 1930.
Vol. II. *Il Codice A* (2172) *nell' Istituto di Francia.* Roma, 1936.
Serie minore. Vol. I. *Il Codice Forster I nel 'Victoria and Albert Museum.'* Roma, 1930; Vol. II, 1934; Vol. III, 1934; Vol. IV, 1934; Vol. V, 1936.
I fogli mancanti al codice di Leonardo da Vinci nella Biblioteca Reale di Torino. A cura di Enrico Carusi. Roma, 1926.

HART, Ivor B.

The Mechanical Investigations of Leonardo da Vinci.
London, 1925.

LOMAZZO, G. Paolo

Trattato dell'arte della pittura.
Milano, 1584.

MACCURDY, Edward

The Notebooks of Leonardo da Vinci.
2 vols. London, 1938.

MÜLLER-WALDE, Paul

Leonardo da Vinci Lebenskizze und Forschungen über sein Verhältniss zur Florentiner Kunst und zu Rafael.
München, 1899.

POPP, Anny E.

Leonardo da Vinci Zeichnungen.
München, 1928.

RACCOLTA VINCIANA

Presso L'Archivio storico del Comune di Milano, Castello Sforzesco.
Fasc. I to XII.
Milan, 1905-22.

RAVAISSON-MOLLIEN, Charles

Les manuscrits de Léonard de Vinci. Manuscrit A (etc.) de la Bibliothèque de l'Institut.
Paris, 1881 to 1891.

RICHTER, Jean Paul

The Literary Works of Leonardo da Vinci.
Second edition enlarged and revised by Jean Paul Richter and Irma A. Richter.
2 vols. Oxford, 1939.

SABACHNIKOFF, Teodoro and PIUMATI, Giovanni

I manoscritti di Leonardo da Vinci della Reale Biblioteca di Windsor. Dell' Anatomia, Fogli A.
Paris, 1898.
I manoscritti di Leonardo da Vinci della Reale Biblioteca di Windsor. Dell' Anatomia, Fogli B.
Torino, 1901.
I manoscritti di Leonardo da Vinci. Codice sul volo degli uccolli e varie altre materie.
Parigi, 1893.

SEIDLITZ, Woldemar von

Leonardo da Vinci Der Wendepunkt der Renaissance.
2 vols. Berlin, 1909.

SIRÉN, Osvald

Leonardo da Vinci: the Artist and the Man.
New Haven, 1916.

SUIDA, Wilhelm

Leonardo und sein Kreis.
München, 1929.

THIIS, Dr. Jens *The Florentine Years of Leonardo and Verrocchio.*
London, n.d.

TONI, Giambattista de *Le piante e gli animali in Leonardo da Vinci.*
Bologna, 1922.

TRATTATO DELLA PITTURA *Lionardo da Vinci Das Buch von der Malerei.*
Herausgegeben von Heinrich Ludwig (in *Quellenschriften für Kunstgeschichte*).
3 vols. Wein, 1882.

VANGENSTEN, Ove C. L., FONAHN, A., HOPSTOCK, H. *Leonardo da Vinci, Quaderni d'Anatomia ... della Royal Library di Windsor.*
6 vols. Christiania, 1911-1916.

VASARI, Giorgio *Le vite de' più eccelenti pittori scultori ed architettori.*
Con nuovi annotazioni e commenti di Gaetano Milanesi.
7 vols. Firenze, 1878.

b. ARTICLES IN PERIODICALS

BERENSON, Bernhard *Verrocchio e Leonardo, Leonardo e Credi* (in *Bolletino d'Arte*, XXVII (1933) p. 193, 241).

BLUM, André *Leonardo da Vinci graveur* (in *Gazette des Beaux-Arts*, VIII (1932), p. 89).

BORENIUS, Tancred *Leonardo's Madonna with the Children at Play* (in *Burlington Magazine*, LVI (1930), p. 142).

CARUSI, Enrico *Leonardo da Vinci* (life) (in *Enciclopedia Italiana*, Vol. XX, Rome, 1933).

CLARK, Kenneth *Leonardo's Adoration of the Shepherds and Dragon Fight* (in *Burlington Magazine*, LXII (1933), p. 21).

CLARK, Kenneth — *The Madonna in Profile* (in *Burlington Magazine*, LXII (1933), p. 136).

CLARK, Kenneth — *Leonardo da Vinci* [drawing of a bear] (in *Old Master Drawings*, XI (1937), p. 66).

COOK, Herbert F. — *Le carton de Léonard de Vinci à la Royal Academy* (in *Gazette des Beaux-Arts*, XVIII (1897), p. 371).

DODGSON, Campbell — *Two Unpublished Drawings by Leonardo* (in *Burlington Magazine*, XXIII (1913), p. 264).

HAENDCKE, Berthold — *Lionardo da Vinci und Rogier van der Weyden* (in *Repertorium für Kunstwissenschaft*, XIV (1925) p. 114).

HEYDENREICH, Ludwig Heinrich — *La Sainte Anne de Léonard de Vinci* (in *Gazette des Beaux-Arts*, X (1933), p. 205).

HEYDENREICH, Ludwig Heinrich — Review of Clark's Catalogue of Drawings by Leonardo at Windsor (in *Zeitschrift für Kunstgeschichte*, IV (1935), p. 340).

KURZ, Otto — *A Contribution to the History of the Leonardo Drawings* (in *Burlington Magazine*, LXIX (1936), p. 135).

MÖLLER, Emil — *An Unpublished Leonardo drawing* (in *Burlington Magazine*, XLVII (1925), p. 275).

MÖLLER, Emil — *Wie sah Leonardo aus?* (in *Belvedere*, IX (1926), p. 32).

MÖLLER, Emil — *Leonardo's Madonna with the Yarnwinder* (in *Burlington Magazine*, XLIX (1926), p. 61).

MÖLLER, Emil — *Salai und Leonardo da Vinci* (in *Vienna Jahrbuch*, Neue Folge, II (1938), p. 139).

MÖLLER, Emil — *Die Madonna mit den spielenden Kindern aus der Werkstatt Leonardos* (in *Zeitschrift für bildende Kunst*, LXII (1928-29), p. 217).

MÖLLER, Emil — *Der Geburtstag des Leonardo da Vinci* (in *Berlin Jahrbuch*, LX (1939), p. 71).

MÜLLER-WALDE, Paul — *Beiträge zur Kentniss des Leonardo da Vinci* (in *Berlin Jahrbuch*, XVIII (1897), p. 92, 137; XIX (1898), p. 225, 250; XX (1899), p. 54).

OBERHUMMER, Eugen — *Leonardo da Vinci and the Art of the Renaissance in its Relations to Geography* (in *Geographical Journal*, XXXIII (1909), p. 540).

RICHTER, Irma A. — *The Earliest Reference to the Leonardo Drawings in the English Royal Collection* (in *Burlington Magazine*, LXXI (1937), p. 139).

SEIDLITZ, Woldemar von — *Regesten zum Leben Leonardo da Vincis* (in *Repertorium für Kunstwissenschaft*, XXXIV (1911), p. 448).

SUTER, Karl Friedrich — *The Earliest Copy of Leonardo da Vinci's Battle of Anghiari* (in *Burlington Magazine*, LV (1929), p. 181).

VALENTINER, W. R. — *Leonardo and Desiderio* (in *Burlington Magazine*, LXI (1932), p. 53).

VALENTINER, W. R. — *Uber zwei Kompositionen Leonardos* (in *Berlin Jahrbuch*, LVI (1935), p. 213).

VENTURI, Adolfo — *Leonardiana* (in *L'Arte*, XXV (1922), p. 129; XXVII (1924), p. 49; XXVIII (1924), p. 137; XXXI (1928), p. 230; XXXIX (1936), p. 243.

VENTURI, Adolfo — *Leonardo da Vinci parucchiere e vesti-*

	arista teatrale (in *L'Arte*, XLII (1939), p. 13).
VENTURI, Adolfo	*L'uso della mano sinistra nella scrittura e nei disegni di Leonardo da Vinci* (in *L'Arte*, XLII (1939), p. 167).
WIND, Edgar	*An Eighteenth-Century Improvization in a Leonardo Drawing* (in *Old Master Drawings*, XIII (1939), p. 49).
WRIGHT, William	*Leonardo as an Anatomist* (in *Burlington Magazine*, XXXIV (1919), p. 194).

LIST OF ILLUSTRATIONS

NOTE

References in an abridged form are given to the following works:

BERNHARD BERENSON, *The Drawings of the Florentine Painters*. Amplified edition. 3 vols. Chicago, 1938. = B.B.

HEINRICH BODMER, *Leonardo Des Meisters Gemälde und Zeichnungen* (Klassiker der Kunst). Stuttgart und Berlin, 1931. = Bodmer.

I manoscritti e i disegni di Leonardo da Vinci publicati dalla Reale Commissione Vinciana. Disegni; a cura di Adolfo Venturi. Rome. Fascicolo I, 1928; Fascicolo II, 1931; Fascicolo III, 1934; Fascicolo IV, 1936. = Comm. Vinciana.

KENNETH CLARK, *A Catalogue of the Drawings of Leonardo da Vinci in the Collection of His Majesty the King at Windsor Castle*. 2 vols. Cambridge, 1935. The reference to this catalogue is automatically given by the number following 'Windsor, Royal Library.'

ANNY E. POPP, *Leonardo da Vinci Zeichnungen*. Munich, 1928. = Popp.

JEAN PAUL RICHTER, *The Literary Works of Leonardo da Vinci*, 2nd ed. 2 vols. London, 1939. = Richter.

EDWARD MACCURDY, *The Notebooks of Leonardo da Vinci*, 2 vols. London, 1938. = MacCurdy.

(References to the last two are given only where the text on a drawing needs explanation.)

In addition to the references to general works on Leonardo's drawings the following special publications of the anatomical MSS. and drawings are given:

I manoscritti di Leonardo da Vinci della Reale Biblioteca di Windsor. Dell'Anatomia, Fogli A, pubblicati da Teodoro Sabachnikoff, trascritti e annotati da Giovanni Piumati. Paris, 1898. = Anat. MS. A.

I manoscritti di Leonardo da Vinci della Reale Biblioteca di Windsor. Dell'Anatomia, Fogli B, pubblicati da Teodoro Sabachnikoff, trascritti e annotati da Giovanni Piumati. Turin, 1901. = Anat. MS. B.

Leonardo da Vinci, Quaderni d' Anatomia = pubblicati da Ove C. L.

Vangensten, A. Fonahn, H. Hopstock. 6 vols. Christiania, 1911-16. =
Quad. Anat. I, II, III, etc.

I have not thought it necessary to overload the text with other refer-
ences, except on the rare occasions when they are not quoted in one or
other of the works listed above. The publications of the R. Commissione
Vinciana are cited as being in nearly all cases the best reproduction avail-
able. Berenson's great work has the most up-to-date references (except as
regards the Windsor drawings), Bodmer's is the handiest and most likely
to be available to the ordinary reader, Clark's is by far the most valuable
contribution to the study of Leonardo drawings and their chronology,
though it is of course confined to the Windsor collection.

The material on which the drawings are made is, unless otherwise
stated, white or approximately white paper. Toward the end of his life
Leonardo on occasion used blue paper, that is paper stained blue through-
out, otherwise any colouring is in the form of a ground laid on one or
both sides of the paper. This is described as 'prepared surface' in the
catalogue.

1 STUDY OF THE DRAPERY OF A WOMAN KNEELING TO THE LEFT.
25.8 × 19.5 cm. Silver-point on red prepared surface,
heightened with white.
Rome, Corsini Gallery.
B.B. 1082B: Comm. Vinciana 17: Popp. pl. 5.

2 CAST OF DRAPERY FOR THE LEGS OF A SEATED FIGURE.
26.6 × 23.4 cm. Drawn with the brush on linen, heightened
with white.
Paris, Louvre.
B.B. 1061: Comm. Vinciana 15.
There is a close copy of this drawing in the British Museum
ascribed to Lorenzo di Credi, by Berenson to 'Tommaso'
(B.B. 2763A).

3 CAST OF DRAPERY FOR A FIGURE KNEELING TO THE RIGHT.
18.2 × 23.3 cm. Drawn with the brush on linen, heightened
with white.
Paris, Louvre.
B.B. 1067A.

4 CAST OF DRAPERY FOR A STANDING FIGURE.
31.5 × 16.8 cm. Drawn with the brush on linen, heightened
with white.

parently the earlier one. Leonardo then traced the drawing through and experimented with different positions for the Virgin's head.

10 MADONNA AND CHILD WITH A CAT.
12.5 × 10.5 cm. Pen and ink and wash.
Florence, Uffizi.
B.B. 1015: Bodmer, p. 120: Comm. Vinciana 24.
There is a sketch of the Child and cat alone on the *verso* of this sheet (repr. Comm. Vinciana 25) traced through from the *recto* (or *vice versa*).

11 TWO STUDIES OF THE MADONNA AND CHILD WITH A CAT AND THREE STUDIES OF THE CHILD.
27.4 × 19 cm. Pen and ink over black chalk or charcoal (upper study).
London, British Museum (*recto* of 27).
B.B. 1024: Bodmer, p. 121: Comm. Vinciana 18.

12 STUDIES OF A CHILD WITH A CAT.
20.6 × 14.3 cm. Pen and ink.
London, British Museum (*recto* of 13).
B.B. 1025: Bodmer, p. 123: Comm. Vinciana 19.

13 STUDIES OF CHILDREN AND CATS.
20.6 × 14.3 cm. Pen and ink over a sketch with the stylus.
London, British Museum (*verso* of 12).
B.B. 1025: Bodmer, p. 124: Comm. Vinciana 20.
In the upper study the Madonna is also sketched in with the stylus (not visible in the reproduction).

14 STUDIES FOR A MADONNA AND CHILD WITH A CAT.
22.8 × 16.5 cm. Pen and ink.
Bayonne, Musée Bonnat.
B.B. 1010D: Bodmer, p. 122: Comm. Vinciana 26.

15 STUDY OF A MADONNA AND CHILD, OF PROFILES AND OF MACHINERY.
19.8 × 15 cm. Metal-point on pale pink, prepared surface; the Madonna outlined in pen and ink.
London, British Museum (*recto* of 16).

B.B. 1027: Bodmer, p. 118: Comm. Vinciana 28.
The writing in the right-hand bottom corner *In principio era* . . . is merely scribbling.

16 THREE STUDIES OF A MADONNA AND CHILD.
19.8 × 15 cm. Pen and ink and lead-point.
London, British Museum (*verso* of 15).
B.B. 1027: Bodmer, p. 117: Comm. Vinciana 29.

17 MADONNA AND CHILD WITH THE INFANT ST. JOHN AND AN ANGEL.
14.5 × 19.1 cm. Lead-point over a sketch with the stylus.
Oxford, Ashmolean Museum.
B.B. 1059: Bodmer, p. 126: Comm. Vinciana 85.

18 STUDY OF A WOMAN'S HANDS.
21.5 × 15 cm. Silver-point on pink prepared surface, heightened with white.
Windsor, Royal Library, No. 12,558.
B.B. 1173.

19 HEAD OF A WOMAN LOOKING DOWN TO THE LEFT.
18 × 16.8 cm. Silver-point on greenish prepared surface.
Paris, Louvre.
B.B. 1067C: Bodmer, p. 230: Comm. Vinciana 95.

20 STUDIES OF A CHILD.
17.1 × 21.8 cm. Silver-point on pale pink, prepared surface, reinforced with the pen.
Windsor, Royal Library, No. 12,569.
B.B. 1129E: Bodmer, p. 154: Comm. Vinciana 10.

21 STUDIES OF A CHILD.
13.8 × 19.5 cm. Red chalk.
Windsor, Royal Library, No. 12,568.
B.B. 1129D: Bodmer, p. 155: Comm. Vinciana 9.

22 STUDIES OF A WOMAN'S HEAD AND BUST.
23.2 × 19 cm. Silver-point on pink, prepared surface.
Windsor, Royal Library, No. 12,513.
B.B. 1167A: Bodmer, p. 153: Comm. Vinciana 36.

LIST OF ILLUSTRATIONS

ADORATION OF THE MAGI.
246 × 243 cm. Underpainting in brown on panel.
Florence, Uffizi.

DETAILS

Windsor, Royal Library, No. 12,306.
B.B. 1232.

57 STUDY OF A HORSE, ITS NEAR HIND-LEG AND ITS HIND-QUARTERS.
10.7 × 18.3 cm. Pen and ink over lead-point.
Windsor, Royal Library, No. 12,324.
B.B. 1223A: Bodmer, p. 183.

58 TWO STUDIES OF HORSES, ONE OF A GALLOPING HORSEMAN AND
OTHERS OF HORSES' LEGS.
11.7 × 19.7 cm. Silver-point on orange prepared surface,
partly gone over with pen and ink.
Windsor, Royal Library, No. 12,325.
B.B. 1213: Bodmer, p. 146.

59 STUDIES OF A REARING HORSE AND OF A HORSE'S HIND-QUARTERS.
11.4 × 19.6 cm. Silver-point on pale pinkish-buff prepared
surface.
Windsor, Royal Library, No. 12,315.
B.B. 1232: Bodmer, p. 187.

60A A UNICORN DIPPING ITS HORN INTO THE WATER.
9.4 × 8.1 cm. Pen and ink.
Oxford, Ashmolean Museum.
B.B. 1059A: Bodmer, p. 182: Comm. Vinciana 70.

60B FIGHT BETWEEN A HORSEMAN AND A GRIFFIN.
8.8 × 13.8 cm. Silver-point on pinkish-buff prepared surface.
Oxford, Ashmolean Museum.
B.B. 1056: Comm. Vinciana 65.

61 STUDY OF A HORSE MARKED OUT FOR MEASUREMENT.
29.8 × 29 cm. Pen and ink over black chalk.
Windsor, Royal Library, No. 12,318.
B.B. 1232: Bodmer, p. 182.

62 STUDIES OF A DRAGON.
15.9 × 24.3 cm. Silver-point on white prepared surface,
partly gone over with pen and ink.
Windsor, Royal Library, No. 12,370 *recto*.
B.B. 1169c: Comm. Vinciana 64: Popp 3.

Windsor, Royal Library, No. 12,321.
B.B. 1223: Bodmer, p. 191.

78A HEAD OF A BEAR.
7 × 7 cm. Metal-point on pinkish-buff prepared surface.
London, Collection of Captain Norman Colville.
B.B. 1044C.

78B STUDY OF A BEAR.
10.3 × 13.4 cm. Silver-point on pinkish-buff prepared surface.
Canada, Collection of Mr. Ludwig Rosenthal.
B.B. 1010J: *Old Master Drawings* XI (1937) 65.

79A FOUR STUDIES OF THE PAWS OF A DOG OR WOLF.
13.5 × 10.5 cm. Silver-point on pinkish-buff prepared surface.
London, Collection of Captain Norman Colville (*recto* of 79B).
B.B. 1044B: *Burlington Magazine* LXX (1937) 87.

79B THREE STUDIES OF THE PAWS OF A DOG OR WOLF.
13.5 × 10.5 cm. Silver-point on pinkish-buff prepared surface.
London, Collection of Captain Norman Colville (*verso* of
79A).
B.B. 1044B.

80 TWO HEADS OF MONSTERS.
14 × 17.3 cm. Pen and ink.
Windsor, Royal Library, No. 12,367.
B.B. 1169A: Bodmer, p. 180.

81A A HARNESSED CART-HORSE AND STUDIES OF HARNESS.
10.3 × 7.3 cm. Red chalk.
Paris, Institut de France, MS. H^3 fol. 132 *verso* and 133 *recto*.
Bodmer, p. 234.

81B STUDIES OF A CART, ETC.
10.3 × 7.3 cm. Red chalk.
Paris, Institut de France, MS. H^3 fol. 128 *verso* and 129 *recto*.

82 STUDIES OF THE FOREPART AND HIND-QUARTERS OF A DOG.
18.7 × 12.2 cm. Red chalk.
Windsor, Royal Library, No. 12,361.
Comm. Vinciana 130.

 It is claimed by Dr. Wind in the article in *Old Master Draw-ings* that the brush work on the lower figure on the trophy and some of the wash on the upper figure are not by Leonardo but are additions of the eighteenth century. In the first place, the brush outlines of the lower figure follow closely a preliminary sketch with the stylus similar to that of the figure immediately above, of which only the head has been inked in; secondly, the handling of the outline with the brush seems to me absolutely

characteristic of Leonardo in his Florentine period (compare, for instance, in the drawing of the girl carrying a child (plate 28A), the outline of the face and the lock of hair); thirdly there is no iconographical confusion: The lower figure has not got a shaven back to her head; it is merely that the wind is from behind and has blown her hair forward; the figure is an alternative study of that above to the left, just as the unfinished one above to the right is. The only touching up is in the drapery of the angel above to the left where the ink has bitten a hole. About 1480-1.

104 ALLEGORY OF INGRATITUDE AND ENVY.

16.1 × 26 cm. Silver-point and pen and ink on pink prepared surface, reinforced with pen and ink.

London, British Museum (*recto* of 49).

B.B. 1023: Bodmer, p. 144: Comm. Vinciana 98: Popp 31.

On the extreme right a flying woman 'Fortuna' holds in her arms a child who blows through a tube seeking to extinguish a blazing torch. This is held by a man 'Morte' who is supported by two female figures, 'Invidia' on the right and 'Ingratitudine' on the left. Between the two groups is a mound on which grows a stunted tree. Below the central group is a sketch, in silver-point only, for the figure of 'Morte.' On the extreme left, also in silver-point, 'Superbia' and 'Ignoranzia,' who point at the central group.

As pointed out by Popp, the allegory is similar to that represented by Mantegna (about 1497-1502) for the studio of Isabella d'Este, in which Minerva drives out the vices. The studies for the *Adoration of the Kings* on the *verso* and the style of the drawing itself point, however, to an early date. The style is very similar to that of the angel placing a shield on a trophy (plate 103). Compare especially the head at the top to the right on that sheet with that of 'Ignoranzia' here. The colour of the ground is exactly that of a silver-point drawing at Windsor of figures in conversation (plate 52B) and this may be a fragment of the same sheet.

Müller-Walde (*Jahrbuch* XIX (1898) p. 245) points out the Pollaiuolesque forms of the figures in this drawing and cites Antonio's *Hercules and Antaeus* in the Uffizi.

About 1481.

105 AN ALLEGORY OF STATECRAFT.
 20.5 × 28.5 cm. Pen and ink.
 Oxford, Christ Church (*recto* of 106).
 B.B. 1055: Bodmer, p. 156: Comm. Vinciana 102.
 On the left is Justice holding a sword and mirror; seated on
 her left is Prudence with a double head and body, half man,
 half woman. With her left arm the latter protects a cock (inter-
 preted as Gian Galeazzo, nephew of Lodovico Sforza) ; in her
 right, she flourishes a serpent (emblem of Milan from the Vis-
 conti arms) a besom (?) and a branch and holds a dove by a
 string; from the right a crouching, satyr-like creature ap-
 proaches and unleashes a pack of dogs or wolves against the
 cage on which Prudence is seated and which contains a serpent
 (again perhaps typifying Milan). The two virtues are no doubt
 those of Lodovico Sforza who are defending Milan from some
 insidious attack.
 About 1483-5.

106 ALLEGORY OF FAME ATTACKING ENVY.
 20.5 × 28.5 cm. Pen and ink.
 Oxford, Christ Church (*verso* of 105).
 B.B. 1055; Bodmer, p. 157: Comm. Vinciana 101.
 A winged youth *'fama ovvero la virtu'* attacks Envy *'lanvidia'*
 with a lance. Envy shoots with a bow and arrow, on the end of
 which is a human tongue, against Fame who protects himself
 with a book as a shield. To the left is a small sketch of a man
 blowing a trumpet into the ear of another, who crouches down.
 Above is the inscription *'prima fia il corpo sanza lonbra che la
 virtu sanza invidia'* 'the body is without shadow sooner than
 virtue without envy.' The subject of the little sketch should be
 compared with that of the man blowing a trumpet on the Brit-
 ish Museum drawing (plate 46).
 About 1483-5.

107 TWO ALLEGORIES OF ENVY.
 21 × 29 cm. Pen and ink.
 Oxford, Christ Church (*recto* of 108).
 B.B. 1051: Bodmer, p. 158: Comm. Vinciana 99.
 On the right a figure with two bodies, explained by the text be-
 neath *'subito che nassce la virtu quela parturissce chontra se*

lanvidia e prima fia il chorpo senza lonbra chella virtu sanza lanvidia.' 'In the moment when virtue is born she gives birth to envy against herself, and a body shall sooner exist without a a shadow than virtue without envy.' In the centre an emaciated female figure, Envy, riding on a skeleton, Death. The allegory is explained by the text on the left. 'This Envy is represented making a contemptuous motion towards heaven, because if she could she would use her strength against God. She is made with a mask upon her face of fair appearance. She is made wounded in the eye by palm and olive. She is made wounded in the ear by laurel and myrtle to signify that victory and truth offend her. She is made with many lightnings issuing from her, to denote her evil speaking. She is made lean and wizened because she is ever wasting in perpetual desire. She is made with a fiery serpent gnawing at her heart. She is given a quiver with tongues for arrows, because with the tongue she often offends; and she is made with a leopard's skin, since the leopard from envy slays the lion by guile. She is given a vase in her hand, full of flowers and beneath these filled with scorpions and toads and other venomous things. She is made riding upon death, because envy never dying has lordship over him; and death is made with a bridle in his mouth and laden with various weapons, since these are all the instruments of death' (MacCurdy, II, p. 492). About 1483-5.

108 ALLEGORIES OF PLEASURE AND PAIN AND OF ENVY.
21 × 29 cm. Pen and ink.
Oxford, Christ Church (*verso* of 107).
B.B. 1051: Bodmer, p. 159: Comm. Vinciana 100.
On the right a nude male figure with four arms and two heads explained by the text 'Pleasure and Pain are represented as twins, as though they were joined together, for there is never the one without the other; and they turn their backs because they are contrary to each other. If you shall choose pleasure, know that he has behind him one who will deal out to you tribulation and repentance.' On the left two women mounted on a toad followed by death with scythe and hour glass. The two figures are explained as *'il mal pensieri e invidia ovvero ingratitudine.'* The translation of the text above, a further expan-

sion of the allegory of pleasure and pain on the right, is as follows: 'This is pleasure together with pain and they are represented as twins because the one is never separated from the other. They are made with their backs turned to each other because they are contrary one to the other. They are made growing out of the same trunk because they have one and the same foundation, for the foundation of pleasure is labour with pain, and the foundations of pain are vain and lascivious pleasures. And accordingly it is represented here with a reed in the right hand, which is useless and without strength, and the wounds made with it are poisoned. In Tuscany reeds are put to support beds, to signify that here occur vain dreams, and here is consumed a great part of life: here is squandered much useful time, namely that of the morning when the mind is composed and refreshed, and the body therefore is fitted to resume new labours. There also are taken many vain pleasures, both with the mind imagining impossible things, and with the body taking those pleasures which are often the cause of the failing of life; so that for this the reed is held as representing such foundations' (MacCurdy, II, pp. 492-3)
About 1483-5.

109A The Ermine as a Symbol of Purity.
Diameter 9.1 cm. Pen and ink.
London, Collection of Miss Clarke.
B.B. 1082D: Bodmer, p. 232: Comm. Vinciana 107.
The allegory is explained by a passage in Ms. H of 1494 (fol. 12 *recto*). 'The ermine because of its moderation eats only once a day, and it allows itself to be captured by the hunters rather than take refuge in a muddy lair, in order not to stain its purity' (MacCurdy, II, p. 474).
About 1494.

109B The Unmasking of Envy.
9.6 × 9.2 cm. Pen and ink over red chalk.
Bayonne, Musée Bonnat.
B.B. 1010H: Bodmer, p. 232: Comm. Vinciana 105: Popp 28.
The text underneath reads '*fugitiva perche lo invidioso dando falsa infamia no po stare al paragone (ōde coujene) (cō) i verso . . .*' (in the present reproduction part of the text is cov-

ered). According to Popp this is identical with a subject described in Ms. H (fol. 88 *verso*) *'il moro cho gli ochiali e la invidia cholla falsa infamia dipinta e la giustizia nera pel moro.'* 'Il Moro with the spectacles and Envy represented with lying Slander and Justice black for Il Moro' (MacCurdy, II, p. 490). On the left Il Moro, with right hand on hip holding out spectacles with his left hand before the face of flying Envy. In front of him stands Justice, who holds out her mantle to protect him. Invidia holds a *drapello* (banner) on which is represented a bird pierced by an arrow.
About 1494.

110A ALLEGORY: ANIMALS FIGHTING AND A MAN WITH A BURNING-GLASS.
10.5 × 12.5 cm. Pen and ink over lead-point.
Paris, Louvre.
B.B. 1064: Bodmer, p. 164: Popp 21.
A much enlarged engraving of this composition by an anonymous North Italian artist (Master of the Beheading of St. John the Baptist) with various modifications, especially in the figure of the man, may derive from a more elaborate drawing by Leonardo himself.
About 1494.

110B ARISTOTLE AND PHYLLIS.
9.3 × 13.4 cm. Pen and ink on greyish-blue prepared surface.
Hamburg, Kunsthalle.
B.B. 1020C: Bodmer, p. 110.
On the *verso* in Leonardo's hand is written *'cōpagnje volupta djspiacere amore. gielosia felicita. Ividja fortuna. penjtēca.'*
About 1480.

111 ALLEGORY OF THE LIZARD SYMBOLIZING TRUTH.
20.2 × 13.6 cm. Pen and ink.
New York, Metropolitan Museum (*recto*).
B.B. 1049B: Bodmer, p. 233: Comm. Vinciana 106: Popp 27.
The allegory is explained by the accompanying text *'El ramarro fedele allomo vedēdo quello adormētato cōbatte cholla bisscia esse vede nōlla potere vincere core sopa, il volto dellomo ello dessta accioche essa bisscia no noffenda lo adormentato homo.'*

'The lizard faithful to man, seeing him asleep, fights with the serpent and, if it sees it cannot conquer it, runs over the face of the man and thus wakes him in order that the serpent may not harm the sleeping man.'

On the *verso* (repr. Raccolta Vinciana X, p. 262) are studies for the Masque of Danae composed by Baldassare Taccone and represented on January 31, 1496, in the house of Gio. Francesco Sanseverino Conte di Cajazzo. See also Raccolta Vinciana XI, p. 226.

I see no justification for Popp's statement that the *recto* is materially earlier on the grounds of the writing, though this does, as she says, resemble the text on the drawings of skulls of 1489. 1496.

112 ALLEGORICAL REPRESENTATION.

15.7 × 21.5 cm. Pen and ink.
Windsor, Royal Library, No. 12,497.
B.B. 1119.
The allegory has not been interpreted. The sketch at right angles to this represents miscellaneous objects falling from the clouds as in plate 116B. The style and subject is similar to plates 113, 114.
About 1498.

113 GEOMETRICAL FIGURES AND DESIGNS FOR ALLEGORICAL REPRESENTATIONS.

28.4 × 19.9 cm. (whole sheet of which half is reproduced here). Pen and ink.
Windsor, Royal Library, No. 12,700 *verso*.
B.B. 1121.
The allegories in ovals or circles are variations of the theme of a mask of falsehood melted by the rays of the sun. The writing in the bottom right-hand corner (Richter No. 684) sums up the ideas represented in these devices. '*Il foco è da essere messo per cōsumatore d'ogni sofistico e scopritore e dimostratore di verità, perché lui é luce, scacciatore delle tenebre occultatrici d'ogni essentia.*'
Probably of the same date as the other emblems at Windsor (plate 114), and MS. M.
About 1498.

114 THREE EMBLEMS.

26.9 × 19.5 cm. Pen and ink and brown wash and blue chalk (in the upper two).
Windsor, Royal Library, No. 12,701.
B.B. 1120.
Finished drawings for emblems, for which there are sketches on another sheet at Windsor, No. 12,282. From the fact that MS. M (fol. 4 *recto*) contains a drawing of a lantern similar to the lowest emblem here and that this manuscript can be dated about 1498, these drawings are likely to belong to the same year. The inscriptions read at the top *'hostinato rigore'* : centre *'destinato rigore'* : to the left *'nona revolutione chiattale stella effisso.'*
About 1498.

115 SHEET OF PICTOGRAPHS.

30 × 25.3 cm. Pen and ink.
Windsor Royal Library, No. 12,692 *recto*.
This sheet is dated by Clark rather later than other similar pictographs at Windsor, which he assigns to about 1490. None of these seems to have any consecutive sense: Leonardo is here experimenting with picture writing. The pictographs, which mostly consist of animals, with often a written termination, are translated underneath.
Similar pictographs are found in a pair of engravings signed by Ambrogio Brambilla in the British Museum.

116A GROUP OF FIGURES.

3.1 × 4.3 cm. Pen and ink.
Windsor, Royal Library, No. 12,704.
Similar in style to the drawing reproduced on plate 112 and therefore probably dating from about 1498.

116B SKETCH OF THREE FIGURES.

2.3 × 3 cm. Pen and ink.
Windsor, Royal Library, No. 12,707 *recto*.
Dated by Clark about 1505.

116C IMPLEMENTS RAINED DOWN ON THE EARTH FROM THE CLOUDS.

11.7 × 11.1 cm. Pen and ink.
Windsor, Royal Library, No. 12,698.

Probably connected with the other emblematical drawings. Inscribed at the top to the left *'di qua adā e di la eva.'* 'On this side Adam and on that side Eve.' I cannot see 'two roughly drawn human figures' described by Clark on the clouds. The allegory may be of the same nature as that contained in an etching by Ambrogio Brambilla in which all sorts of implements and headgear, appropriate to different callings, are rained down by Fortune from a tree on humanity assembled below. About 1498.

117A A MAN PURSUING A WOMAN.
> 3.6 × 5.4 cm. Pen and ink.
> Windsor, Royal Library, No. 12,708.
> Probably dating from the period of the *Battle of Anghiari,* 1503-5.

117B SKETCH OF A DRAPED FIGURE AND DETAIL OF COSTUME.
> 5.2 × 4.6 cm. Pen and ink.
> Windsor, Royal Library, No. 12,705.
> B.B. 1138.
> As pointed out by Clark, an almost identical figure is to be found on fol. 81 *verso* of MS. L, which dates from about 1497-8.

117C SHEET OF STUDIES WITH A YOUNG WOMAN, A WOLF, ETC.
> 7.5 × 13 cm. Pen and ink.
> Windsor, Royal Library, No. 12,706.
> The drawings are like those on the allegorical sheet (plate 112). About 1498.

118 A MAN WITH A CLUB AND SHACKLED FEET.
> 18.4 × 12.7 cm. Black chalk.
> Windsor, Royal Library, No. 12,573 *recto.*
> B.B. 1132 : Bodmer, p. 207.
> Similar in style to the following five drawings. Obviously designs for a masque and dated by Clark about the period of the later drawings for the Trivulzio monument, i.e. 1511.

119 A YOUTH ON HORSEBACK.
> 24 × 15.2 cm. Pen and ink over black chalk on rough porridge-coloured paper.
> Windsor, Royal Library, No. 12,574.

B.B. 1130: Bodmer, p. 204.
A late drawing after 1513, according to Clark, who says it may be for the same masquerade as the preceding, which he dates apparently about 1511.

120 A YOUTH WITH A LANCE.
27.3 × 18.3 cm. Pen and ink and wash, over black chalk, on porridge-coloured paper.
Windsor, Royal Library, No. 12,575.
B.B. 1125: Bodmer, p. 205.
Perhaps for the same masquerade as the preceding, dated by Clark after 1513.

121 A WOMAN WEARING A BODICE OF INTERLACED RIBBONS.
21.5 × 11.2 cm. Black chalk.
Windsor, Royal Library, No. 12,576.
B.B. 1127: Bodmer, p. 206.
For a masquerade; dated by Clark about 1513.

122 A WOMAN WITH A PLAITED BODICE AND A CLOAK OVER HER LEFT ARM.
21.4 × 10.7 cm. Black chalk.
Windsor, Royal Library, No. 12,577.
B.B. 1126.
Companion drawing to the preceding; about 1513.

123 A YOUNG WOMAN POINTING.
21 × 13.5 cm. Black chalk.
Windsor, Royal Library, No. 12,581.
B.B. 1128: Popp 89.
Dateable after 1513 and possibly drawn in France, perhaps for a masquerade.

124 A MAN WITH THE HEAD OF AN ELEPHANT RIDING ON HORSE-BACK AND ARCHITECTURAL SKETCHES.
19.7 × 28 cm. Black chalk.
Windsor, Royal Library, No. 12,585 *recto*.
B.B. 1122: Bodmer, p. 203: Comm. *Vinciana* 103.
The head and ears are those of the traditional medieval elephant. One is reminded of Dürer's drawing in the Victoria and Albert Museum of a bagpiper on horseback, though the horse

is more like that in the same artist's *Knight, Death and the Devil*. Possibly the resemblance is pure coincidence in both cases.

125 ALLEGORY: A CROWNED EAGLE STANDING ON A GLOBE AND A WOLF STEERING A BOAT.

17 × 28 cm. Red chalk on brownish-grey paper.
Windsor, Royal Library, No. 12,496.
B.B. 1118: Bodmer, p. 345.
The allegory contained in this drawing has never been precisely interpreted. One would expect the eagle on the globe to symbolize the Emperor, but why the royal, instead of the imperial, crown? The wolf traditionally symbolizes the papacy and the tree, as suggested by Heydenreich, may be an allusion to the family arms of Julius II della Rovere. If this is the case it would date before the latter's death in 1513. The date 1516 detected by Bodmer and others on the globe is, as pointed out by Clark, an illusion.
About 1510 (?).

126 STUDIES OF DANCING NYMPHS.

9.8 × 14.9 cm. Pen and ink.
Venice, Academy.
B.B. 1101: Bodmer, p. 333.
There is no work with which this drawing can be connected or any hint of its purpose. Though the head of the central figure reminds one of the Victory in the British Museum (plate 103) the drawing must be more than 20 years later. The forms are modelled with curving strokes and even cross hatching is introduced. Bodmer's suggestion that it may have been inspired by Mantegna's Parnassus is not improbable.
About 1504-8.

127 TWO PROFILES AND STUDIES OF MACHINERY.

20.2 × 26.6 cm. Pen and ink.
Florence, Uffizi.
B.B. 1016: Bodmer, p. 115: Comm. Vinciana 33.
Inscribed '. . . *bre 1478 Inchominciai le 2 Verginie Marie.*'
The ratchet to the right is the study for part of a machine for throwing darts (drawing in Codice Atlantico, fol. 64 *recto*).

On the *verso* are studies of other military machines (repr. Comm. Vinciana 34).

128 PROFILE OF A GIRL.
> 32 × 20 cm. Silver-point on pinkish prepared surface.
> Windsor, Royal Library, No. 12,505.
> B.B. 1154: Bodmer, p. 231: Comm. Vinciana 96.
> About 1486/8?

129 PROFILE OF A WARRIOR WEARING AN ELABORATE HELMET AND CUIRASS.
> 28.5 × 20.7 cm. Silver-point on prepared cream-coloured surface.
> London, British Museum.
> B.B. 1035: Bodmer, p. 112.
> About 1480.

130A PROFILE OF A MAN TO THE RIGHT.
> 10.7 × 7.8 cm. Pen and ink.
> Florence, Uffizi.
> B.B. 1018: Bodmer, p. 109: Comm. Vinciana 35.
> Dated by Bodmer before 1470, by Berenson about the time of the *Adoration*. It is certainly an early drawing and the type resembles that of the British Museum warrior.

130B PORTRAIT OF A MAN IN PROFILE TO THE LEFT.
> 12.7 × 10.6 cm. Silver-point on pink prepared surface.
> Windsor, Royal Library, No. 12,498.
> B.B. 1164A: Bodmer, p. 170.
> Berenson says the lines of the profile are hard and along with the modelling of the face must have been entirely gone over, perhaps by Melzi. Clark regards it as authentic and typical and dates it about 1480. It might to my mind be later, of the time of the *Virgin of the Rocks*.

131A PROFILE OF A YOUTH TO THE RIGHT.
> 13.7 × 8.2 cm. Pen and ink.
> Windsor, Royal Library, No. 12,432 *recto*.
> Comm. Vinciana 50B.
> About 1486.

Windsor, Royal Library, No. 12,448.
About 1490.

135 A Grotesque Betrothal.
26.2 × 12.3 cm. Pen and ink.
Windsor, Royal Library, No. 12,449.
B.B. 1163A: Bodmer, p. 225: Popp 34.
About 1490.

136A A Grotesque Profile of a Man to the Right.
16 × 13.5 cm. Pen and ink.
Windsor, Royal Library, No. 12,489.
B.B. 1163A: Bodmer, p. 219.
About 1495.

136B Grotesque Profiles of a Man and Woman Facing.
16.3 × 14.3 cm. Pen and ink and some wash.
Windsor, Royal Library, No. 12,490.
B.B. 1163A: Bodmer, p. 223.
About 1495.

137A Grotesque Profile of a Man to the Right.
12.7 × 9.6 cm. Pen and ink.
Milan, Ambrosiana.
B.B. 1048A: Bodmer, p. 166.
Of the same style and period as the two Windsor drawings,
about 1495.

137B Grotesque Head of a Man Turned Three-quarters to the
Right.
11.5 × 7.4 cm. Pen and ink.
Venice Academy.
B.B. 1112A: Bodmer, p. 222.
Same period as preceding, about 1495.

138A Half-length Caricature of an Old Man with a Prominent
Chin.
18 × 10 cm. Red chalk.
Rome, Corsini Gallery (*recto* of 138B).
B.B. 1082c: Bodmer, p. 220.
About 1500 (?).

B.B. 1019: Bodmer, p. 224.
The head of the youth is of the type with crisp curling hair, which is generally identified as Salai (cf. plate 143) and must date from about 1500 when Salai was about twenty.

142 FULL FACE OF AN OLD MAN WEARING A WREATH.
18.3 × 13.6 cm. Red chalk on pink prepared surface, heightened with white.
Windsor, Royal Library, No. 12,502.
B.B. 1135: Bodmer, p. 308.
Date about 1498-99. Compare the drawing of a profile in black chalk, but similar in style on the *verso* of the British Museum studies for the *Virgin and Child with St. Anne* (plate 144).

143 PROFILE TO THE LEFT OF A CURLY-HEADED YOUTH.
19.3 × 14.9 cm. Black chalk.
Windsor, Royal Library, No. 12,557.
B.B. 1149: Bodmer, p. 260.
Date about 1496-7 when Salai, whom it probably represents, was about 16 or 17. See plate 141.

144 PROFILE TO THE RIGHT OF AN OLD MAN.
26.1 × 20 cm. Black chalk.
London, British Museum (*verso* of 175).
B.B. 1028.
On the *verso* of a sheet with drawings for the *Virgin and Child with St. Anne* (one of which is traced through) and therefore about 1498-9.

145 WHOLE LENGTH OF AN OLD MAN IN PROFILE TO THE RIGHT.
21.2 × 15.7 cm. Black chalk.
Windsor, Royal Library, No. 12,582.
B.B. 1137: Bodmer, p. 208.
No doubt intended as a caricature of pedantry. Dated by Clark in the early 1490's.

146 GROTESQUE HEAD IN PROFILE TO THE RIGHT.
39 × 28 cm. Charcoal, retouched to a certain extent by another hand.
Oxford, Christ Church.
B.B. 1050: Bodmer, p. 305.

It is suggested by Berenson that this is the head referred to by Vasari, *'Scaramuccia capitano de' Zingari che poi ebbe Messer Donato Valdambrini lassatogli del Giambullari.'*
Dates from about the time of the *Battle of Anghiari*, 1503-4.

147 HEAD OF A YOUTH IN PROFILE TO THE RIGHT.
 21.7 × 15.3 cm. Red chalk on red prepared surface, the hair touched with black chalk.
 Windsor, Royal Library, No. 12,554.
 B.B. 1145.
 Probably a portrait of Salai (cf. plates 141 and 143).
 About 1504.

148 PROFILE TO THE RIGHT OF AN ELDERLY MAN.
 22.2 × 16.9 cm. Red chalk, corrected with black on red prepared surface, with touches of white.
 Windsor, Royal Library, No. 12,556.
 B.B. 1147: Bodmer, p. 309.
 Of the same date as the anatomies on red paper, about 1510.

149 PROFILE TO THE RIGHT OF A BEARDED MAN.
 17.8 × 13 cm. Black chalk.
 Windsor, Royal Library, No. 12,553.
 B.B. 1144: Bodmer, p. 259.
 Regarded by Berenson as a study for St. Matthew in the *Last Supper*. Clark points out that the character of the shading is later and compares it with the drawings for masques (i.e. plate 118).

150 FULL FACE OF AN OLD MAN.
 17.8 × 13.6 cm. Red chalk on red prepared surface.
 Windsor, Royal Library, No. 12,503.
 B.B. 1167.
 The style, technique and paper resemble a number of anatomical drawings and also some landscapes on red surface, one of which is dated 1511 (cf. plates 285, 286).

151 HEAD AND BUST OF AN OLD MAN TO THE LEFT.
 19.8 × 14.6 cm. Red chalk on red prepared surface.
 Windsor, Royal Library, No. 12,598.
 B.B. 1146.

This might perhaps be classed as an anatomical drawing rather than a profile. It very closely resembles a number of drawings (Anatomical MS. A 3 *verso* etc.). It is of the same date, 1511, as plate 150.

152 HALF-LENGTH OF A YOUNG WOMAN IN PROFILE TO THE RIGHT.
17 × 14.6 cm. Black chalk with (unintentional) touches of red.
Windsor, Royal Library, No. 12,508.
B.B. 1160.
About 1512.

153 HEAD AND SHOULDERS OF A BEARDED MAN.
14.5 × 20.5 cm. Pen and ink and wash.
Windsor, Royal Library, No. 19,106 *recto*.
The notes have reference to the weight of air.
About 1510.

154 SELF-PORTRAIT OF LEONARDO.
33.3 × 21.4 cm. Red chalk.
Turin, Royal Library.
B.B. 1083: Bodmer, p. 229.
Inscribed below in a sixteenth-century hand (not Leonardo's) *'Leonardus Vincius'* (red chalk) *'ritratto di se stesso assai vecchio'* (black chalk). The drawing must date from about 1512.

155 PROFILE OF AN OLD, BEARDED MAN TO THE LEFT.
25.3 × 18.2 cm. Black chalk on coarse grey paper.
Windsor, Royal Library, No. 12,500.
B.B. 1166: Bodmer, p. 310.
Very late in style. Certainly after 1513.

156 PROFILE OF AN OLD, BEARDED MAN TO THE RIGHT.
21.3 × 15.5 cm. Black chalk.
Windsor, Royal Library, No. 12,499.
B.B. 1159: Bodmer, p. 311.
There is in the British Museum a copy of this by Lucas Vorsterman, made no doubt when the drawing was in the Arundel collection. It is inscribed *'Effigies Leonardi da Vinci/Vince costui pursolo/Tutti alteri: e vince Fidia: e*

Vince Appelle/Et tutto il lor/Virtuoso scuolo.' Clark suggests it is a study for a Christ among the doctors, of which a picture by Luini in the National Gallery may be a version. This would have dated from about 1504. However, it resembles the masquerade costumes and is most probably dateable about 1512.

157 STUDY OF THE HEAD OF A GIRL.
18.2 × 15.9 cm. Silver-point on light brown prepared surface.
Turin, Royal Library.
B.B. 1084: Bodmer, p. 151: Comm. Vinciana 86.
Study for the *Virgin of the Rocks* (Louvre version), 1483-90.

158 STUDY OF THE DRAPERY OF A FIGURE KNEELING TO THE LEFT.
21.3 × 15.9 cm. Drawn with the brush on blue prepared surface, heightened with white.
Windsor Royal Library, No. 12,521.
B.B. 1175: Bodmer, p. 152: Comm. Vinciana 14.
Study for the *Virgin of the Rocks* (National Gallery version), about 1506.

159 STUDIES FOR A VIRGIN ADORING THE INFANT CHRIST.
19.5 × 16.2 cm. Pen and ink over lead-point.
New York, Metropolitan Museum.
B.B. 1049c: Bodmer, p. 149: Comm. Vinciana 40.
About 1483.

160 STUDIES OF ARCHITECTURE AND OF A VIRGIN ADORING THE IN-FANT CHRIST.
18.3 × 13.7 cm. Silver-point, touched with pen on light blue prepared surface.
Windsor, Royal Library, No. 12,560.
B.B.1171: Bodmer, p. 150: Comm. Vinciana 42.
About 1483.

161 STUDY FOR THE LAST SUPPER AND MATHEMATICAL FIGURES AND CALCULATIONS.
26 × 21 cm. Pen and ink.
Windsor, Royal Library, No. 12,542.
B.B. 1188: Bodmer, p. 251: Popp 35.
About 1495-7.

Windsor, Royal Library, No. 12,514.
B.B. 1168.
Study for the *Madonna with the Yarn-winder,* 1501(?).

174A VIRGIN AND CHILD WITH ST. ANNE.
12.1 × 10 cm. Pen and ink over black chalk.
Venice Academy.
B.B. 1102: Bodmer, p. 277: Popp 45.
About 1498-9.

174B VIRGIN AND CHILD WITH ST. ANNE.
12 × 10 cm. Pen and ink over black chalk.
Paris, Louvre.
B.B. 1070: Bodmer, p. 278.
About 1498-9.

175 STUDIES FOR THE VIRGIN AND CHILD WITH ST. ANNE.
26 × 19.7 cm. Pen and ink and wash over black chalk.
London, British Museum.
B.B. 1028: Bodmer, p. 279.
About 1498-9.

176 VIRGIN AND CHILD WITH ST. ANNE AND INFANT ST. JOHN.
139 × 101 cm. Cartoon in charcoal on brown paper,
heightened with white.
London, Royal Academy of Arts.
B.B. 1039: Bodmer, p. 280.
About 1498-9.

DETAILS FROM THE ABOVE.

177 Head of St. Anne.

178 Head of the Virgin.

179 Head of the Infant St. John.

180 Head of the Infant Jesus.

181 STUDIES OF INFANTS.
20.5 × 15.2 cm. Pen and ink and black chalk.
Windsor, Royal Library, No. 12,562.
B.B. 1129B.
About 1498-9.

182　HEAD OF A WOMAN LOOKING DOWN TO THE RIGHT.
18.8 × 13 cm. Black chalk.
Windsor, Royal Library, No. 12,533.
B.B. 1152: Bodmer, p. 281.
Study for the head of St. Anne in the Louvre *Virgin and Child with St. Anne.*

183　HEAD OF A WOMAN THREE-QUARTERS TO THE LEFT.
24.4 × 18.7 cm. Red and black chalk with touches of pen and white on the veil.
Windsor, Royal Library, No. 12,534.
B.B. 1151.
The face has been stippled over by a later hand.

184A　STUDY OF THE BODY AND ARMS OF A CHILD.
12 × 14.3 cm. Red chalk on prepared surface.
Windsor, Royal Library, No. 12,538.
B.B. 1185: Bodmer, p. 283: Popp 47.
Study for the body of the Infant Christ in the Louvre *Virgin and Child with St. Anne.*

184B　STUDY OF A SLEEVE AND HAND.
8.6 × 17 cm. Pen and ink with washes of black, black and red chalk.
Windsor, Royal Library, No. 12,532.
B.B. 1182.
Study for the sleeve of the Virgin in the Louvre *Virgin and Child with St. Anne.*

185　STUDIES OF A CHILD AND PARTS OF A CHILD.
28 × 22 cm. Red chalk.
Venice, Academy.
B.B. 1109A.
Studies for the Louvre *Virgin and Child with St. Anne.*

186　STUDY OF THE DRAPERY OF A SEATED FIGURE TO THE RIGHT.
16.4 × 14.5 cm. Black chalk, washed with lamp-black on yellowish paper heightened with white.
Windsor, Royal Library, No. 12,530.
B.B. 1179: Bodmer, p. 284.
Study for the drapery of the Virgin in the Louvre *Virgin and Child with St. Anne.*

204 A Fantastic Battle.
 14.8 × 20.7 cm. Red and black chalk on red prepared surface.
 Windsor, Royal Library, No. 12,332.
 B.B. 1230: Popp 70.
 About 1511.

205 Neptune with Four Sea-horses.
 25.1 × 39.2 cm. Black chalk.
 Windsor, Royal Library, No. 12,570.
 B.B. 1117: Bodmer, p. 315: Popp 48.
 About 1503-4.

206 Two Studies of a Nude Figure and the View and Plan of
 a Building.
 27 × 20.1 cm. Pen and ink and black chalk.
 Windsor, Royal Library, No. 12,591.
 B.B. 1189: Bodmer, p. 314: Richter, No. 1103.
 About 1504 (?).

207A Study of a Sleeve.
 22 × 13.9 cm. Red chalk on prepared red surface with touches
 of white.
 Windsor, Royal Library, No. 12,524.
 B.B. 1183: Bodmer, p. 285.
 This drawing and the other reproduced on the same plate are
 studies for a lost picture of Christ blessing with one hand and
 holding the globe in the other. This work, which is known from
 copies and from an engraving by Hollar (Parthey 217), was
 probably that commissioned by Isabella d'Este on May 14, 1504.

207B Study of the Front of a Dress and of a Sleeve.
 16.4 × 15.8 cm. Red chalk and white on pink prepared surface.
 Windsor, Royal Library, No. 12,525.
 B.B. 1184: Bodmer, p. 287.

208 Leda and the Swan.
 12.5 × 11 cm. Pen and ink over black chalk.
 Rotterdam, Boymans Museum (Koenigs collection).
 B.B. 1020A: Bodmer, p. 329: Popp 61.
 About 1504.

209A STUDY OF A WOMAN'S BRAIDED HAIR.
 9.2 × 11.2 cm. Pen and ink.
 Windsor, Royal Library, No. 12,515.
 B.B. 1157: Bodmer, p. 332.
 Inscribed in Leonardo's hand *'questo sipo | levare eppo | re sanza gu | asstarrsi'* 'this can be removed and put on without hurting it.'
 Study for *Leda and the Swan*, about 1504-6.

209B STUDY OF A WOMAN'S BRAIDED HAIR.
 9.3 × 10.4 cm. Pen and ink over black chalk.
 Windsor, Royal Library, No. 12,517.
 B.B. 1158.
 Study for *Leda and the Swan*, about 1504-6.

210 STUDIES OF A WOMAN'S HEAD AND COIFFURE.
 20 × 16.2 cm. Pen and ink over black chalk.
 Windsor, Royal Library, No. 12,516.
 B.B. 1155: Bodmer, p. 330.
 Study for *Leda and the Swan*, about 1504-6.

211 STUDY OF A WOMAN'S HEAD.
 17.7 × 14.7 cm. Pen and ink over black chalk.
 Windsor, Royal Library, No. 12,518.
 B.B. 1156: Bodmer, p. 331: Popp 60.
 Study for *Leda and the Swan*, about 1504-6.

212 SKETCHES FOR A KNEELING LEDA AND OF A HORSE.
 28.7 × 40.5 cm. Pen and ink and black chalk.
 Windsor, Royal Library, No. 12,337 *recto*.
 B.B. 1123: Bodmer, p. 328.
 Studies for the *Battle of Anghiari* and *Leda and the Swan*, about 1504.

213A STUDY FOR A YOUTHFUL ST. JOHN THE BAPTIST.
 17.8 × 12.2 cm. Silver-point on blue prepared surface, heightened with white (which has oxidized).
 Windsor, Royal Library, No. 12,572.
 B.B. 1124: Bodmer, p. 177.
 About 1476.

213B STUDY FOR A ST. SEBASTIAN.
 17.4 × 6.4 cm. Pen and ink over metal-point.
 Hamburg, Kunsthalle.
 B.B. 1022: Bodmer, p. 178: Comm. Vinciana 69A.
 About 1480-1.

214 STUDIES OF LEGS, OF THE BONES AND TENDONS OF A LEG, OF AN
 ARM, AND OF THE BONES AND TENDONS OF AN ARM AND
 OF ORGANS LIKE A VALVE.
 29.8 × 22.5 cm. Pen and ink over silver-point on blue-green
 prepared surface.
 Windsor, Royal Library, No. 12,613 *verso*.
 Quad. Anat. V, fol. 21.
 About 1487.

215 HUMAN FIGURE IN A CIRCLE, ILLUSTRATING PROPORTIONS.
 34.3 × 24.5 cm. Pen and ink.
 Venice, Academy.
 B.B. 1099: Bodmer, p. 171: Richter, No. 343.
 About 1485-90.

216 STUDY OF A MAN'S NUDE TORSO, THE HEAD SQUARED FOR
 PROPORTION.
 21.3 × 15.3 cm. Silver-point on blue prepared surface, the
 head gone over with pen and ink.
 Windsor, Royal Library, No. 12,601.
 Bodmer, p. 172: Richter, No. 316.

217 ANATOMICAL DRAWINGS OF TWO SKULLS IN PROFILE TO THE LEFT.
 18.1 × 12.9 cm. Pen and ink.
 Windsor, Royal Library, No. 19,057 *recto*.
 Bodmer, p. 176: Anatomical MS. B, fol. 40 *recto*.
 1489.

218 ANATOMICAL DRAWING OF A SKULL TO THE LEFT.
 18.3 × 13 cm. Pen and ink.
 Windsor, Royal Library, No. 19,058 *recto*.
 Anatomical MS. B, fol. 41 *recto*.
 1489.

219 DRAWING OF THE TWO HALVES OF A SKULL.
18.3 × 13 cm. Pen and ink.
Windsor, Royal Library, No. 19,058 *verso*.
Bodmer, p. 176: Anatomical MS. B, fol. 41 *verso*.
1489.

220 TWO DRAWINGS OF THE BONY STRUCTURE OF THE HEAD.
18.5 × 13.5 cm. Pen and ink.
Windsor, Royal Library, No. 19,059.
Bodmer, p. 175: Anatomical MS. B, fol. 42 *recto*.
Inscribed at the top:
 'a di 2 daprile 1489 libro titolato de figura vmana.'

221 STUDY OF THE LOWER HALF OF A MAN AND OF MACHINERY.
19 × 14.3 cm. Pen and ink.
Windsor, Royal Library, No. 12,632.
Quad. Anat. VI, fol. 14.
About 1490 according to Clark, but perhaps later.

222 STUDIES OF A NUDE MAN SEEN FROM THE BACK AND FROM THE
SIDE.
17.7 × 14 cm. Silver-point on blue prepared surface, heightened with white (which has oxidized).
Windsor, Royal Library, No. 12,637.
B.B. 1193A: Bodmer, p. 174.
About 1490-1.

223 STUDY OF A NUDE MAN WITH HIS LEFT HAND ON HIS HIP.
19 × 11.5 cm. Silver-point on blue prepared surface, reinforced with the pen.
Windsor, Royal Library, No. 12,638.
B.B. 1204A: Bodmer, p. 173.
About 1490-1.

224 STUDIES OF THE PROPORTIONS OF THREE FIGURES.
15.9 × 20.8 cm. Pen and ink.
Windsor, Royal Library, No. 19,132.
Quad. Anat. VI, fol. 8: Bodmer, p. 214: Richter, No. 332.
This sheet, with three others at Windsor (19,130, 19,131, 19,-133, and 12,304) seems to have formed part of a notebook on the proportions of the human figure. The text has reference to

the relative loss of height in kneeling and sitting. The drawings must date from about 1490.

225 DISSECTION OF A BEAR'S FOOT TO THE RIGHT.
14.2 × 18.2 cm. Silver-point reinforced with ink on blue prepared surface, heightened with white.
Windsor, Royal Library, No. 12,374.
Quad. Anat. V, fol. 13.
About 1490-3.

226 DISSECTION OF A BEAR'S FOOT TO THE LEFT.
16.2 × 13.7 cm. Silver-point reinforced with ink on grey-blue prepared surface, heightened with white.
Windsor, Royal Library, No. 12,372.
Quad. Anat. V, fol. 2.
About 1490-3.

227 SECTIONS OF A MAN'S HEAD SHOWING THE ANATOMY OF THE EYE, ETC.
20.2 × 14.8 cm. Red chalk and pen and ink.
Windsor, Royal Library, No. 12,603.
Quad. Anat. V, fol. 6.
About 1500.

228 MEN PLOUGHING AND DIGGING.
9.6 × 26.8 cm. Red chalk.
Windsor, Royal Library, No. 12,643.
B.B. 1191: Popp 29.
About 1492-4.

229A TWO SEATED NUDES AND A WOMAN WASHING.
14.6 × 9.4 cm. Red chalk.
Windsor, Royal Library, No. 12,648 *recto*.
B.B. 1190: Bodmer, p. 234.
About 1503.

229B MEN DIGGING, CARRYING EARTH, ETC.
20.1 × 13 cm. Black chalk and some pen and ink.
Windsor, Royal Library, No. 12,644 *recto*.
B.B. 1191A.
About 1503.

230 STUDIES OF HUMAN LEGS AND OF THE BONES OF THE LEG IN A
 MAN AND IN A DOG.
 28.5 × 20.5 cm. Pen and ink over red chalk on red prepared
 surface.
 Windsor, Royal Library, No. 12,625.
 Quad. Anat. V, fol. 22.
 About 1504.

231 A NUDE MAN SEEN FROM THE FRONT.
 23.6 × 14.6 cm. Red chalk on red prepared surface, the out-
 line reinforced with the pen.
 Windsor, Royal Library, No. 12,594.
 B.B. 1202: Bodmer, p. 210.
 About 1507.

232 MAN DRAWN AS AN ANATOMICAL FIGURE TO SHOW THE HEART,
 LUNGS, AND MAIN ARTERIES.
 28.2 × 19.9 cm. Pen and ink over black chalk, the organs
 washed with green.
 Windsor, Royal Library, No. 12,597.
 Quad. Anat. V, fol. 1.
 About 1504-6.

233 A NUDE MAN SEEN FROM THE BACK.
 27 × 16 cm. Red chalk.
 Windsor, Royal Library, No. 12,596.
 B.B. 1200: Bodmer, p. 209.
 About 1503-7.

234 STUDY OF THE LOWER HALF OF A NUDE MAN FACING TO THE
 FRONT.
 21 × 14.6 cm. Red chalk on red paper, partly outlined in pen
 and ink.
 Windsor, Royal Library, No. 12,629.
 B.B. 1203: Bodmer, p. 211.
 About 1504-6.

235 STUDY OF THE BODY AND LEG OF A MAN.
 25.2 × 19.8 cm. Red chalk on salmon-pink prepared surface.
 London, British Museum.
 B.B. 1031: Bodmer, p. 302.
 About 1504.

249 TWO DRAWINGS OF THE HEART.
> 41 × 28 cm. Pen and ink on blue paper.
> Windsor, Royal Library, No. 19,074 *verso*.
> Quad. Anat. II, fol. 3.
> 1513.

250 SIX STUDIES OF AN ARM SHOWING IN THREE CASES THE BONES.
> 20 × 15 cm. Pen and ink.
> Windsor, Royal Library, No. 12,612.
> Quad. Anat. V, fol. 5.
> About 1504.

251 TWO STUDIES OF THE UPPER PART OF AN OLD MAN AND TWO STUDIES OF ARMS.
> 19.7 × 28.7 cm. Pen and ink.
> Windsor, Royal Library, No. 19,004 *verso*.
> Bodmer, p. 342: Anat. MS. A, fol. 5.
> 1510.

252 STUDY OF THE BACK VIEW OF A SKELETON, SHOWING THE TENDONS OF THE NECK.
> 27.4 × 20.4 cm. Coarse pen and ink on blue paper.
> Windsor, Royal Library, No. 19,075 *verso*.
> Quad. Anat. II, fol. 5.
> 1513 or later.

253 LANDSCAPE.
> 19 × 28.5 cm. Pen and ink.
> Florence, Uffizi.
> B.B. 1017: Bodmer, p. 111: Comm. Vinciana 2: Popp 1.
> Inscribed in Leonardo's hand '*di di santa Maria della neve addi 5 daghossto 1473.*' On the *verso* is an unfinished landscape sketch and a figure (repr. Comm. Vinciana 3).

254 A LILY.
> 31.4 × 17.7 cm. Pen and ink and brown wash over black chalk, heightened with white, the outlines picked for transfer.
> Windsor, Royal Library, No. 12,418.
> B.B. 1236: Bodmer, p. 270: Comm. Vinciana 13.

255 ROCKS AND STREAM.
 22 × 15.8 cm. Pen and ink.
 Windsor, Royal Library, No. 12,395.
 B.B. 1260: Bodmer, p. 163: Popp 20.

256 STUDIES OF FLOWERS.
 18.3 × 20.3 cm. Pen and ink over metal-point.
 Venice, Accademia.
 B.B. 1105: Comm. Vinciana 91.
 About 1483.

257 STUDIES OF VIOLAS AND OF METHODS OF SOLDERING LEAD ROOFS.
 23.2 × 16.7 cm. Pen and ink.
 Paris, Bibliothèque de l'Institut, MS. B. fol. 14 r.
 MS. B dates from about 1487. The text at the top on the left
 has reference to geometry, that at the bottom to the method of
 soldering the joints of lead roofing.

258 PAGE OF TEXT WITH SKETCHES OF LANDSCAPE.
 29 × 22 cm. Pen and ink.
 Milan, Ambrosiana, Codice Atlantico, fol. 145 v.-a.
 The text, transliterated and translated in Richter No. 1336, is
 that of the much discussed letter to Diodarius of Syria, lieuten-
 ant of the Sultan of Babylon. Though it was supposed by
 Richter to afford evidence for an Eastern journey made by Leo-
 nardo, it is in fact certainly an imaginative exercise in the form
 of a letter. It must, with the drawing, date from about 1497.

259 PAGE OF TEXT WITH SKETCHES OF LANDSCAPE.
 28.8 × 18 cm. Pen and ink.
 Milan, Ambrosiana, Codice Atlantico, fol. 145 v.-b.
 Continuation of the text from plate 258, to which see note.
 About 1497.

260A VIEW OF A MOUNTAIN RANGE.
 9.3 × 15.2 cm. Red chalk.
 Windsor, Royal Library, No. 12,405.
 B.B. 1252: Bodmer, p. 264.
 About 1499.

260B VIEW OVER A VALLEY WITH MOUNTAINS BEYOND.
 8.7 × 15.1 cm. Red chalk.

Windsor, Royal Library, No. 12,406.
B.B. 1252: Bodmer, p. 264: Popp 50.
About 1499.

261 A STORM OVER AN ALPINE VALLEY.
29 × 15 cm. Red chalk.
Windsor, Royal Library, No. 12,409.
B.B. 1251: Bodmer, p. 262: Popp 42.
About 1499.

262A STUDY OF A COPPICE.
19.1 × 15.3 cm. Red chalk.
Windsor, Royal Library, No. 12,431 *recto*.
B.B. 1238: Bodmer, p. 347: Comm. Vinciana 93.
About 1498.

262B STUDY OF A TREE.
19.1 × 15.3 cm. Red chalk.
Windsor, Royal Library, No. 12,431 *verso*.
B.B. 1238: Bodmer, p. 346: Comm. Vinciana 92.
The text, translated by Richter, No. 456, is as follows:
'The part of a tree which has shadow for background is all of
one tone, and wherever the trees or branches are thickest they
will be darkest, because there are no little intervals of air. But
where the boughs lie against a background of other boughs, the
brighter parts are seen lightest and the leaves lustrous from
the sunlight falling on them.'
About 1498.

263 PLAN OF IMOLA.
44 × 60.2 cm. Pen and ink and water-colour.
Windsor, Royal Library, No. 12,284.
The text, which has reference to the position of towns in the
neighbourhood of Imola, is given in Richter, No. 1051.
1502.

264 BIRD'S-EYE VIEW OF PART OF TUSCANY.
27.5 × 40.1 cm. Pen and ink and colour.
Windsor, Royal Library, No. 12,683.
About 1502-3.

265 MAP OF NORTHERN ITALY, SHOWING THE WATERSHED OF THE
ARNO.
> 31.7 × 44.9 cm. Pen and ink and brown wash and blue.
> Windsor, Royal Library, No. 12,277.
> About 1502-3.

266 BIRD'S-EYE VIEW SHOWING AREZZO, BORGHO SAN SEPOLCRO,
PERUGIA, CHIUSI AND SIENA.
> 33.8 × 48.8 cm. Pen and ink and water-colour.
> Windsor, Royal Library, No. 12,278.
> June, 1502.

267 PLAN OF AN EMBANKMENT FOR DIVERTING THE ARNO.
> 23.6 × 41.6 cm. Pen and ink and water-colour.
> Windsor, Royal Library, No. 12,680.
> This detail plan is explained by another smaller scale map of
> the bed of the Arno, also at Windsor (No. 12,679). It was
> drawn in connection with a scheme for straightening the Arno
> and probably dates from about 1502.
> On the extreme left is a chain ferry, in the centre are two weirs
> with openings in the centre of each for directing the river in
> the course desired.

268A TWO TREES ON THE BANK OF A STREAM.
> 7 × 7.4 cm. Pen and ink.
> Windsor, Royal Library, No. 12,402.
> B.B. 1234: Bodmer, p. 334.
> About 1503.

268B BIRD'S-EYE VIEW OF A RIVER WITH A ROPE FERRY.
> 10 × 12.8 cm. Pen and ink.
> Windsor, Royal Library, No. 12,400.
> B.B. 1239: Bodmer, p. 334: Popp 73.
> About 1503.

269A A RIVER WITH A CANAL ALONGSIDE AND A CASTLE ON A HILL.
> 10 × 14.7 cm. Pen and ink.
> Windsor, Royal Library, No. 12,399.
> B.B. 1260A: Bodmer, p. 263: Popp 69.
> About 1503.

274B SKETCH OF A PLANT.
> 8.5 × 14 cm. Pen and ink over black chalk.
> Windsor, Royal Library, No. 12,423.
> B.B. 1236.
> About 1505-8.

275 A BRANCH OF BLACKBERRY.
> 15.5 × 16.2 cm. Red chalk on pink prepared surface, heightened with white.
> Windsor, Royal Library, No. 12,419.
> B.B. 1236: Bodmer, p. 272: Popp 2.
> About 1505-8.

276 A SPRAY OF A PLANT.
> 14.4 × 14.3 cm. Red chalk on pink surface touched with white.
> Windsor, Royal Library, No. 12,421.
> B.B. 1236.
> About 1505-8.

277 OAK-LEAVES WITH ACORNS AND DYER'S GREENWEED.
> 18.8 × 15.4 cm. Red chalk on pink surface, touched with white.
> Windsor, Royal Library, No. 12,422.
> B.B. 1236: Bodmer, p. 273.

278 SPRAY OF BLACKBERRY.
> 18.8 × 16.5 cm. Red chalk on pink prepared surface.
> Windsor, Royal Library, No. 12,420 *recto*.
> B.B. 1236: Bodmer, p. 271.
> About 1505-8.

279 STUDIES OF THE FORMATION OF WATER IN MOTION.
> 20.5 × 20.3 cm. Red chalk on pen and ink.
> Windsor, Royal Library, No. 12,661.
> The text, given by Clark, has reference to the forms of water. There are three other drawings (Nos. 12,659, 12,660, 12,662) at Windsor of the same character and date, two of which are illustrated on the two following plates.
> About 1507-9.

280　STUDIES OF WATER FORMATIONS.
26.8 × 18.2 cm. Red chalk and pen and ink.
Windsor, Royal Library, No. 12,662.
See note to plate 279.
About 1507-9.

281　STUDIES OF WATER FORMATIONS.
29 × 20.2 cm. Pen and ink.
Windsor, Royal Library, No. 12,660 *verso*.
Popp 79.
See note to plate 279.
About 1507-9.

282　STUDIES OF AN OLD MAN SEATED AND OF SWIRLING WATER.
15.2 × 21.3 cm. Pen and ink.
Windsor, Royal Library, No. 12,579 *recto*.
B.B. 1131: Bodmer, p. 228 (left half only).
The text given in Richter No. 389 is as follows:
'*Nota il moto del livello dell'acqua, il quale fa a uso de'
capelli, che ànno due moti, de'quali l'uno attēde al peso del
uello, l'altro al liniamento delle volte; cosi l'acqua à le sue
volte revertiginose, delle quali una parte attende al inpeto del
corso principale, l'altro attēde al moto incidēte e reflesso.*'
'Observe the motion of the surface of the water which resem-
bles that of hair, which has two motions, of which one depends
on the weight of the hair, the other on the direction of the
curls; thus the water forms eddying whirlpools, one part of
which is due to the impetus of the principal current and the
other to the incidental motion and return flow.'
On the *verso* are some slight architectural drawings.
About 1510.

283　A FLOOD BREAKING INTO A VALLEY.
16.3 × 20.6 cm. Pen and ink over black chalk.
Windsor, Royal Library, No. 12,401.
B.B. 1251A: Bodmer, p. 336.
About 1512-13.

284A　STUDY OF ROCK FORMATIONS.
13.3 × 20.5 cm. Black chalk.
Windsor, Royal Library, No. 12,396.

B.B. 1260.
About 1508-11.

284B STUDY OF ROCK FORMATIONS.
16.4 × 20.1 cm. Charcoal.
Windsor, Royal Library, No. 12,397.
B.B. 1260: Popp 64.
About 1508-11.

285A STUDY OF MOUNTAIN RANGES.
10.5 × 16 cm. Red chalk on red prepared surface, heightened with white.
Windsor, Royal Library, No. 12,410.
B.B. 1253.
1511.

285B STUDIES OF MOUNTAIN RANGES.
15.9 × 24 cm. Red chalk on red prepared surface.
Windsor, Royal Library, No. 12,414.
B.B. 1257.
The text, transcribed by Clark, has reference to the change of colour in the mountains under different atmospheric conditions.
About 1511.

286 VIEW OF A DELTA.
15 × 23.5 cm. Red chalk on red prepared surface.
Windsor, Royal Library, No. 12,412.
B.B. 1255.
About 1511.

287 BIRD'S-EYE VIEW OF THE COAST OF ITALY, NORTH OF TERRACINA.
27.7 × 40 cm. Pen and ink and water-colour.
Windsor, Royal Library, No. 12,684.
About 1515. The names of places are not in Leonardo's hand.

288 DESTRUCTION RAINED FROM HEAVEN ON EARTH.
30 × 20.3 cm. Pen and ink over black chalk.
Windsor, Royal Library, No. 12,388.
B.B. 1250B: Bodmer, p. 339: Popp 77.
The text given by Richter No. 477 has reference to the colour

296 DELUGE.
 16.3 × 21 cm. Black chalk.
 Windsor, Royal Library, No. 12,378.
 B.B. 1242: Popp 84.
 After 1513.

297 STUDIES OF SUCTION PUMPS, ARCHIMEDES TUBES, ETC.
 27.4 × 38.8 cm. Pen and ink and wash.
 Milan, Ambrosiana, Codice Atlantico, fol. 386 *recto*-b.
 The inscriptions have reference to the machinery. Other
 drawings of the same character on the *verso* (fol. 386 *verso*-b).
 A second sheet of the same size with exactly similar drawings
 is Codice Atlantico, fol. 7 *recto*-a, 7 *verso*-a. A similar device
 to that on the left, for breathing under water, is illustrated in
 British Museum, Add. 34, 113, fol. 180 *verso*.
 About 1475-80.

298 DEVICE FOR REPELLING SCALING LADDERS.
 25.5 × 19.4 cm. Pen and ink.
 Milan, Ambrosiana, Codice Atlantico, fol. 49 *verso*-b.
 Preliminary sketches of this device are on fol. 34 *verso*-a and
 on fol. 372 *verso*-b of the Codice Atlantico. The text has
 reference to the manner of fixing into the wall the beam on
 which the device pivots.
 About 1475-80.

299 A CANAL WITH LOCKS AND WEIRS.
 27.7 × 20.8 cm. Pen and ink.
 Milan, Ambrosiana, Codice Atlantico, fol. 33 *verso*-a.
 The text has reference to the machinery of the lock gates.
 About 1475-80.

300 METHOD OF CONSTRUCTING A TRESTLE BRIDGE.
 21.3 × 29.7 cm. Pen and ink.
 Milan, Ambrosiana, Codice Atlantico, fol. 16 *verso*-a.
 The text has reference to the method of construction of the
 bridge. A sketch for details is on fol. 329 *verso* of the
 Codice Atlantico.
 About 1485-8.

B.B. 1191c: Bodmer, p. 196: Comm. Vinciana 81.
On the *verso* is the drawing of a town on a hill being blown up by a mine.
About 1485-8.

307 VARIOUS ARMS OF OFFENCE AND DEFENCE.
22 × 36 cm. Pen and ink on blue-green prepared surface.
Paris, Louvre.
B.B. 1065A: Bodmer, p. 197: Comm. Vinciana 71.
About 1485-8.

308 A CHARIOT ARMED WITH SCYTHES, TWO DRAWINGS OF A SORT OF TANK AND A PARTISAN.
17.3 × 24.6 cm. Pen and ink and wash.
London, British Museum.
B.B. 1030: Comm. Vinciana 78.
For an account of such chariots see MS. B, fol. 10 *recto* (MacCurdy, II, p. 185).
About 1485-8.

309 DRAWINGS OF CHARIOTS ARMED WITH FLAILS, OF AN ARCHER WITH A SHIELD AND OF A HORSEMAN WITH THREE LANCES.
20 × 27.8 cm. Pen and ink and wash.
Windsor, Royal Library, No. 12,653.
B.B. 1231: Bodmer, p. 195: Comm. Vinciana 79.
About 1485-8.

310 DRAWINGS OF TWO TYPES OF CHARIOT ARMED WITH SCYTHES.
20 × 28 cm. Pen and wash.
Turin, Royal Library.
B.B. 1094: Comm. Vinciana 80.
The text gives measurements and particulars of the mechanism of the machinery actuating the scythes.
About 1485-8.

311 SKETCHES OF CHARIOTS ARMED WITH SCYTHES AND FLAILS, OF A HORSEMAN WITH THREE LANCES AND OF A MACHINE FOR HURLING STONES FROM BATTLEMENTS.
17.9 × 26.5 cm. Pen and ink.
Milan, Ambrosiana, Codice Atlantico, fol. 40 *verso*-a.

Preliminary sketches for the drawings at Windsor (plate 309)
and at Turin (plate 310).
About 1485-8.

312 TWO DESIGNS FOR A DOMED CHURCH WITH SURROUNDING CU-
POLAS.
23 × 16 cm. Pen and ink.
Paris, Institut de France, MS. B. fol. 17 *verso.*
The text to the right has reference to the growth and uses of
trees illustrated at the top on the right. The text at the bot-
tom reads '*questo.edifitio.anchora starebbe bene affarlo
dalla linia. a.b.c.d. insui.*' 'It would be still better to make
this building from the line a b c d.'
About 1488-9.

313 SKETCH OF A SQUARE CHURCH WITH A CENTRAL DOME AND
MINARETS.
23 × 16 cm. Pen and ink.
Paris, Bibliothèque Nationale, MS. 2037, fol. 4 *recto.*
The translation of the text (Richter, No. 756) is as follows:
'This edifice is inhabited (accessible) below and above, like
San Sepolcro, and it is the same above as below, except that
the upper story has the dome *c d*, and the lower has the dome
a b, and when you enter into the crypt you descend ten steps,
and when you mount into the upper you ascend twenty steps,
which, with one-third *braccio* for each, make ten *braccia,* and
this is the height between one floor of the church and the other.'
About 1488-9.

314 VIEW AND PLAN OF A SQUARE CHURCH WITH A CENTRAL DOME
AND FOUR CUPOLAS.
23 × 16 cm. Pen and ink.
Paris, Institut de France, MS. B. fol. 22 *recto.*
The text has reference to the machinery sketched below the
plan.
About 1488-9.

315 SKETCH DESIGN FOR A STABLE.
23 × 16 cm. Pen and ink.
Paris, Institut de France, MS. B. fol. 39 *recto.*
Richter, Pl. LXXVIII (1), No. 761.

The text, given by Richter, explains the plan and arrangement of the stable.
About 1488-9.

316 DRAWING OF A DECORATIVE SCREEN AND OTHER SKETCHES.
28.5 × 19.5 cm. Pen and ink.
Milan, Ambrosiana, Codice Atlantico, fol. 357 *verso*-a.
Richter, pl. CVI a (detail) : Calvi, p. 110.
Calvi notes a connection with fol. 23 *verso* of MS. B in which similar sketches to those at the top on the right occur. They are methods for roofing garden walls (*'modi di muri d'orti'*). He suggests that this screen and the ornamental interlacements may have been designed for the wedding feasts of 1488-9.

317 DRAWING OF A FLYING MACHINE.
23 × 16 cm. Pen and ink.
Paris, Institut de France, MS. B. fol. 74 *verso*.
Calvi, p. 114.
Another drawing of the machine in almost exactly the same form in the Codice Atlantico, fol. 302 *verso*-a. The text is translated by MacCurdy, I, p. 516.
About 1488-9.

318 DRAWING OF A FLYING MACHINE WITH A MAN OPERATING IT.
23 × 16 cm. Pen and ink.
Paris, Institut de France, MS. B. fol. 80 *recto*.
The text is translated by MacCurdy, I, p. 517.

319 MACHINE FOR SHAPING IRON RODS FOR MAKING CANNON.
29.7 × 21.2 cm. Pen and ink.
Milan, Ambrosiana, Codice Atlantico, fol. 2 *recto*-a. Müller-Walde, *Leonardo da Vinci Lebenskizze*, Munich, 1889, p. 218 f.
About 1500.

320 DRAWINGS OF A SQUARE CASTLE.
22.8 × 30.5 cm. Pen and ink.
Milan, Ambrosiana, Codice Atlantico, fol. 43 *verso*-a.
About 1500-5.

CONCORDANCE

Concordance Between the Numbers of Berenson, Bodmer, Clark, the Commissione Vinciana and those of the Plates

BERENSON

Berenson	This vol.	Berenson	This vol.	Berenson	This vol.
1010A	26	1034B	28A	1067A	3
1010B	39	1035	129	1067C	19
1010C	45	1035A	63A	1068	42
1010D	14	1036	46	1069	25
1010H	109B	1037	103	1070	174B
1010J	78B	1037A	5	1070A	4
1011	198	1039	176-180	1071C	6
1012	199	1044A	64	1081	48
1013	74	1044B	79A, B	1082	301
1013B	29A	1044C	78	1082B	1
1014	47	1044D	65	1082C	138A, B
1015	10	1045A	8B	1082D	109A
1015C	7	1048	139A	1083	154
1016	127	1048A	137A	1084	157
1017	253	1049A	63B	1085	189
1018	130A	1049B	111	1089	197
1019	141	1049C	159	1091	73
1020	53	1049D	140C	1094	310
1020A	208	1050	146	1095	192A
1020C	110B	1051	107, 108	1096	193B
1021	41	1054	8A	1097	194
1022	213B	1055	105, 106	1098	192B
1023	49, 104	1056	60B	1099	215
1024	11, 27	1058	51	1100	196
1025	12, 13	1059	17	1101	126

163

CONCORDANCE

Berenson	This vol.	Berenson	This vol.	Berenson	This vol.
1026	9A, B	1059A	60A	1102	174A
1027	15, 16	1060	139B	1103	171B
1028	144, 175	1061	2	1104	304
1029	193A	1062	172	1105	256
1030	308	1063	188	1106	191
1031	235	1064	110A	1107	162
1034	140B	1065	43, 44	1109	40A
1034A	29B	1065A	307	1109A	185
1110	40B	1159	156	1216	101
1112A	137B	1160	152	1219	92
1113	164	1162	132	1220	100
1117	205	1163A	135, 136A, B	1221	93, 94
1118	125	1164	133	1222	98, 99
1119	112	1164A	130B	1223	77
1120	114	1166	155	1223A	57
1121	113	1166A	140A	1224	200
1122	124	1167	150	1224A	89
1123	212	1167A	22	1225	83, 85
1124	213A	1168	173	1226	66
1125	120	1169A	80	1227	202, 203
1126	122	1169B	88	1227A	195
1127	121	1169C	62	1228	86
1128	123	1170	23, 24	1228A	84A, B
1129B	181	1171	160	1230	204
1129C	170	1173	18	1231	309
1129D	21	1175	158	1232	55, 56
1129E	20	1176	169		59, 61
1130	119	1178	187		67, 70
1131	282	1179	186		71, 72
1132	118	1182	184B		76, 95
1133	190	1183	207A		96
1135	142	1184	207B	1232A	54
1137	145	1185	184A	1233	87
1138	117B	1187	52B	1234	268A
1139	171A	1187A	52A	1235	270
1140	168	1188	161	1236	254
1141	165	1189	206		271A, B
1142	166	1190	229A		272, 273

CONCORDANCE

Berenson	This vol.	Berenson	This vol.	Berenson	This vol.
1144	149	1191	228		274A, B
1145	147	1191A	229B		275, 276
1146	151	1191C	306		277, 278
1147	148	1194	237	1238	262A, B
1149	143	1200	233	1239	268B
1151	183	1203	234	1240	290
1152	182	1204	242	1241	293
1153	167	1205	239	1242	296
1154	128	1210	90	1243	291
1155	210	1212	91	1244	292
1156	211	1213	58	1246	294
1157	209A	1214	68	1247	295
1158	209B	1215	102	1250B	288
1251	261	1255	286		289
1251A	283	1257	285B	1260A	269A, B
1252	260A, B	1260	255	1261	305
1253	285A		284A, B		

BODMER

Bodmer	This vol.	Bodmer	This vol.	Bodmer	This vol.
109	130A	141	52B	177	213A
110	110B	142	45	178	213B
110	8A	143	28A	179	88
111	253	144	104	180	80
112	129	145	54	181	63A
113	23	146	58	182	60A
114	24	147	64	182	61
115	127	148	65	183	57
116	26	149	159	184	55
117	16	150	29B	185	68
118	15	150	160	186	66
119	25	151	157	187	59
120	10	152	158	188	69
121	11	153	22	189	71
122	14	154	20	190	67
123	12	155	21	191	77

CONCORDANCE

Bodmer	This vol.	Bodmer	This vol.	Bodmer	This vol.
124	13	156	105	192	72
125	8B	157	106	193	76
126	17	158	107	194	301
126	28B	159	108	195	309
127	27	160	103	196	306
128	40A	161	9B	197	307
129	40B	162	9A	199	305
130	41	163	255	203	123
131	39	164	110A	204	118
132	42	166	137A	205	119
133	47	169	131D	206	120
134	44	170	130B	207	117
135	43	171	215	208	145
136	46	172	216	209	233
137	48	173	223	210	231
138	49	174	222	211	234
139	53	175	220	214	224
140	51	176	217	217	84B
141	52A	176	219	218	84A
219	136A	263	269A	305	146
220	138B	263	269B	306	198
220	138A	264	260A	307	199
221	139B	264	260B	308	142
221	140B	266	271B	309	148
222	137B	267	271A	310	155
223	136B	268	272	311	156
224	141	269	270	313	139A
225	135	270	254	314	206
226	133	271	278	315	205
227	189	272	275	316	85
228	282	273	277	319	202
229	154	274	274A	320	86
230	19	275	172	321	87
231	128	277	174A	322	93
232	109A	278	174B	323	92
232	109B	279	175	324	91
233	111	280	176	325	90
234	81A	281	182	326	89

CONCORDANCE

Bodmer	This vol.	Bodmer	This vol.	Bodmer	This vol.
234	229A	283	184A	327	96
240	73	284	186	328	212
241	74	285	207A	329	208
242	70	286	187	330	210
243	101	287	207B	331	211
244	97	288	190	332	209A
246	100	289	191	333	125
251	161	290	200	334	268A
252	162	291	193A	334	268B
253	165	292	195	335	273
254	168	294	192B	336	283
255	167	295	193B	339	288
256	166	296	194	340	291
257	164	299	236	341	243
258	169	300	237	342	251
259	149	301	197	345	124
260	143	302	235	346	262B
261	171B	303	242	347	262A
262	261	304	196	349	293

CLARK

Clark	This vol.	Clark	This vol.	Clark	This vol.
12,276	23, 24	12,278	266	12,283	132
12,277	265	12,281	247	12,284	263
12,285	66	12,370	62	12,466	131B
12,286	75	12,372	226	12,488	140A
12,290	67	12,374	225	12,489	136A
12,294	76	12,376	290	12,490	136B
12,303	95	12,377	293	12,495	133
12,306	56	12,378	296	12,496	125
12,308	55	12,379	291	12,497	112
12,310	71	12,380	292	12,498	130B
12,313	96	12,382	294	12,499	156
12,315	59	12,383	295	12,500	155
12,317	70	12,388	288	12,502	142
12,318	61	12,394	289	12,503	150

CONCORDANCE

Clark	This vol.	Clark	This vol.	Clark	This vol.
12,319	72	12,395	255	12,505	128
12,320	69	12,396	284A	12,508	152
12,321	77	12,397	284B	12,513	22
12,324	57	12,398	269B	12,514	173
12,325	58	12,399	269A	12,515	209A
12,326	83, 85	12,400	268B	12,516	210
12,328	202, 203	12,401	283	12,517	209B
12,330	195	12,402	268A	12,518	211
12,331	86	12,405	260A	12,519	171A
12,332	204	12,406	260B	12,521	158
12,334	84A	12,409	261	12,524	207A
12,336	84B	12,410	285A	12,525	207B
12,337	212	12,412	286	12,527	187
12,339	201	12,414	285B	12,530	186
12,340	200	12,418	254	12,532	184B
12,341	89	12,419	275	12,533	182
12,342	100	12,420	278	12,534	183
12,343	92	12,421	276	12,538	184A
12,344	98, 99	12,422	277	12,540	190
12,353	90	12,423	274B	12,542	161
12,354	102	12,424	273	12,543	163
12,355	91	12,425	274A	12,546	169
12,356	93, 94	12,427	272	12,547	166
12,358	68	12,429	270	12,548	168
12,359	97	12,430	271A, B	12,551	165
12,360	101	12,431	262A, B	12,552	167
12,361	82	12,432	131A	12,553	149
12,362	54	12,441	131D	12,554	147
12,363	87	12,442	131C	12,556	148
12,367	80	12,448	134B	12,557	143
12,369	88	12,449	135	12,558	18
12,560	160	12,612	250	12,698	116C
12,562	181	12,613	214	12,700	113
12,567	170	12,619	241	12,701	114
12,568	21	12,623	236	12,702	52B
12,569	20	12,625	230	12,703	52A
12,570	205	12,629	234	12,704	116A
12,572	213A	12,630	242	12,705	117B

CONCORDANCE

Clark	This vol.	Clark	This vol.	Clark	This vol.
12,573	118	12,631	239	12,706	117C
12,574	119	12,632	221	12,707	116B
12,575	120	12,637	222	12,708	117A
12,576	121	12,638	223	19,001	243
12,577	122	12,640	237	19,003	244, 245
12,579	282	12,643	228	19,004	251
12,581	123	12,644	229B	19,012	246
12,582	145	12,647	305	19,029	240
12,585	124	12,648	229A	19,057	217
12,591	206	12,652	306	19,058	218, 219
12,593	238	12,653	309	19,059	220
12,594	231	12,660	281	19,074	249
12,596	233	12,661	279	19,075	252
12,597	232	12,662	280	19,102	248
12,598	151	12,680	267	19,106	153
12,599	139A	12,683	264	19,132	224
12,601	216	12,684	287		
12,603	227	12,692	115		

COMMISSIONE VINCIANA

Comm. Vinc.	This vol.	Comm. Vinc.	This vol.	Comm. Vinc.	This vol.
2	253	24	10	42	160
4	131C	26	14	43A	40A
5	28B	27	8B	43B	40B
9	21	28	15	44	41
10	20	29	16	45	39
11	8A	30	169	46	42
13	254	31	25	47	53
14	158	32	27	48	23
15	2	33	127	49	24
17	1	35	130A	51	50
18	11	36	22	53	85
19	12	37	26	55A	84A
20	13	38	28A	55B	84B
22	9A	39	45	56	44
23	9B	40	159	57	43

CONCORDANCE

Comm. Vinc.	This vol.	Comm. Vinc.	This vol.	Comm. Vinc.	This vol.
58A	52B	80	310	107	109A
58B	52A	83	305	109	72
59	46	85	17	111	75
60	49	86	157	112	76
61	48	91	256	116	95
62	47	92	262B	121	66
64	62	93	262A	122	67
65	60B	95	19	123	70
66B	64	96	128	124	71
67	63B	97	170	130	82
68	54	98	104	141	73
69A	213B	99	107	147	96
70	60A	100	108	151	74
71	307	101	106	158	98
72	304	102	105	159	65
77	301	103	123	161	97
78	308	105	109B	162	99
79	309	106	111	167	101

INDEX

of collections in which the drawings illustrated are preserved

INDEX

ILLUSTRATIONS

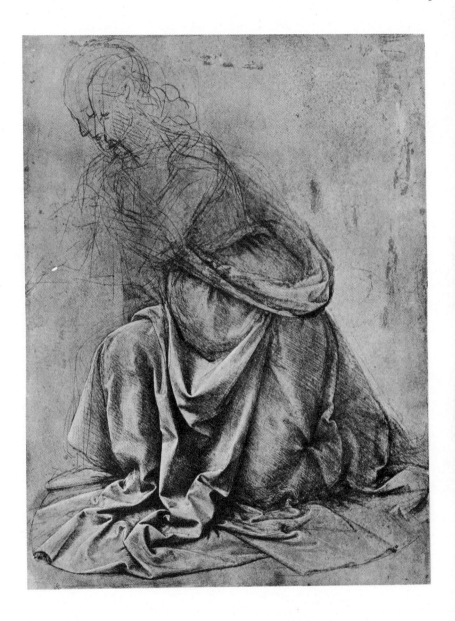

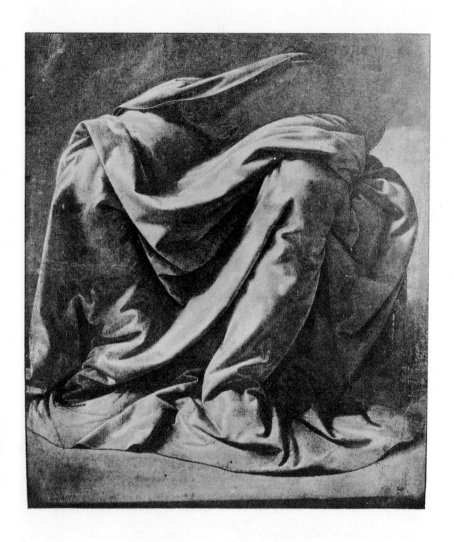

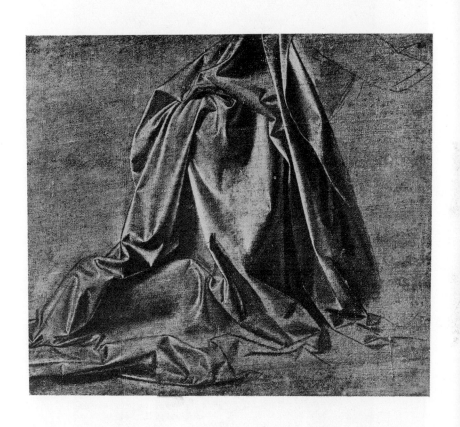

4

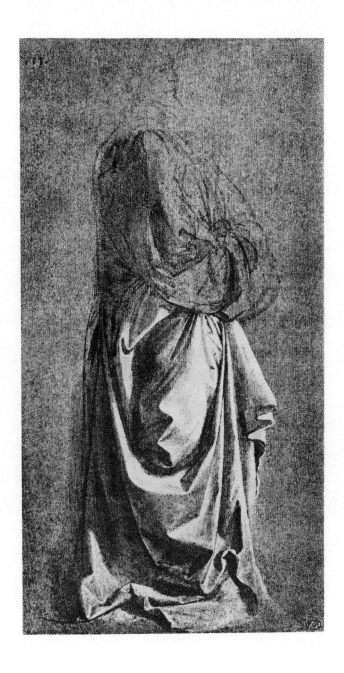

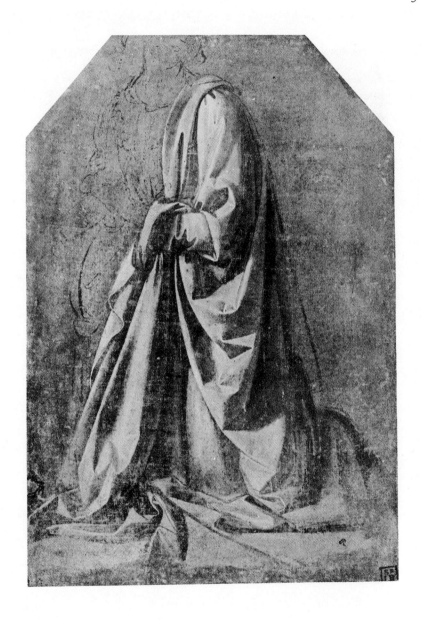

6

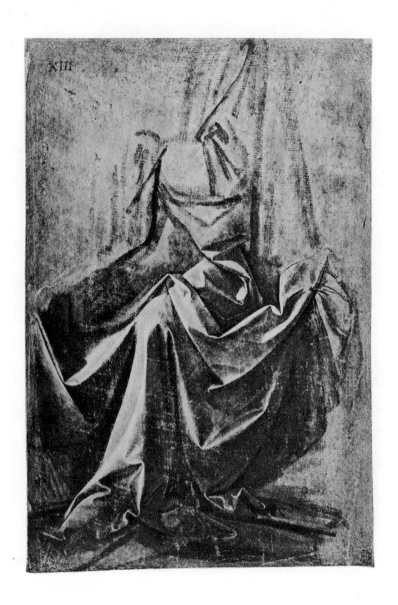

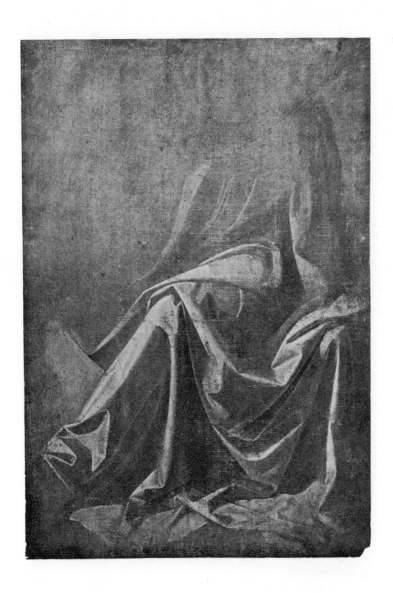

B

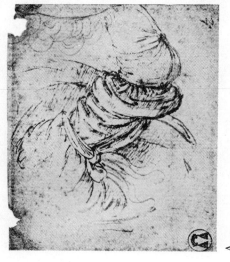

A

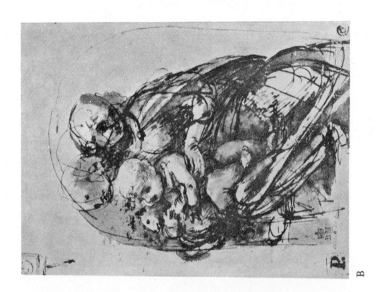

B

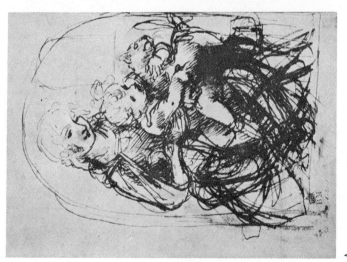

A

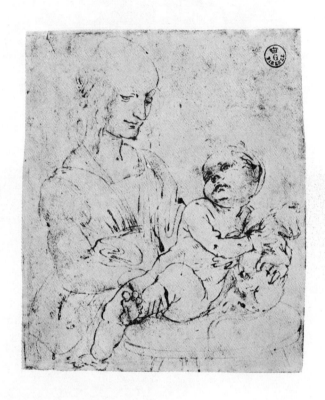

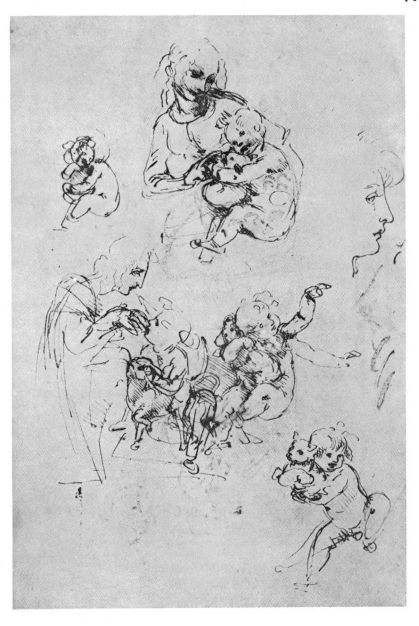

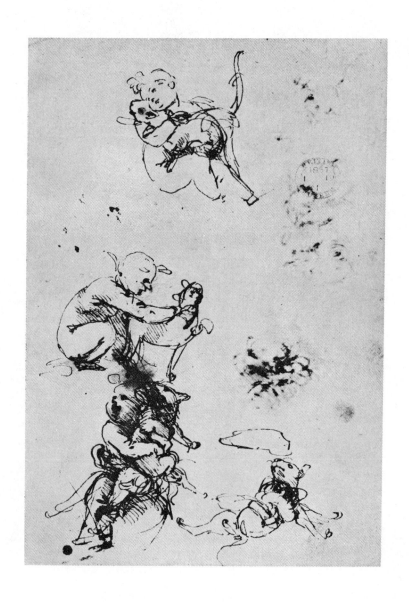

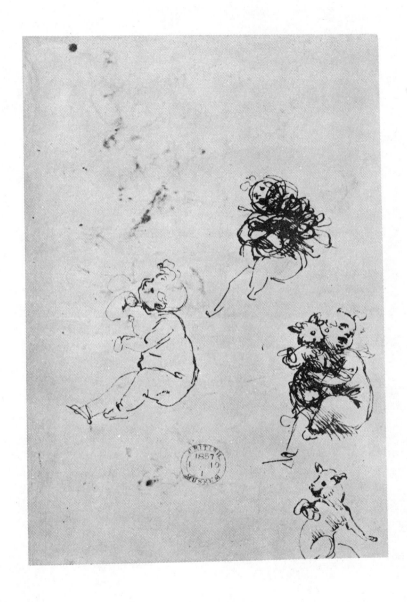

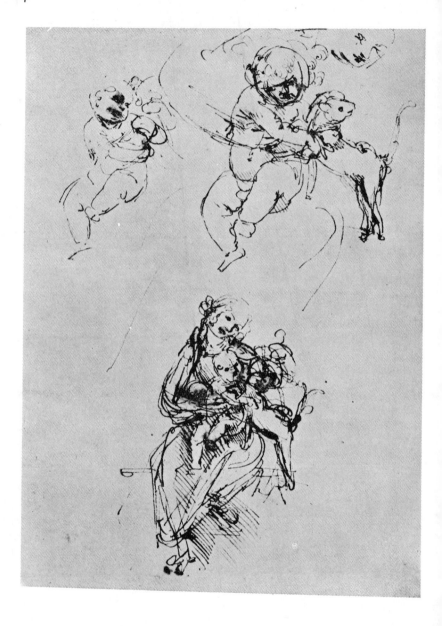

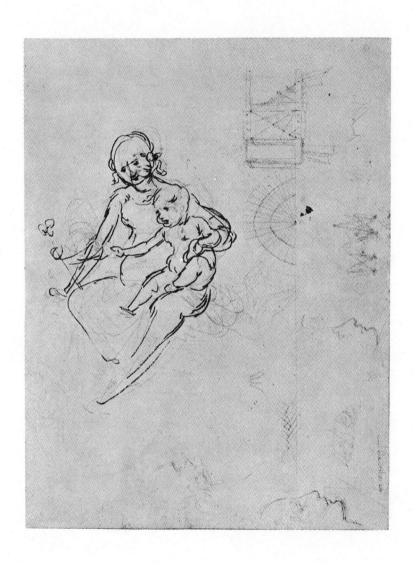

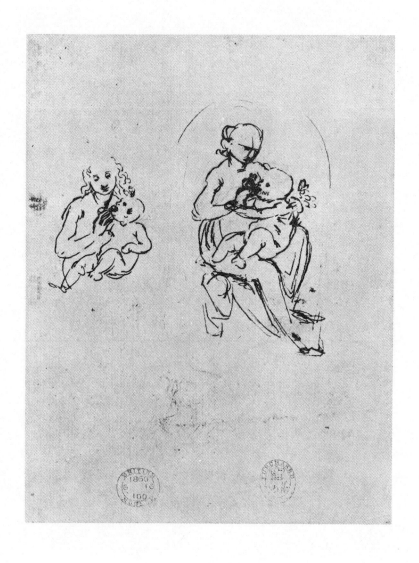

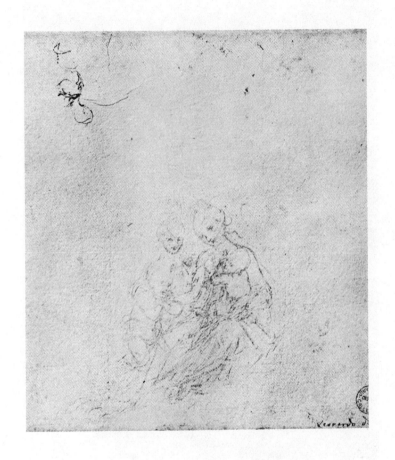

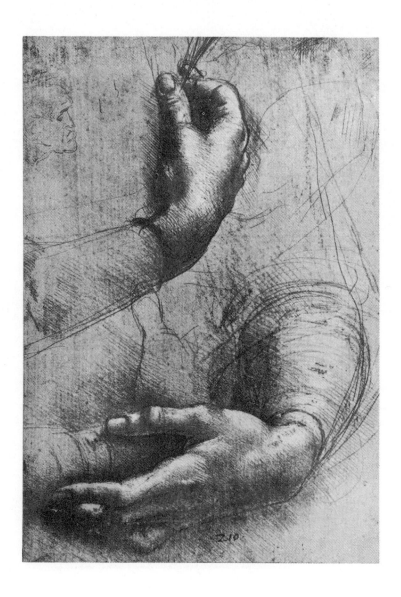

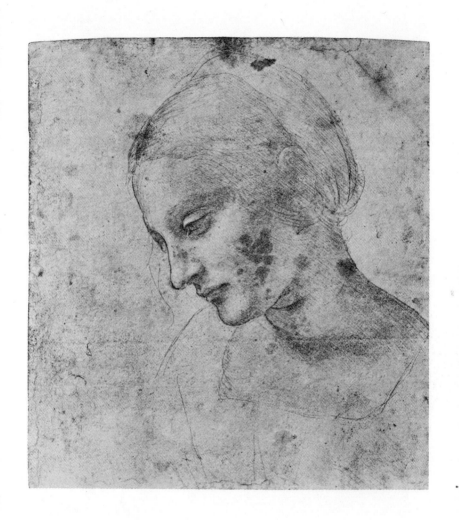

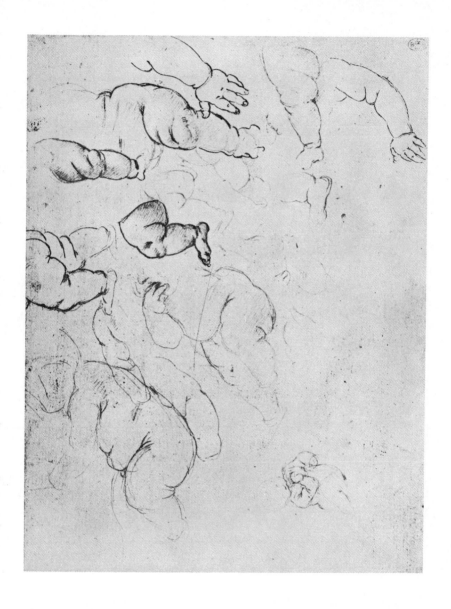

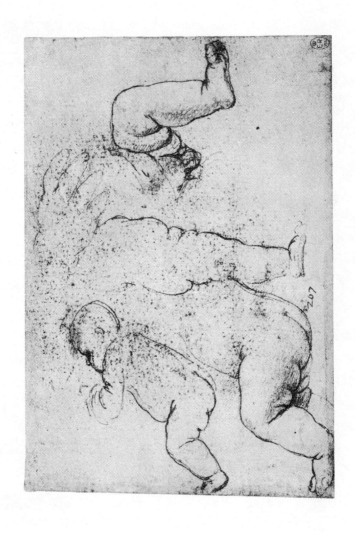

22

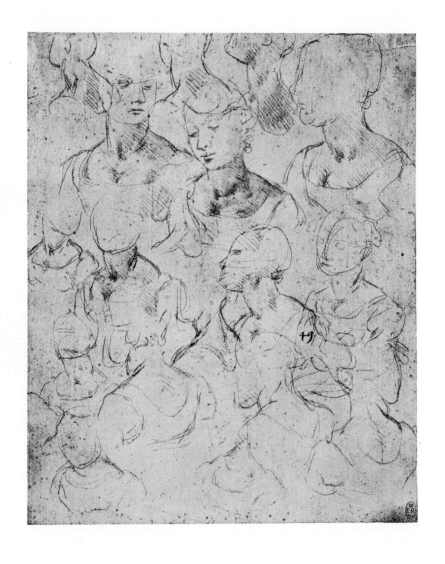

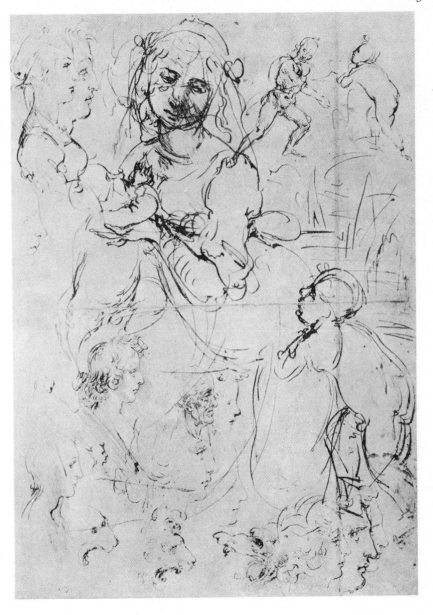

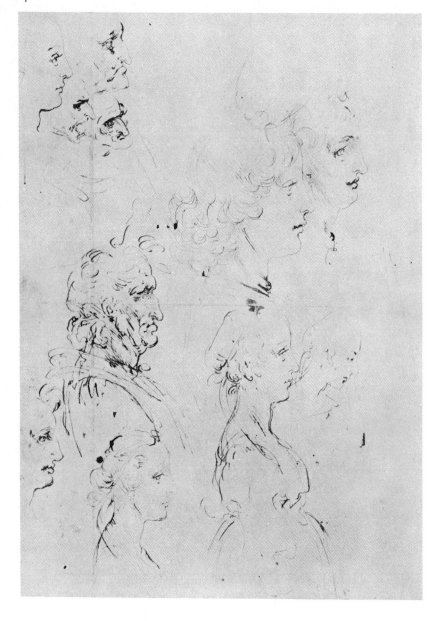

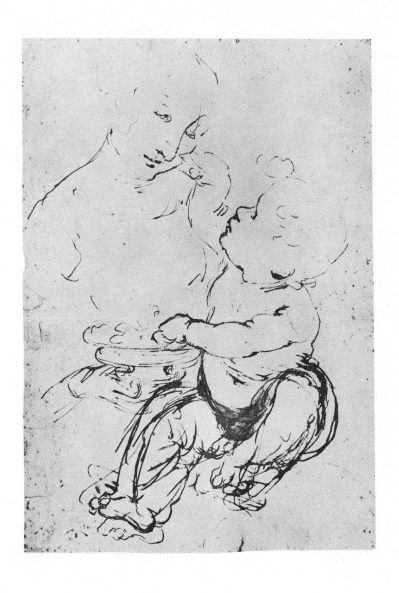

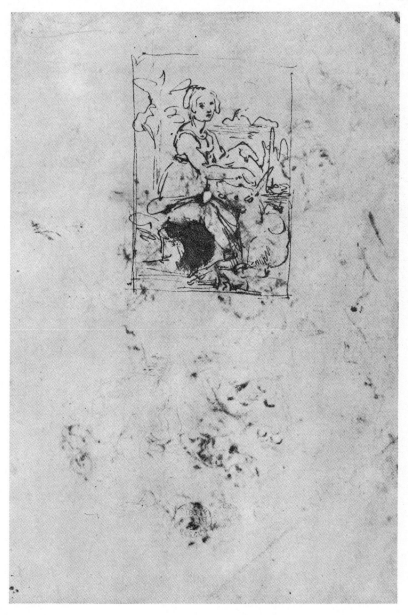

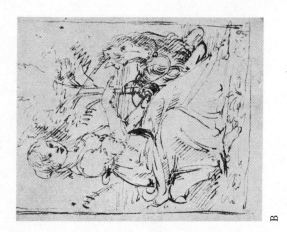

B

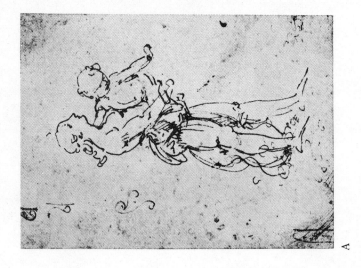

A

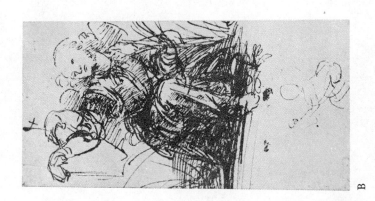

B

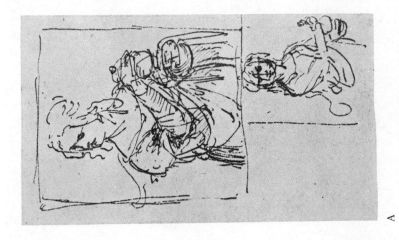

A

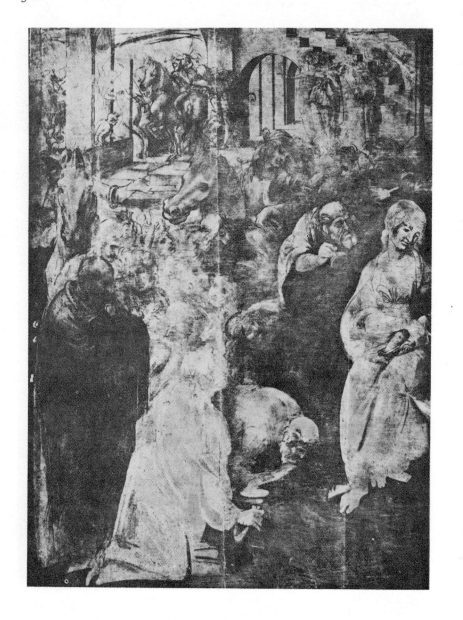

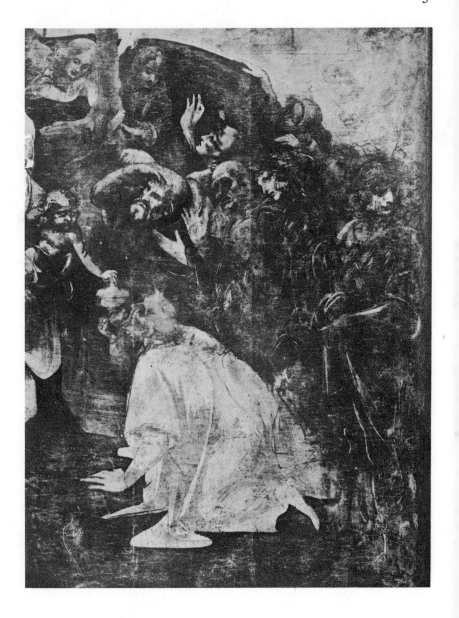

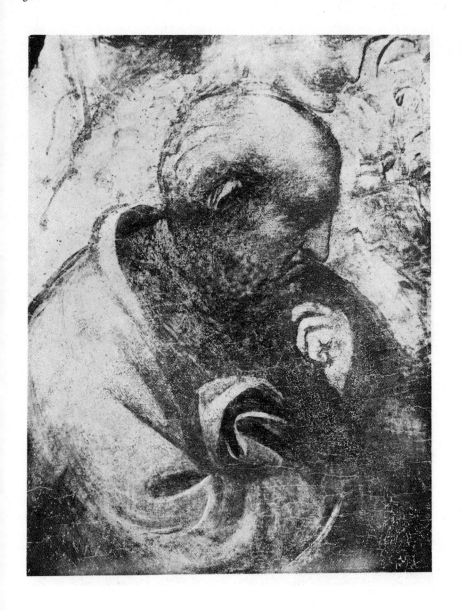

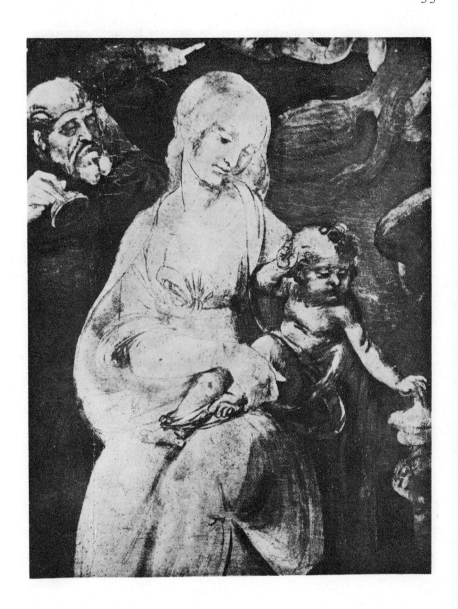

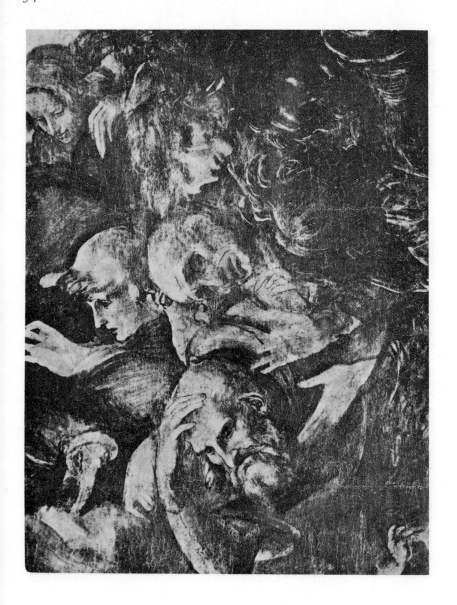

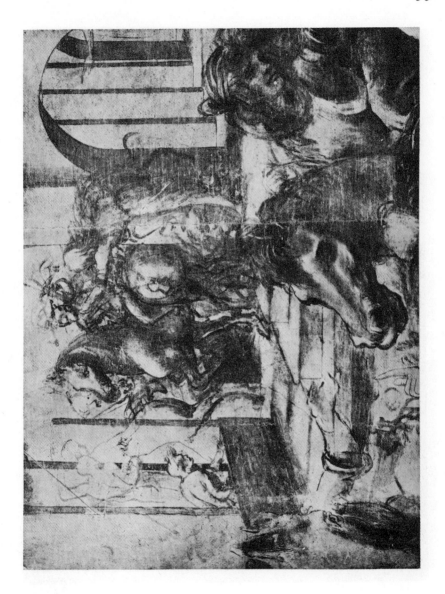

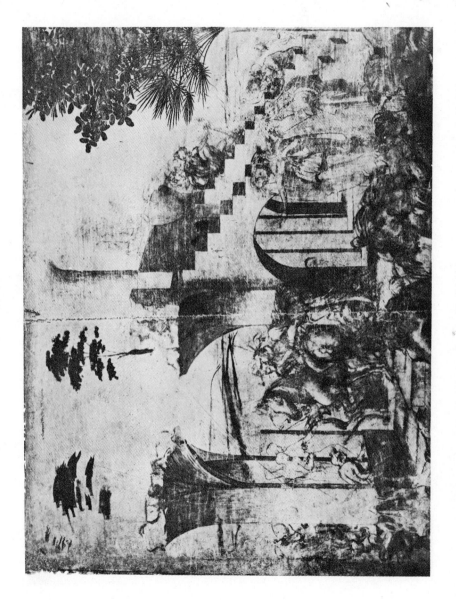

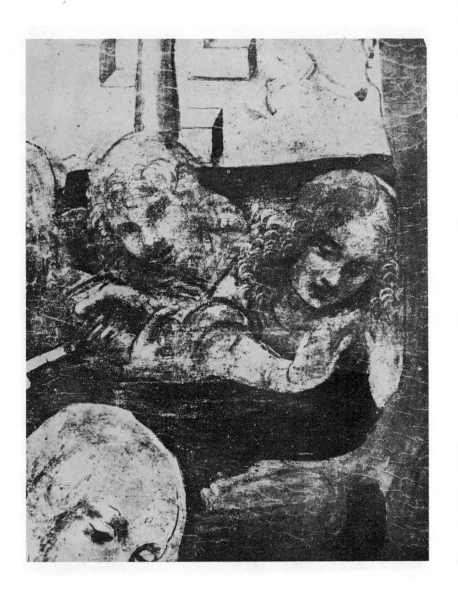

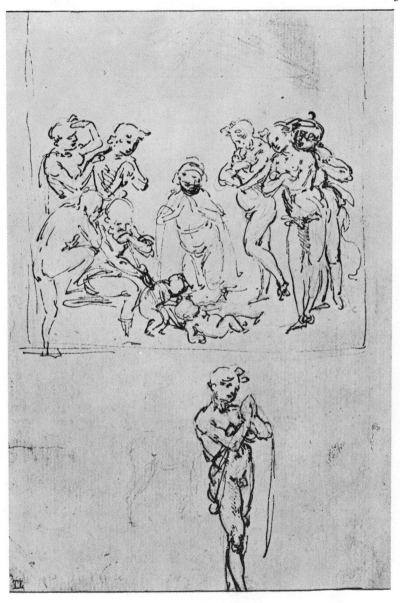

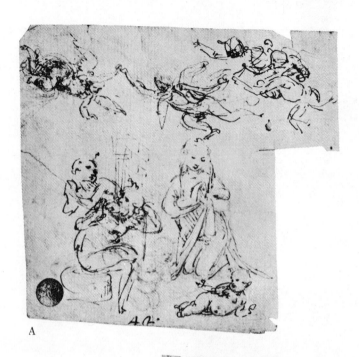

A

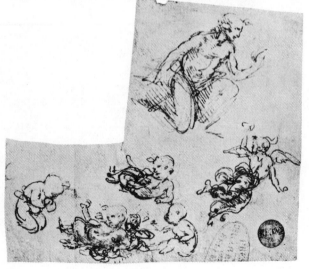

B

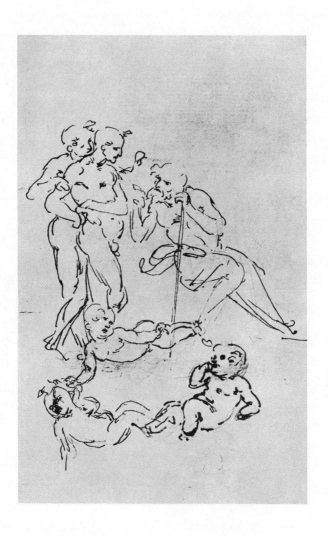

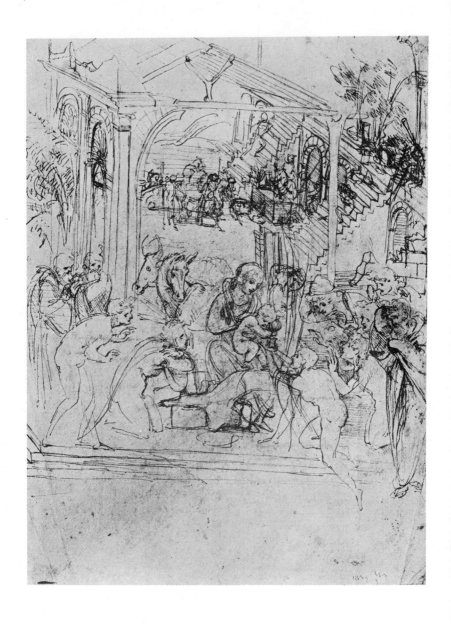

42

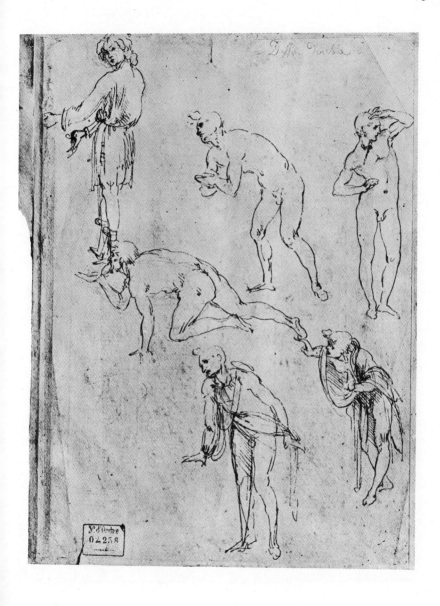

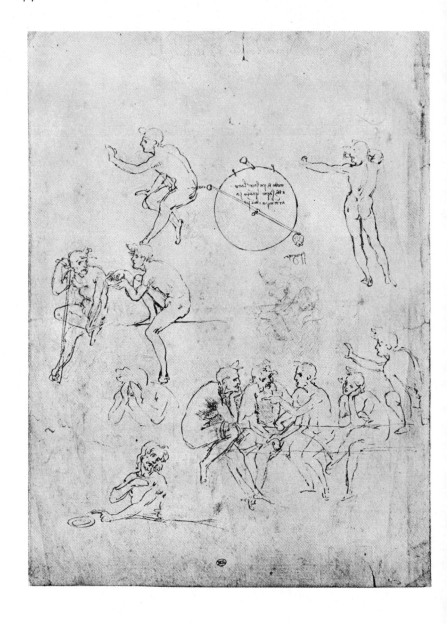

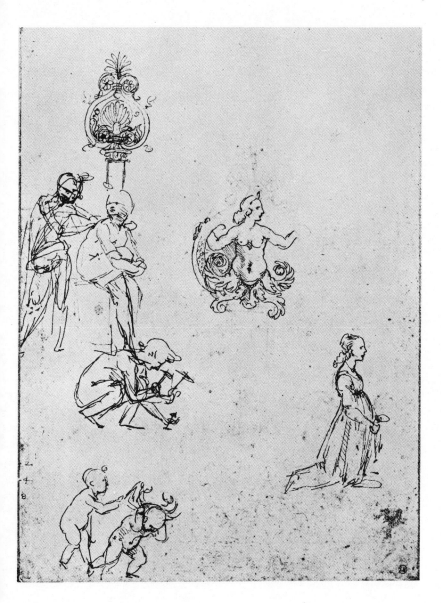

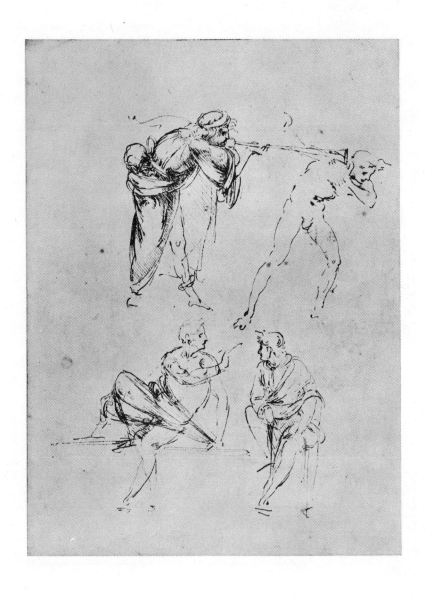

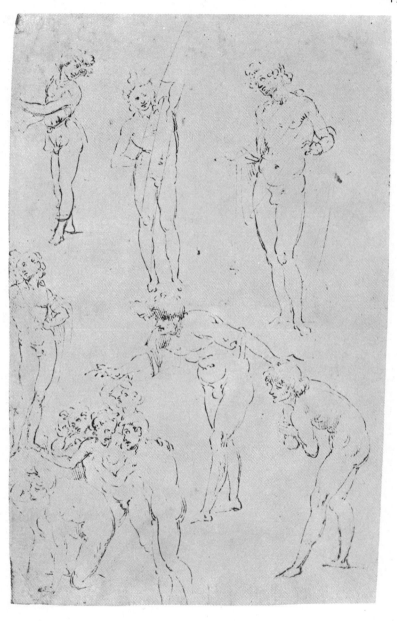

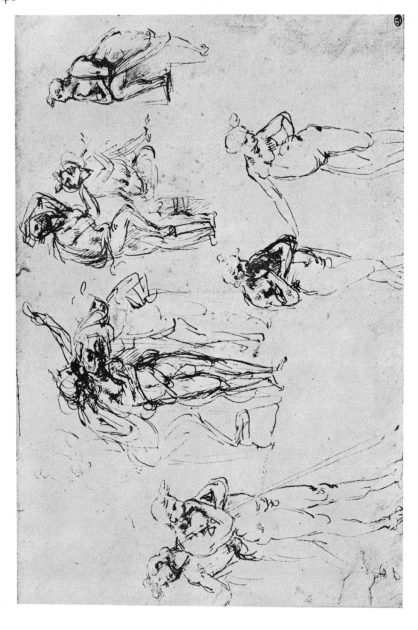

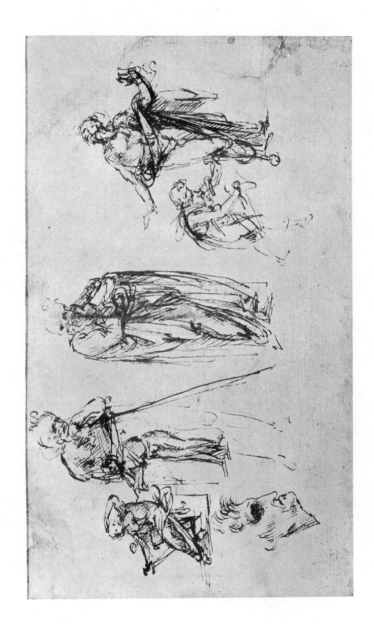

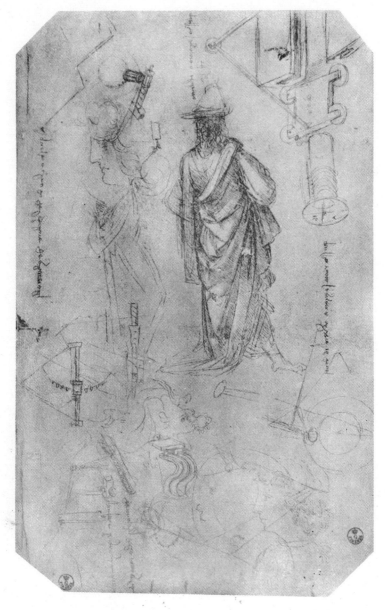

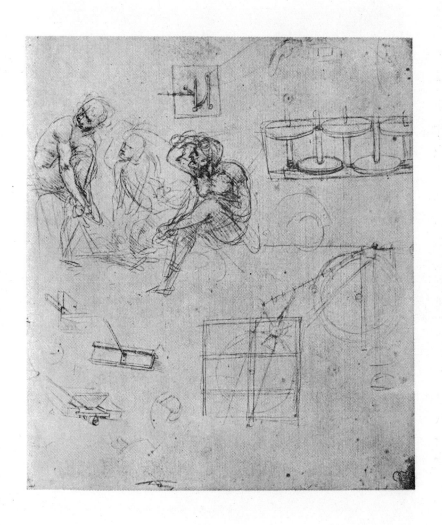

A

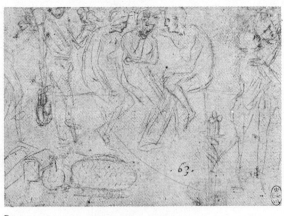

B

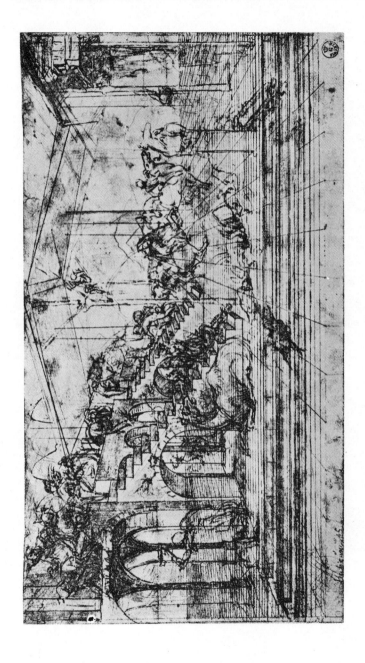

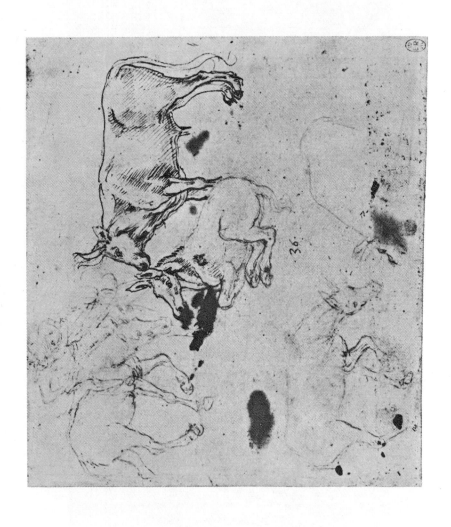

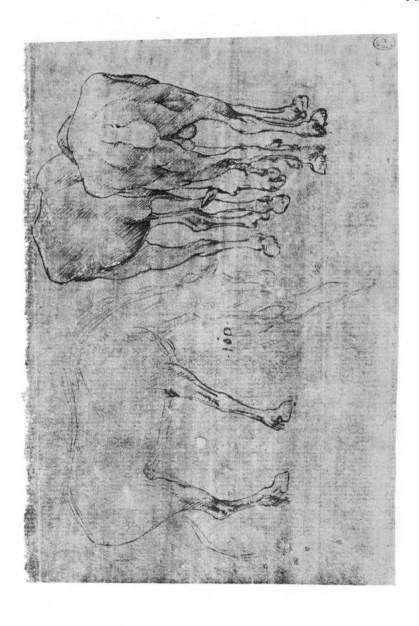

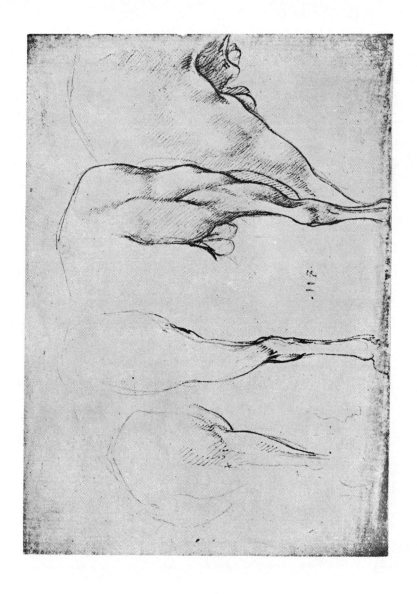

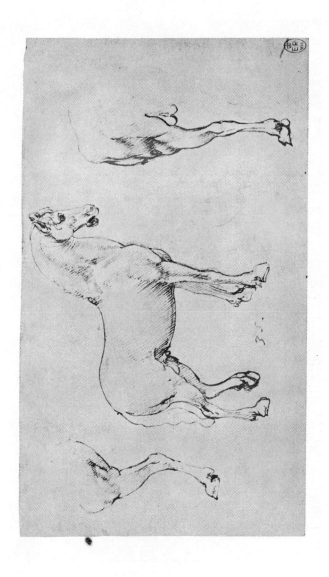

58

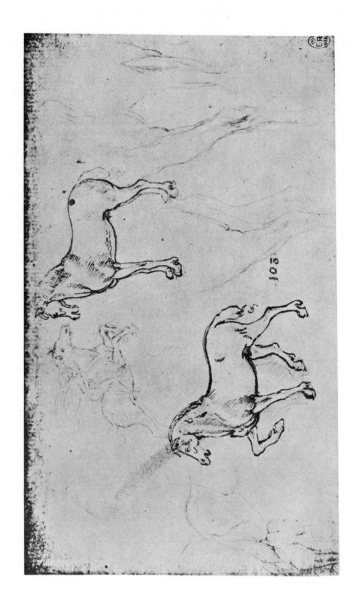

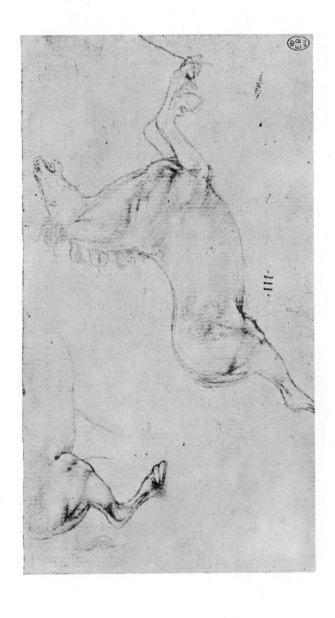

A

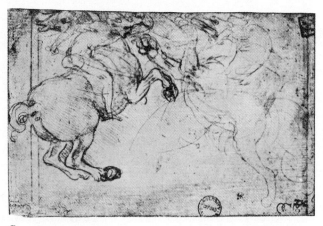

B

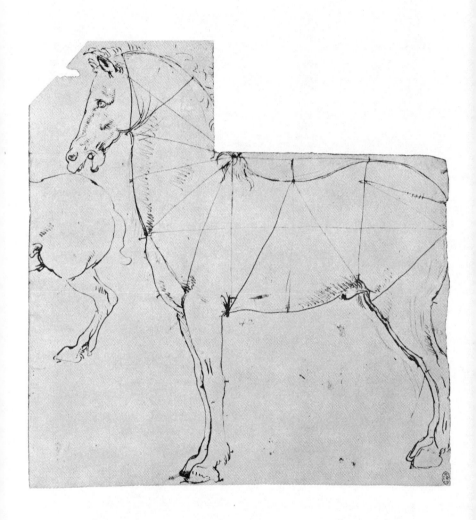

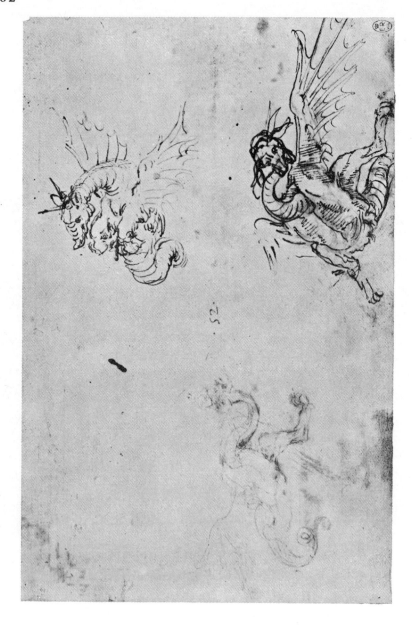

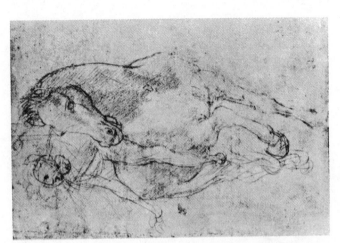

B

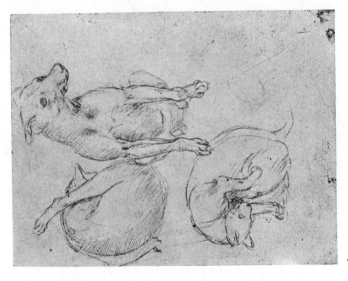

A

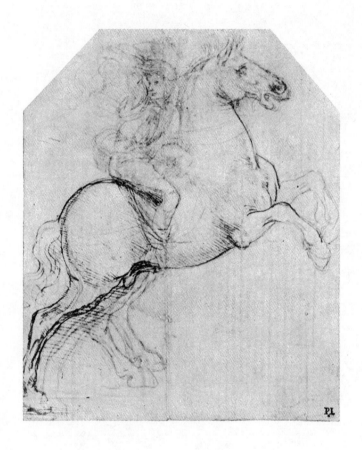

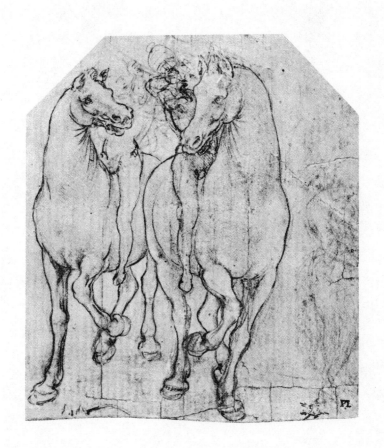

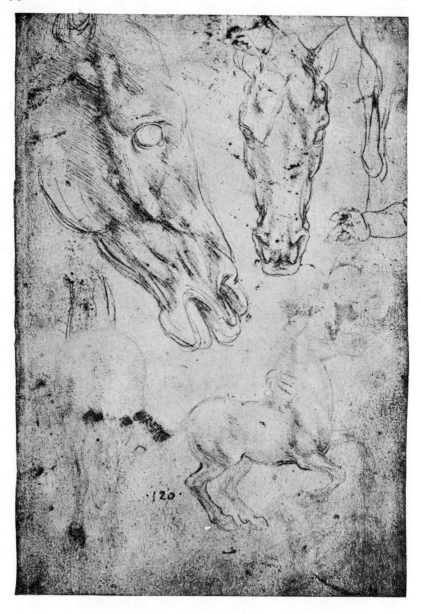

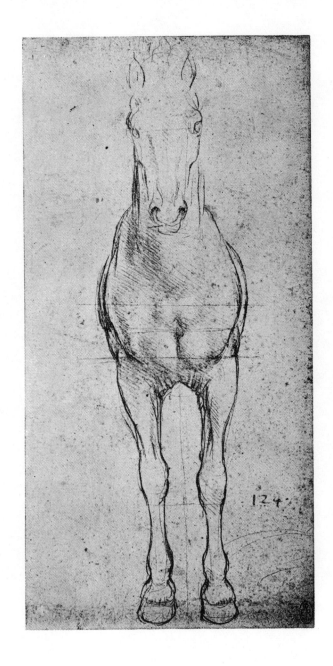

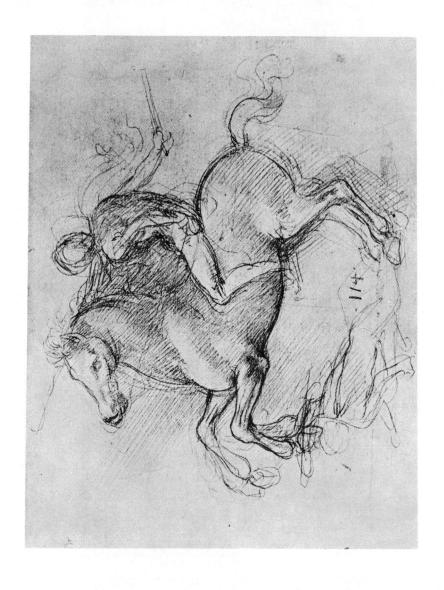

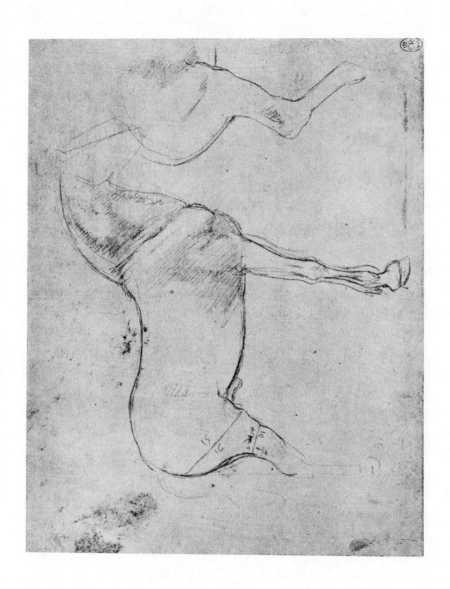

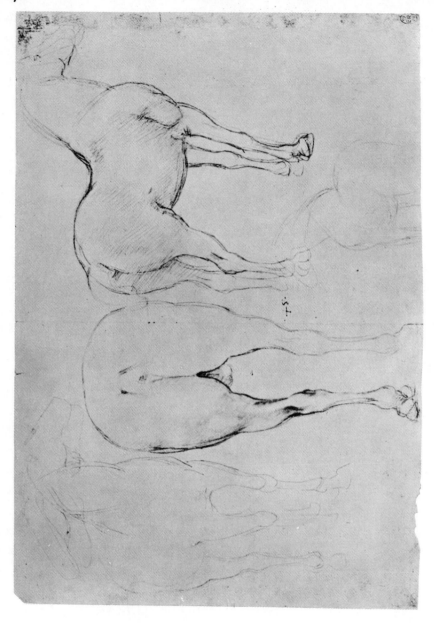

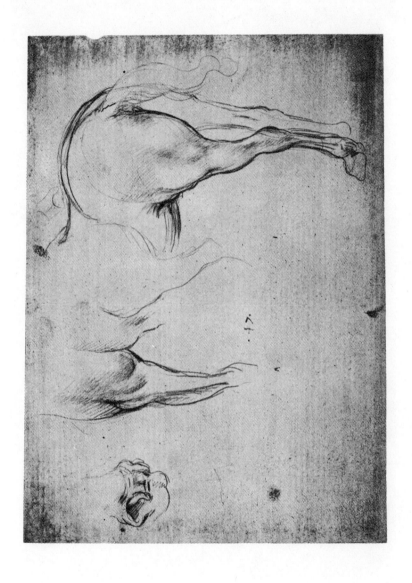

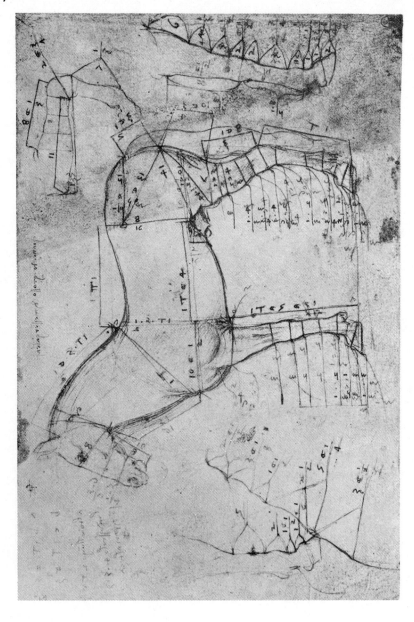

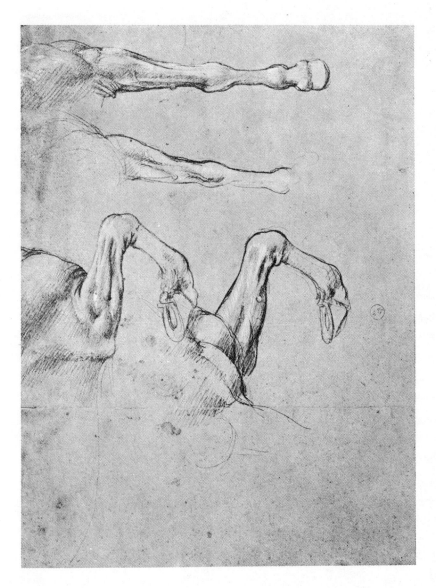

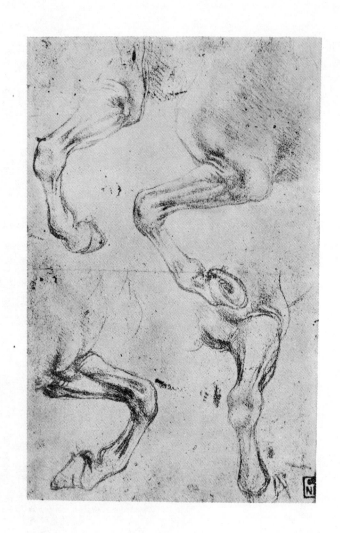

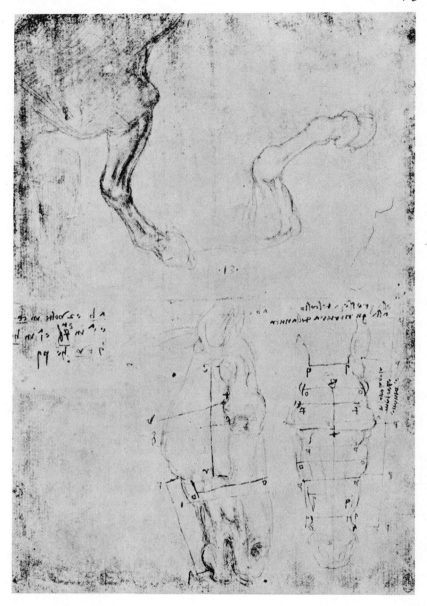

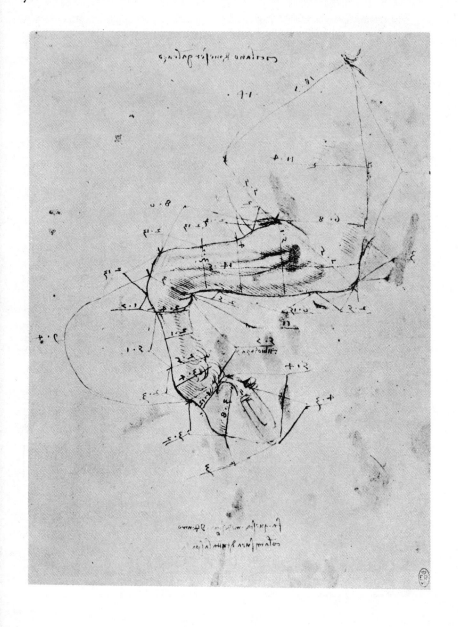

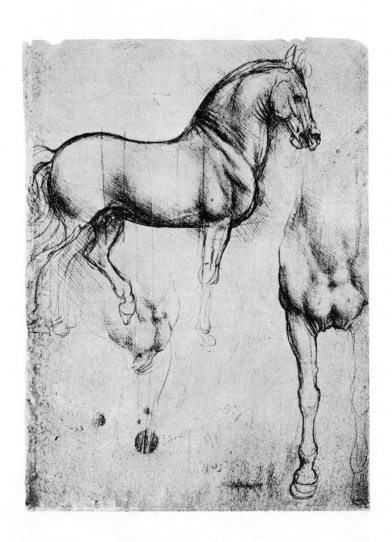

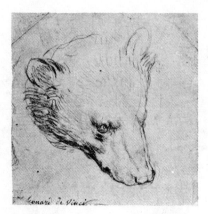

A

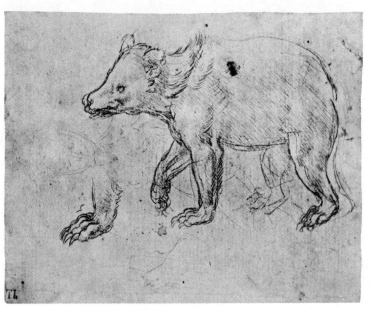

B

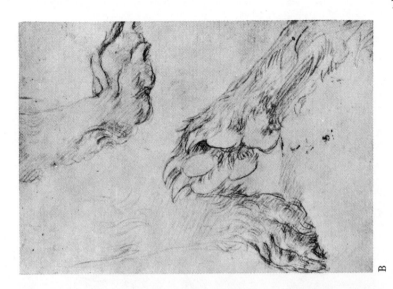

B

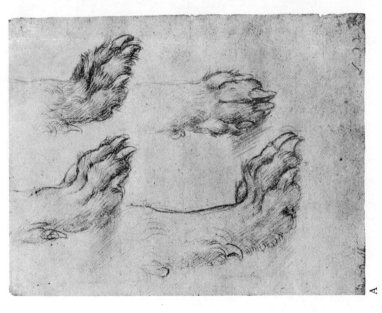

A

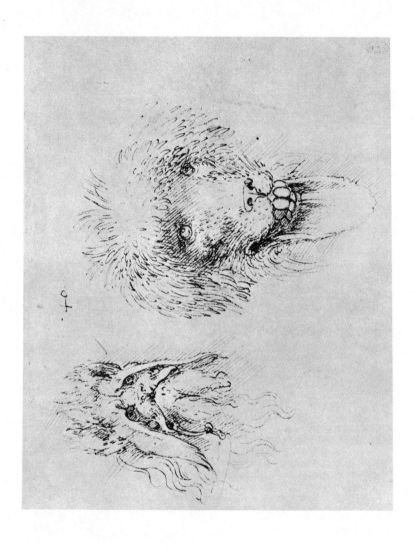

B

A

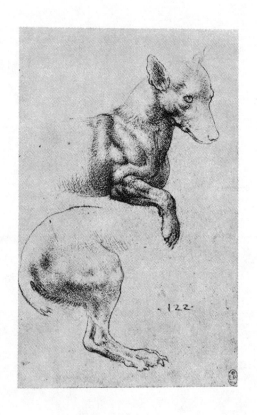

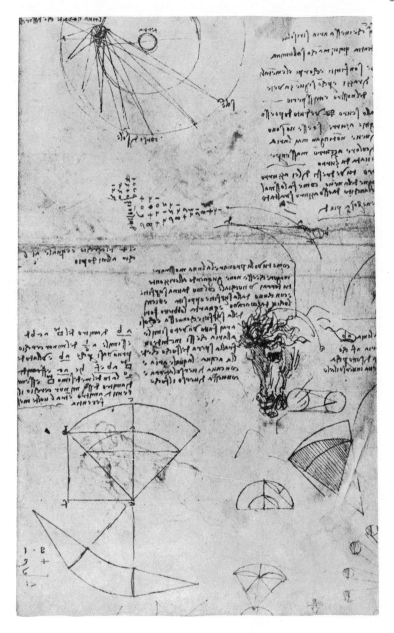

84

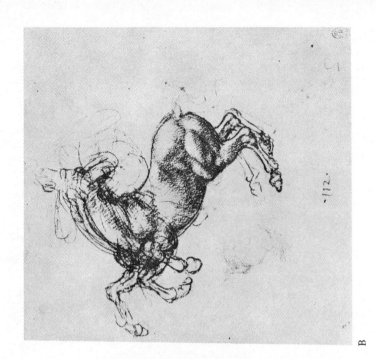

B

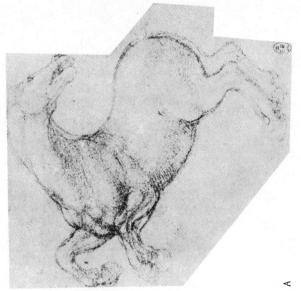

A

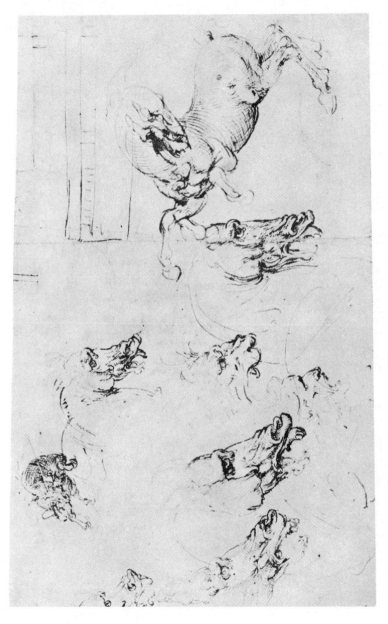

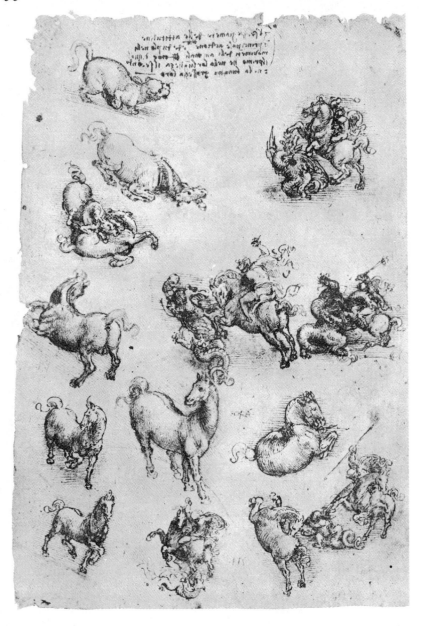

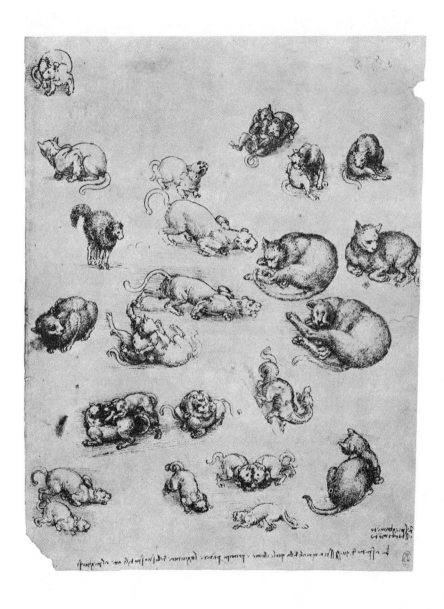

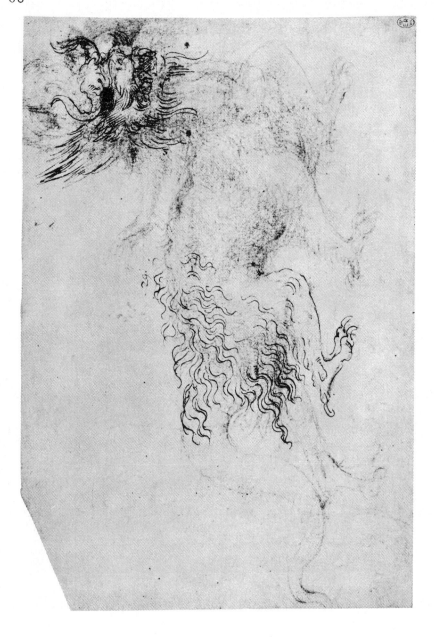

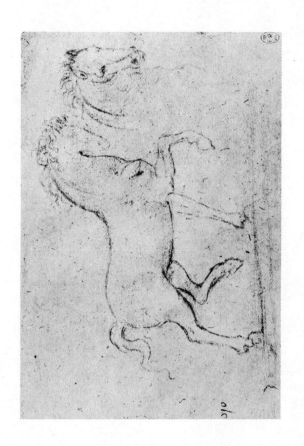

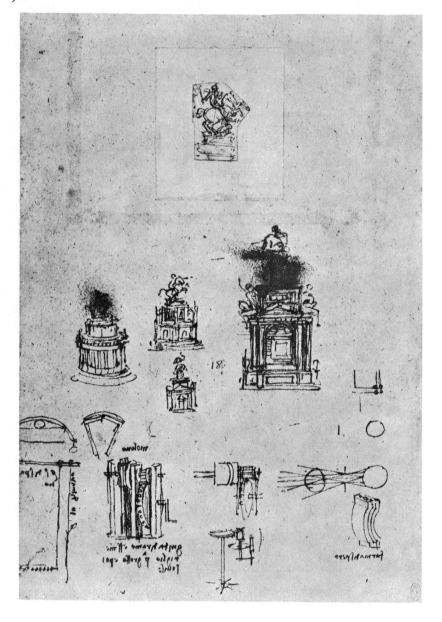

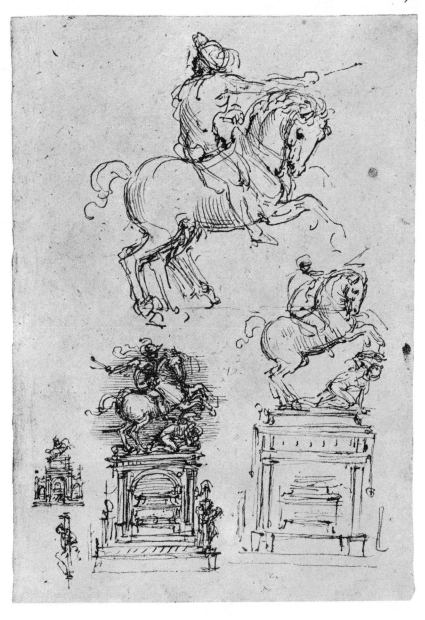

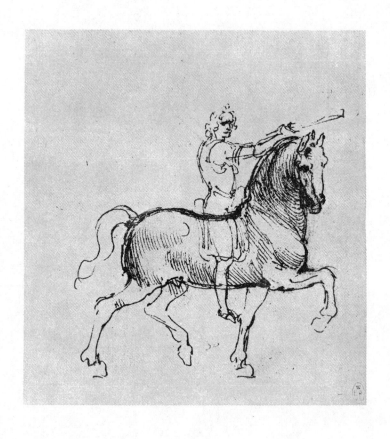

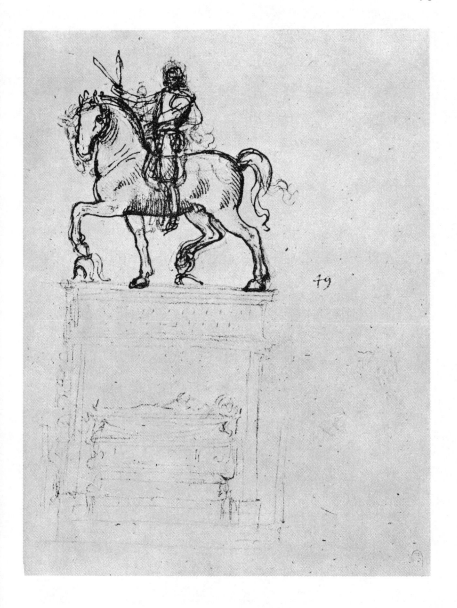

79

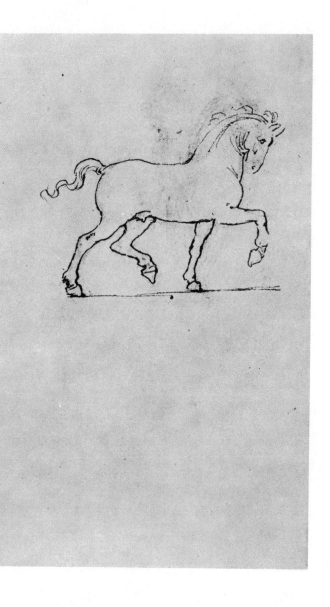

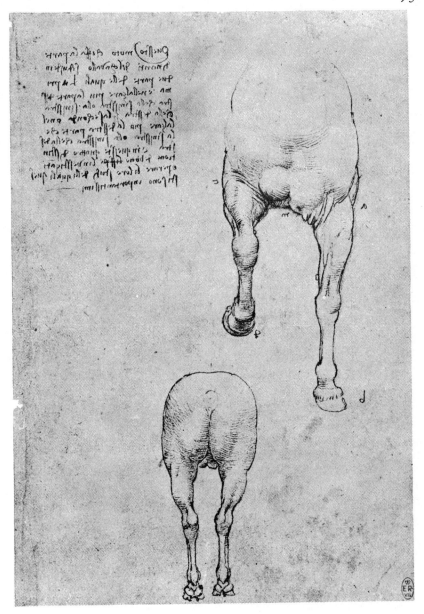

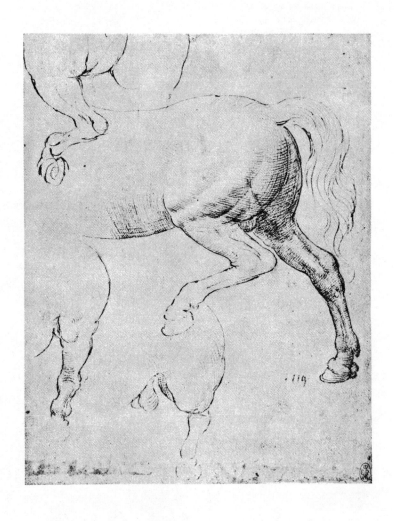

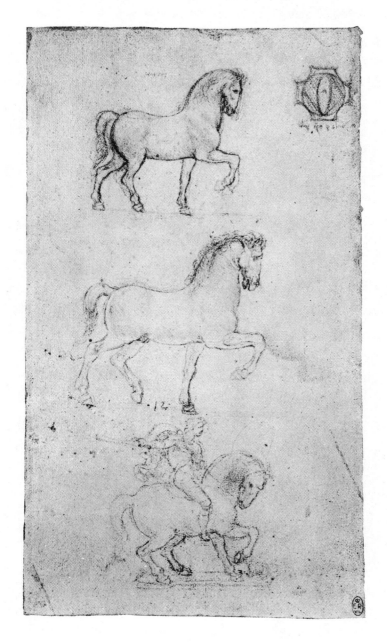

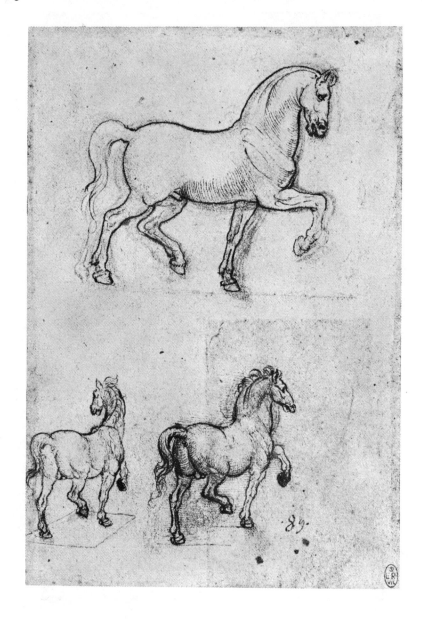

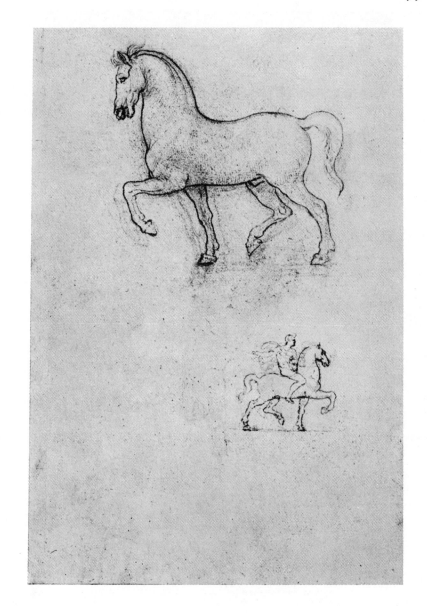

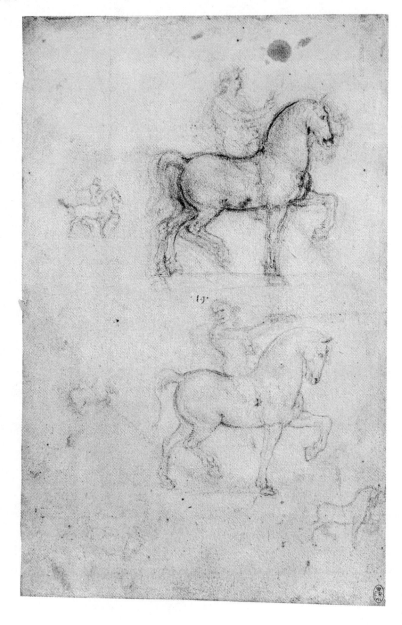

·19·

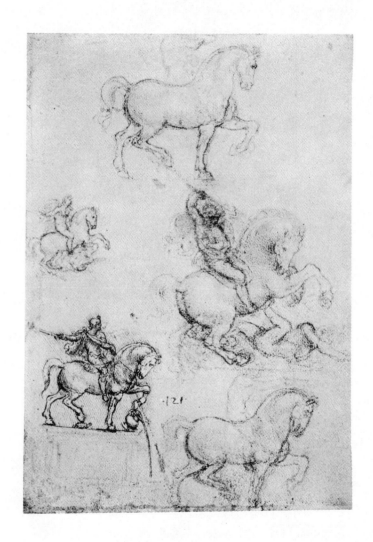

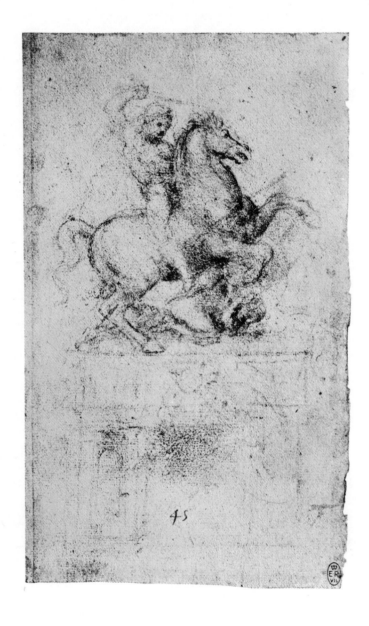

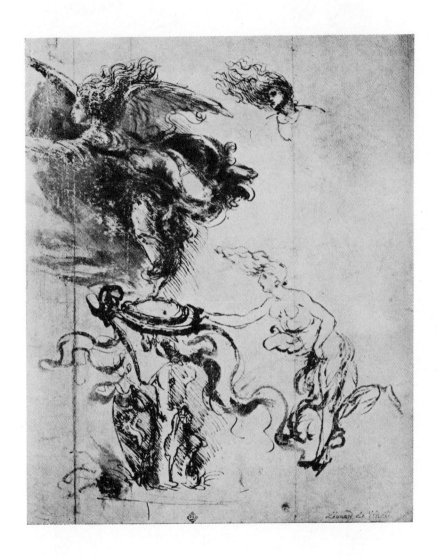

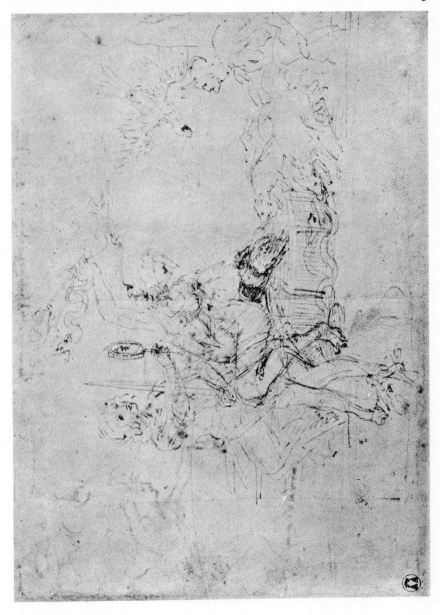

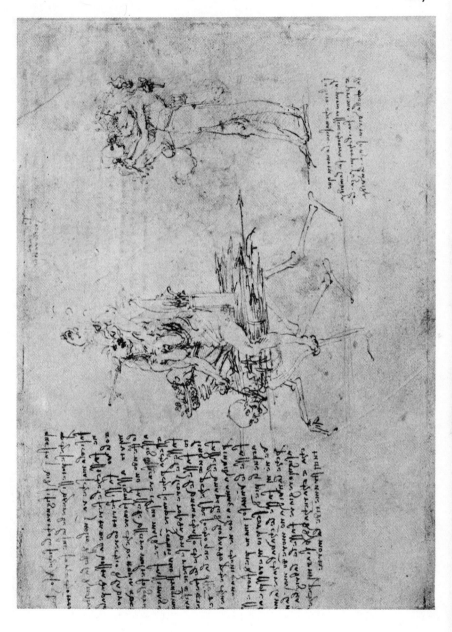

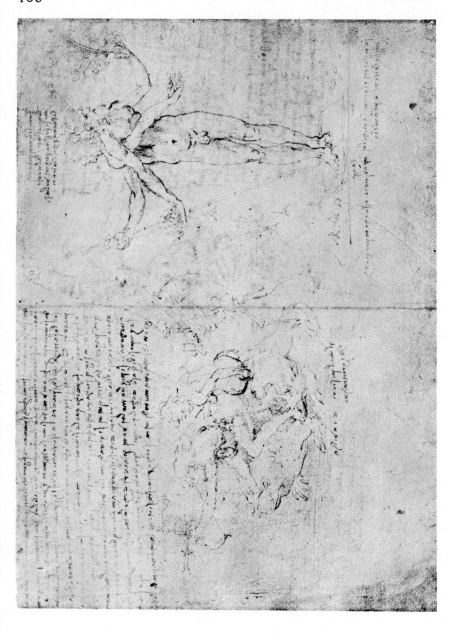

B

A

Leonardo da Vinci

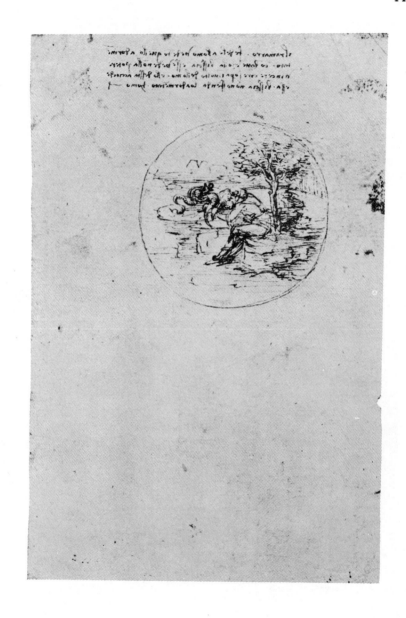

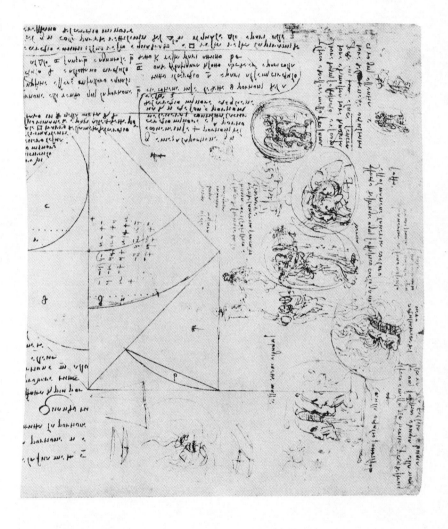

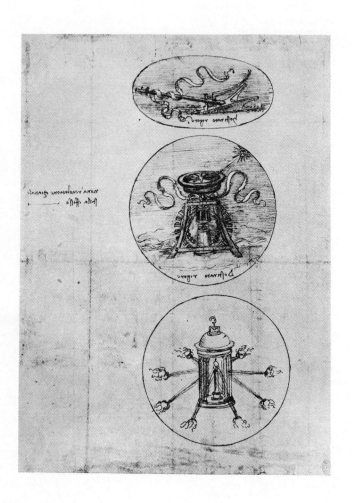

A

B

C

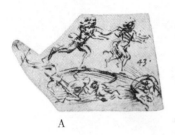

A

B

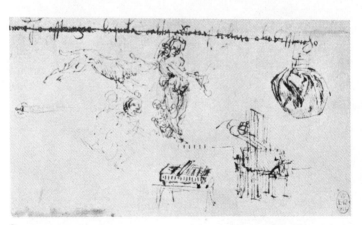

C

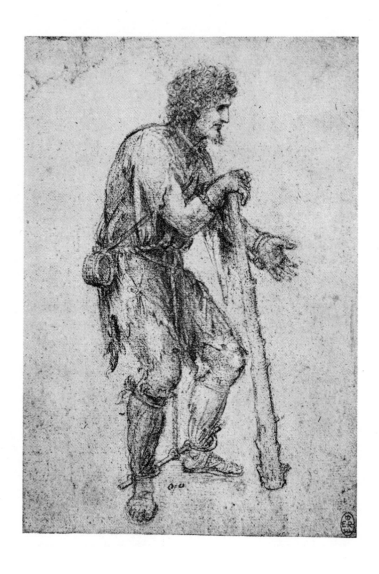

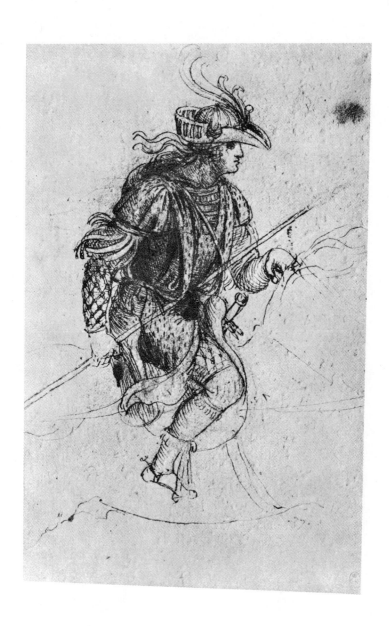

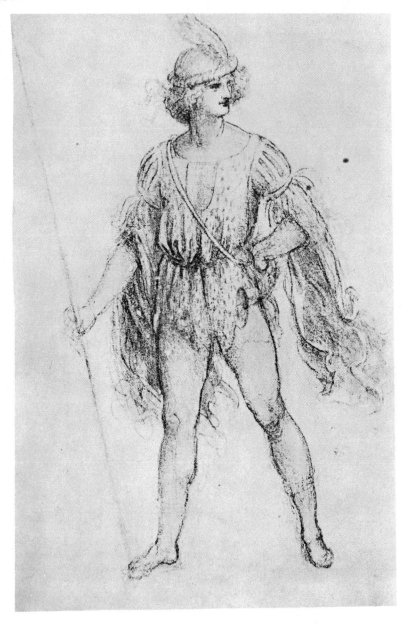

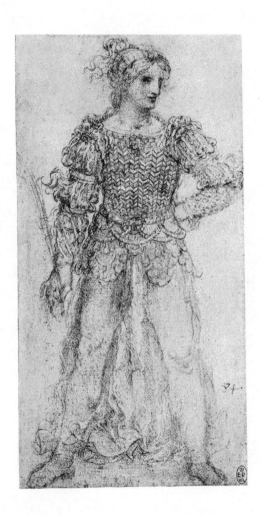

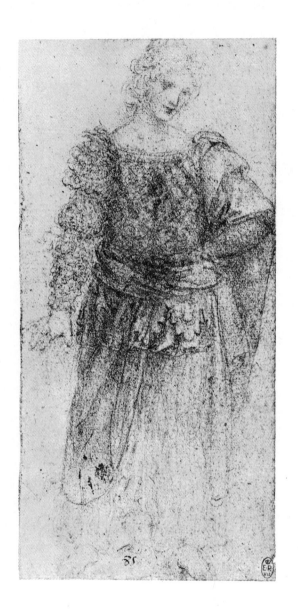

123

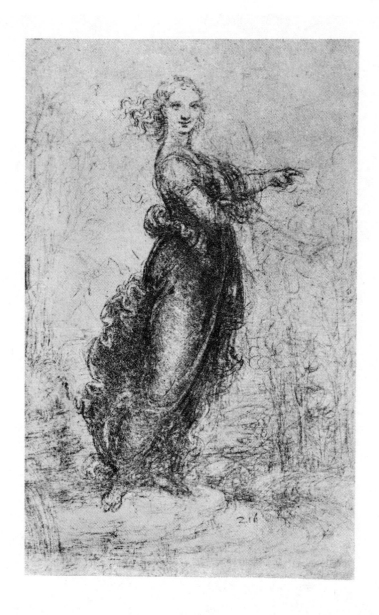

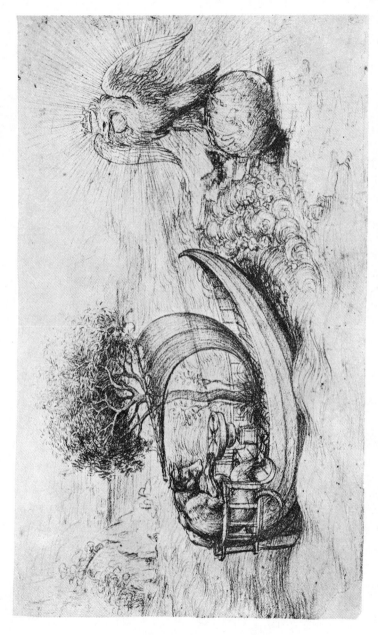

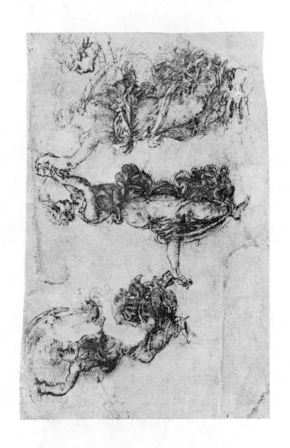

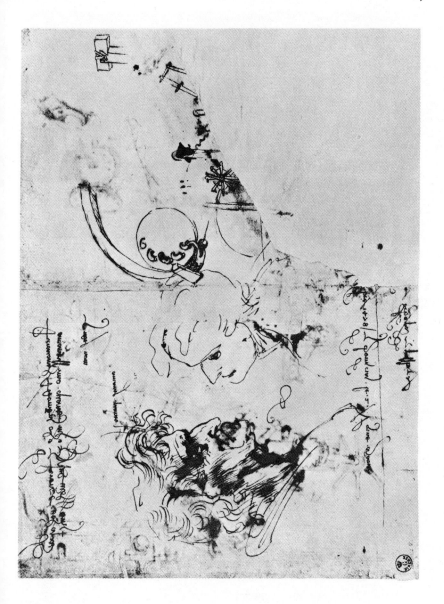

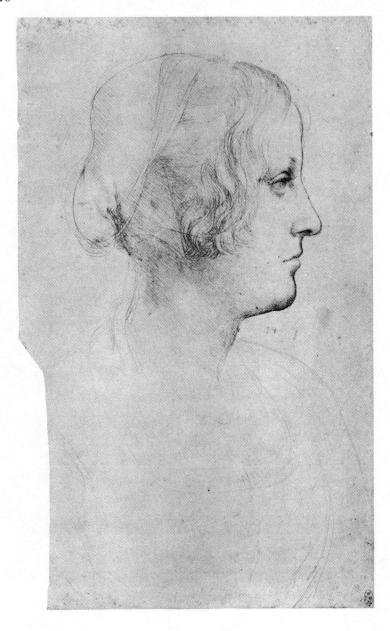

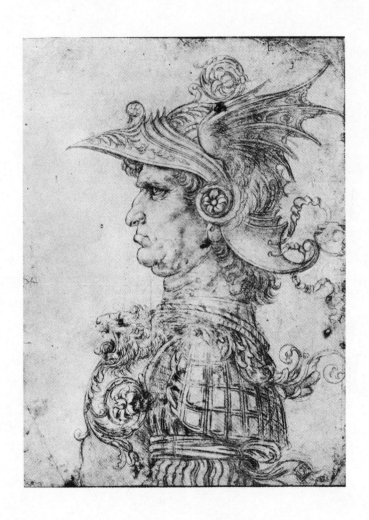

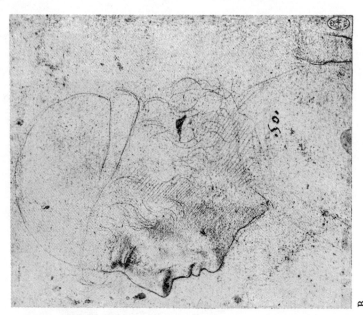

B

A

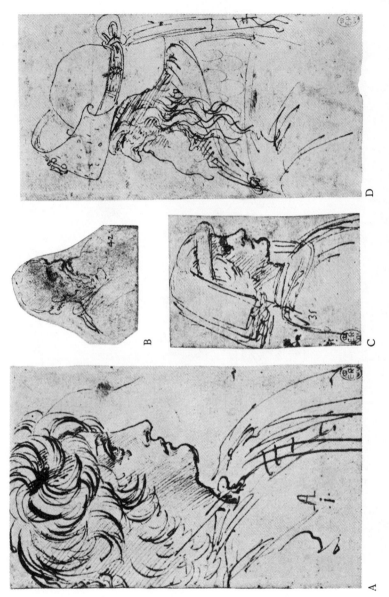

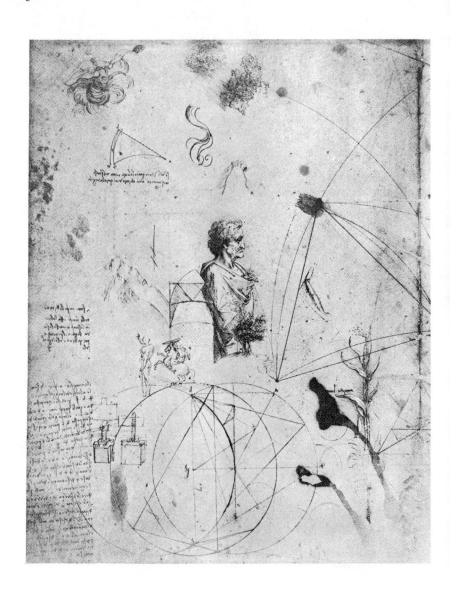

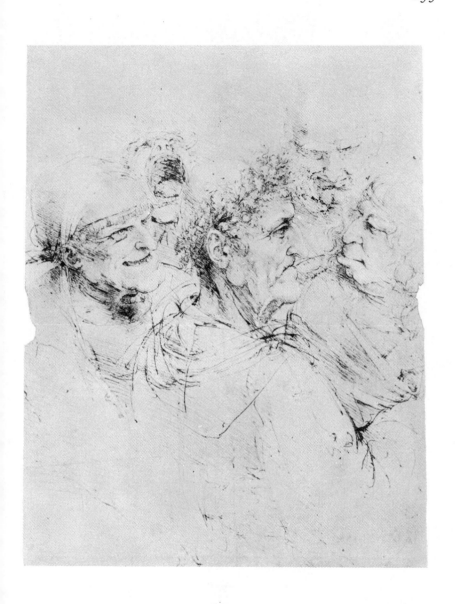

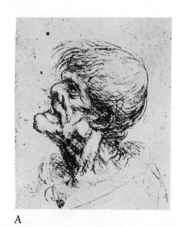

A

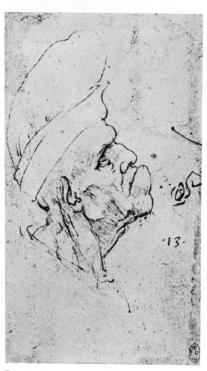

B

B

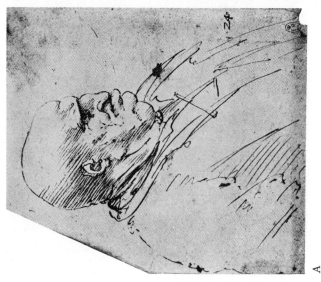

A

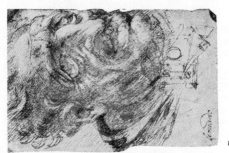

B

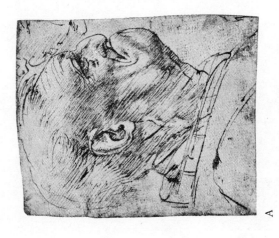

A

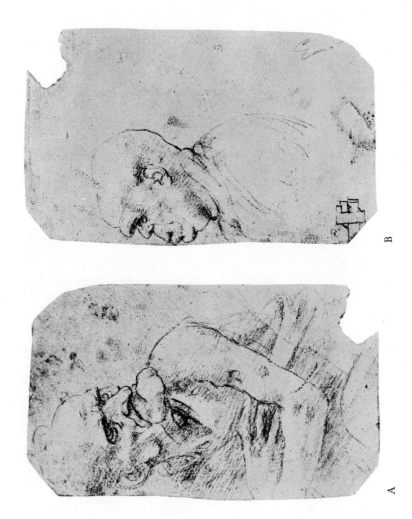

A

B

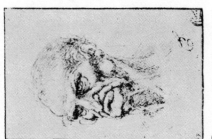

B

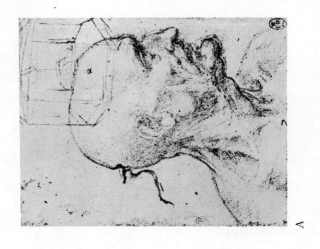

A

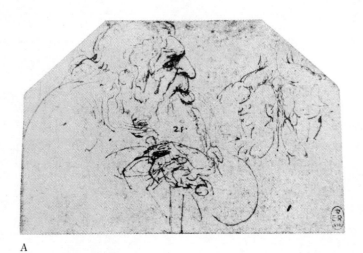

A

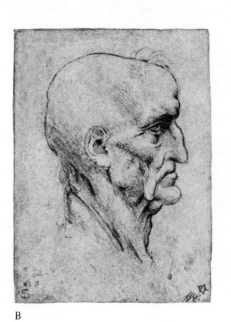

B

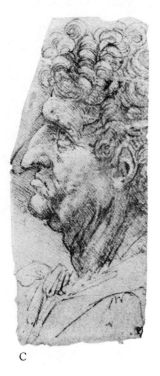

C

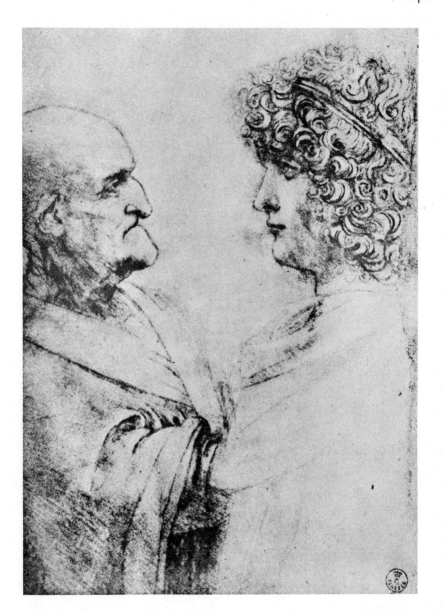

142

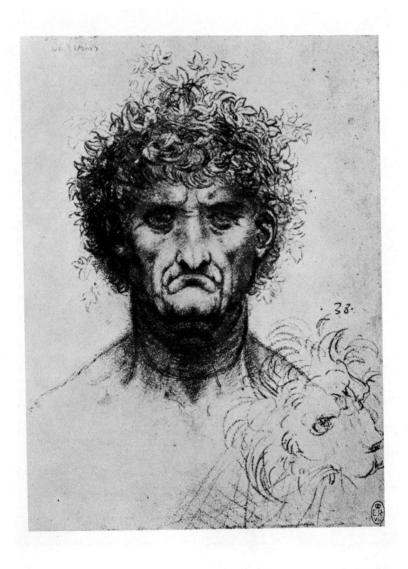

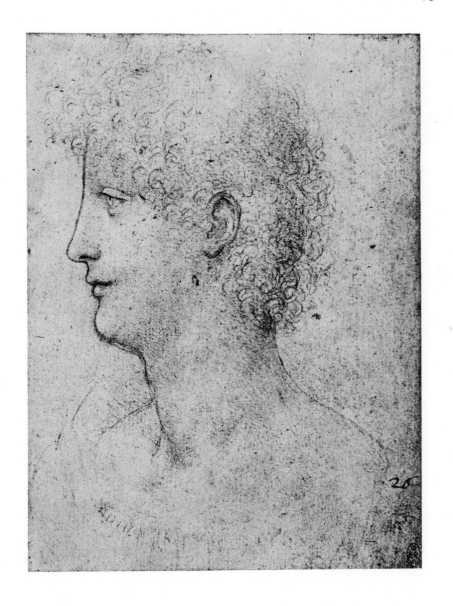

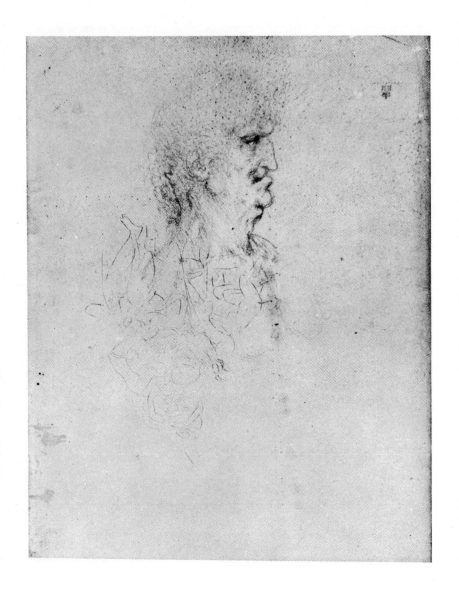

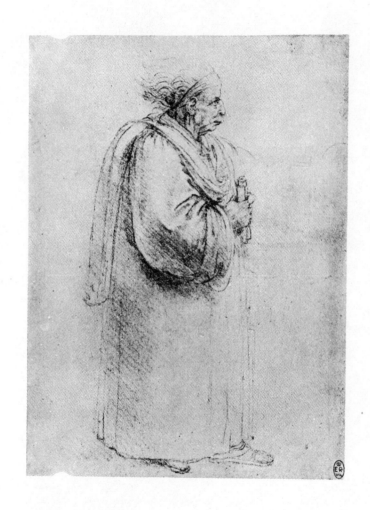

146

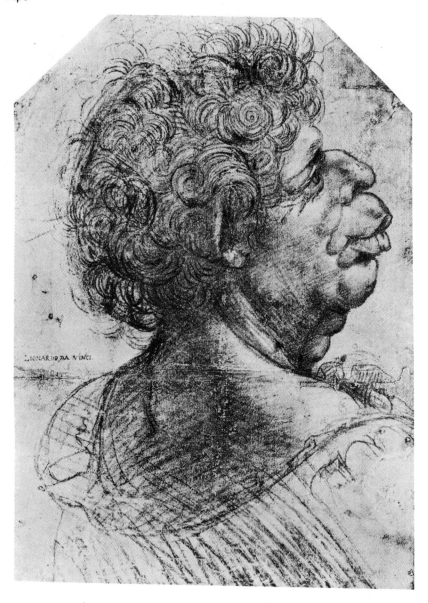

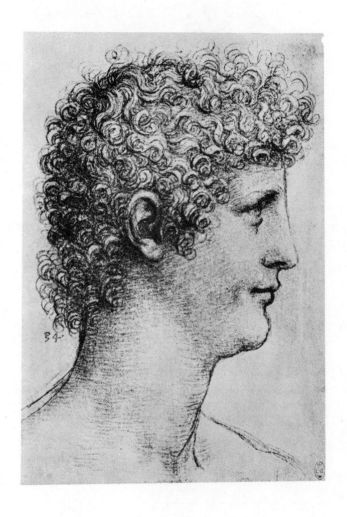

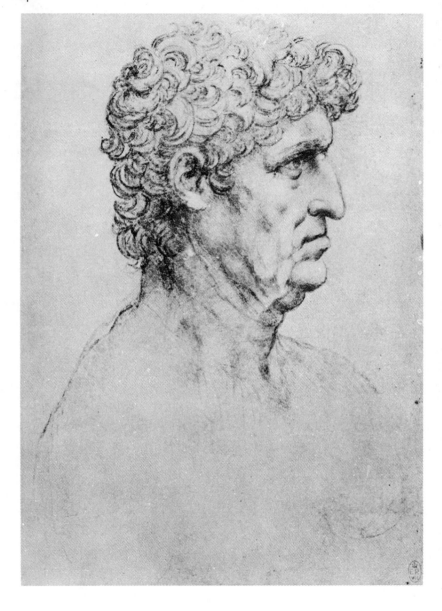

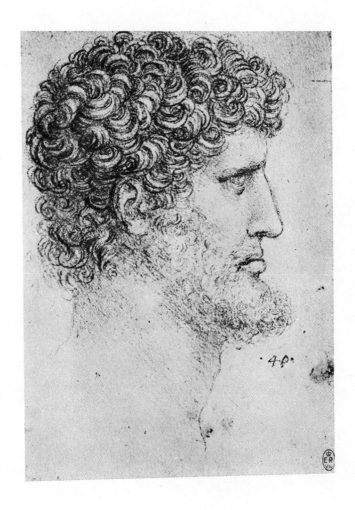

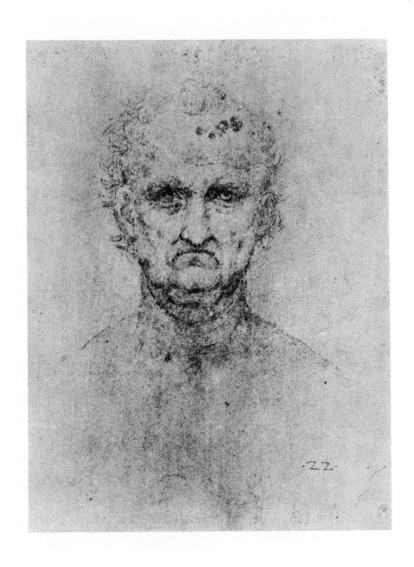

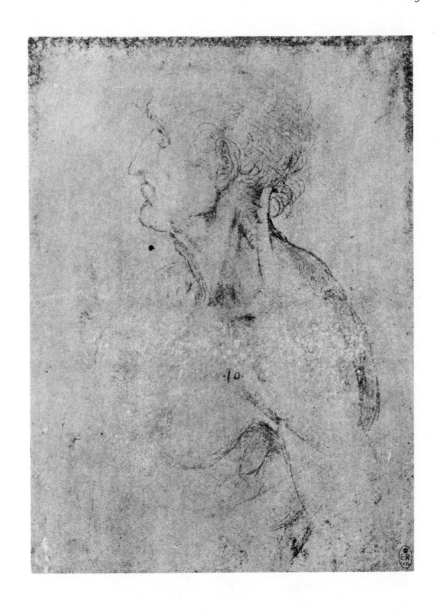

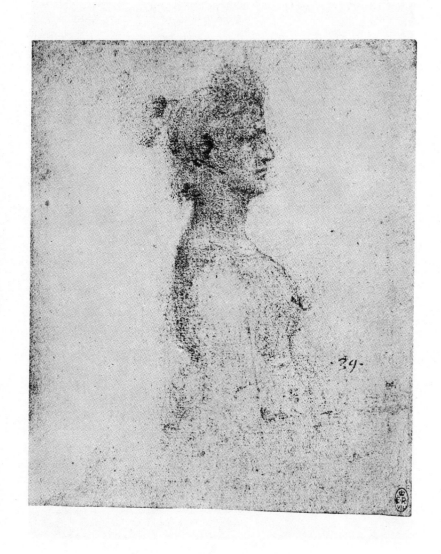

D. 10

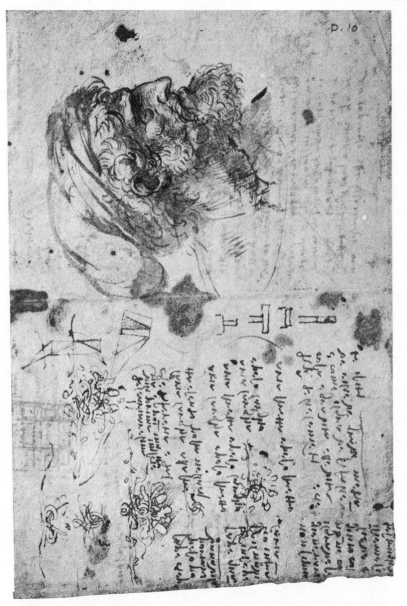

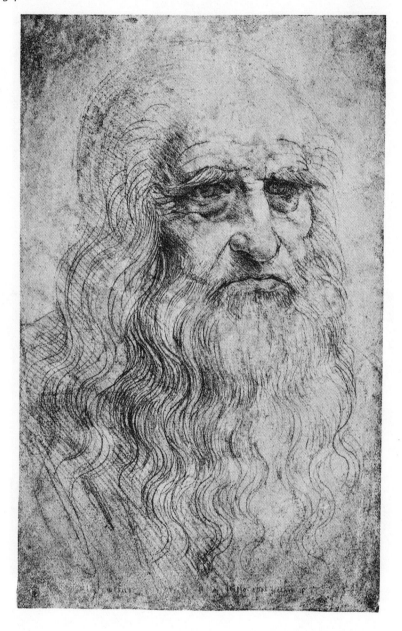

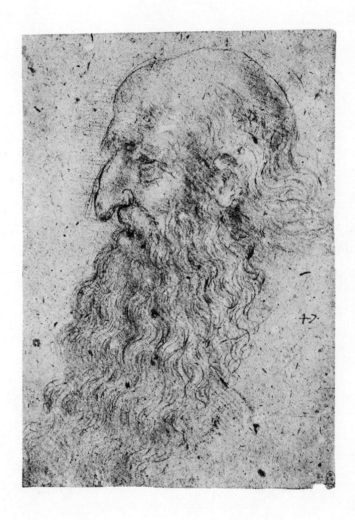

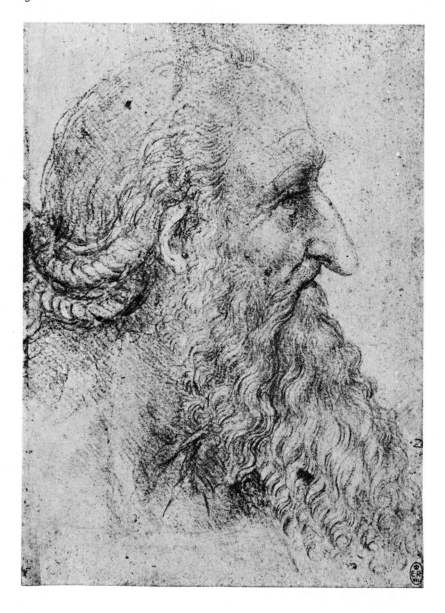

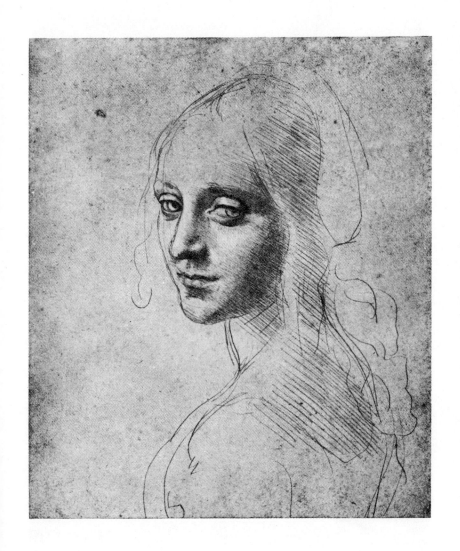

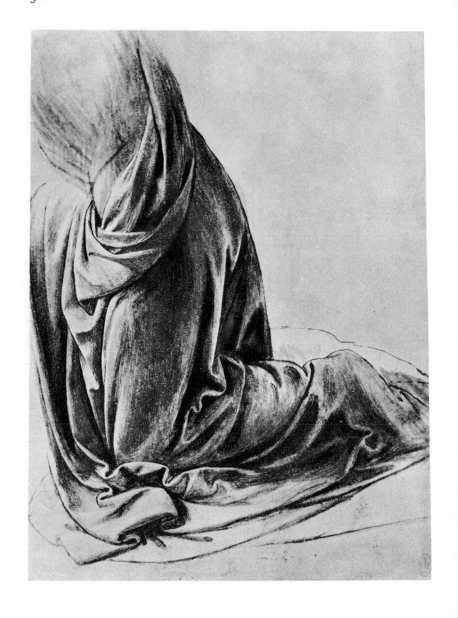

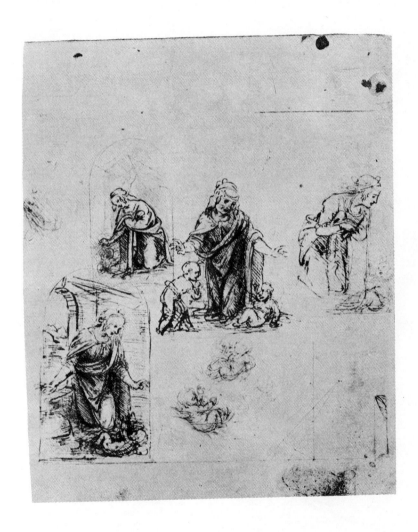

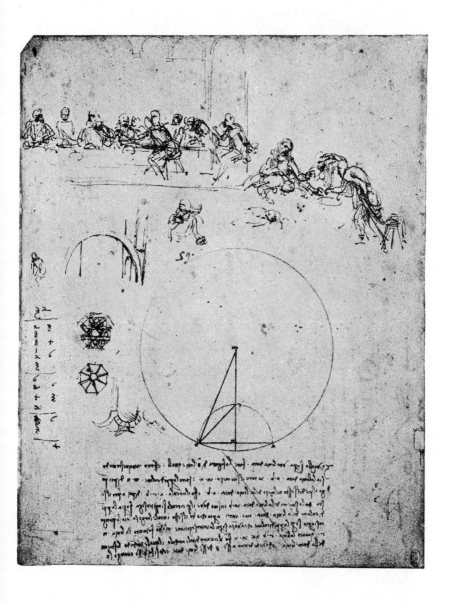

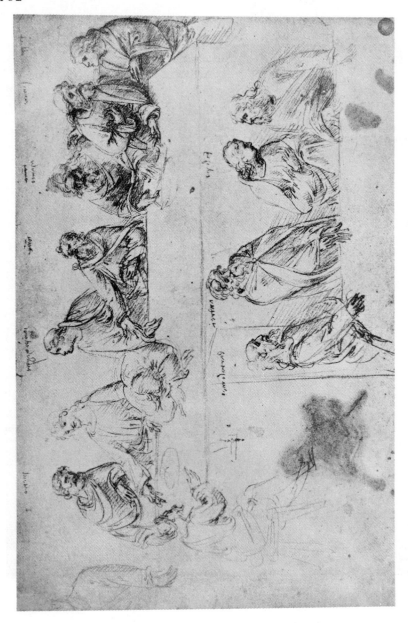

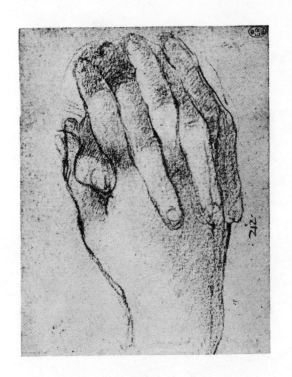

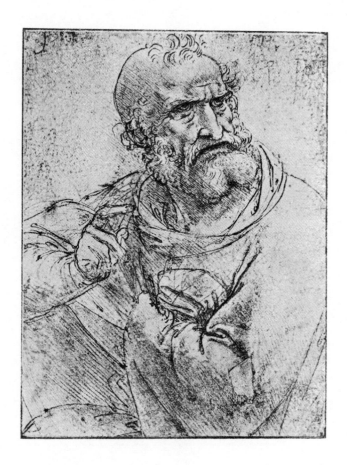

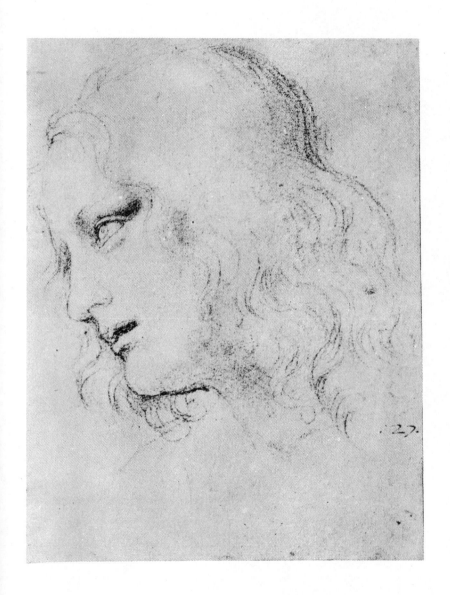

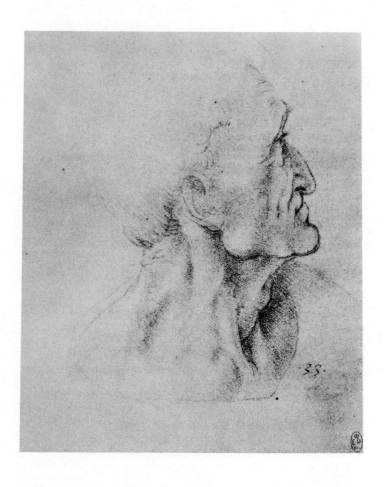

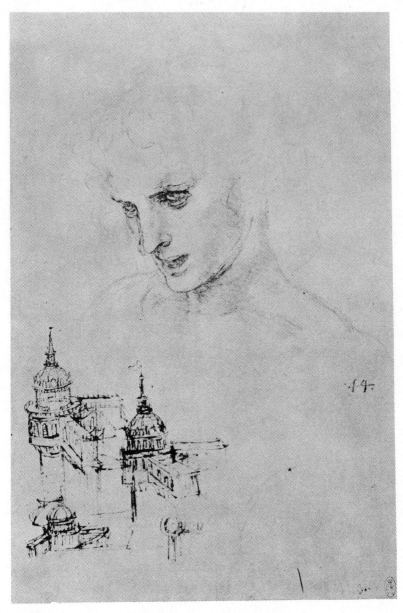

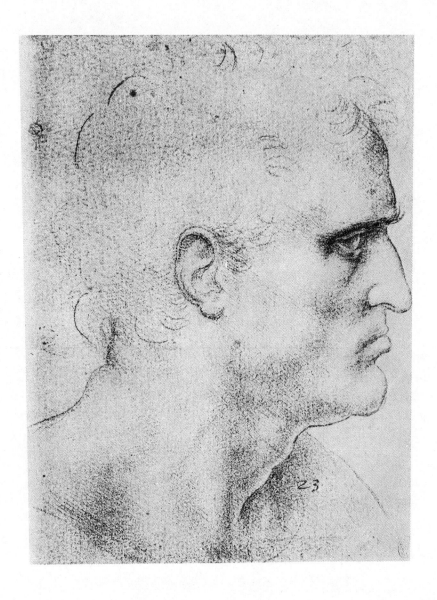

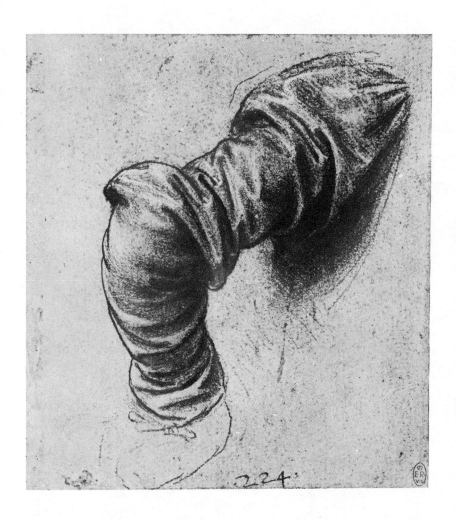

224

A

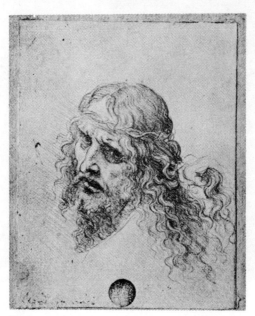

B

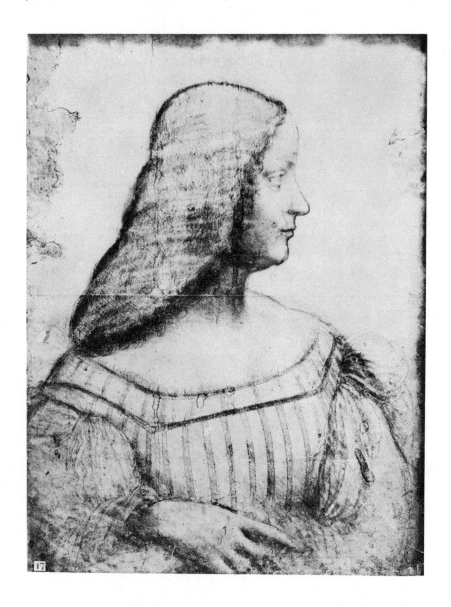

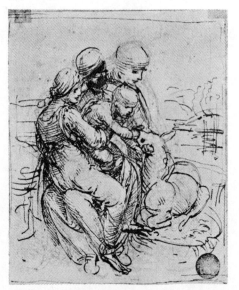

A

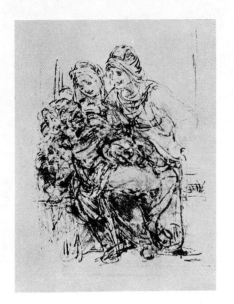

B

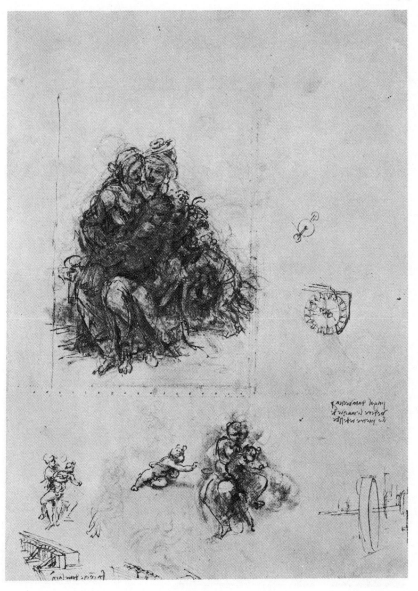

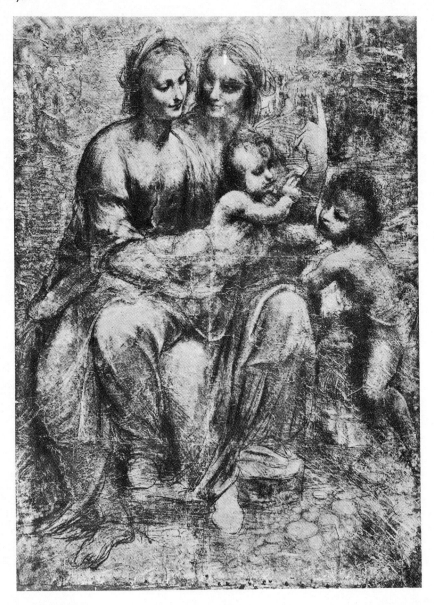

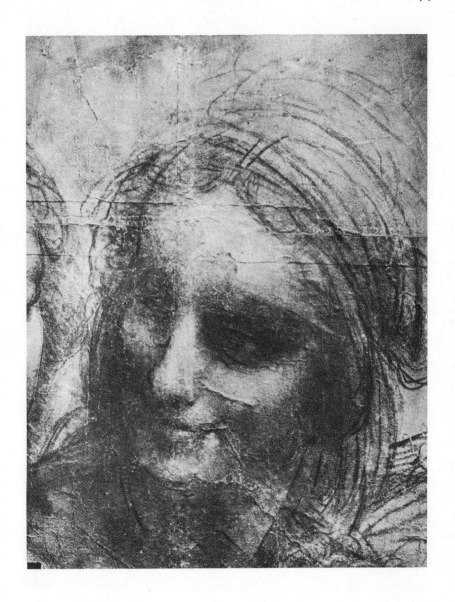

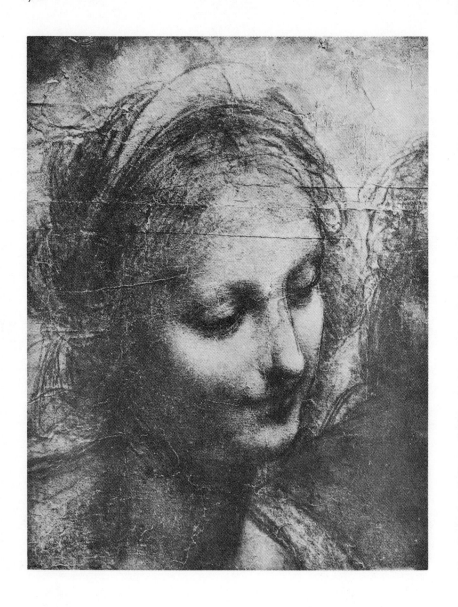

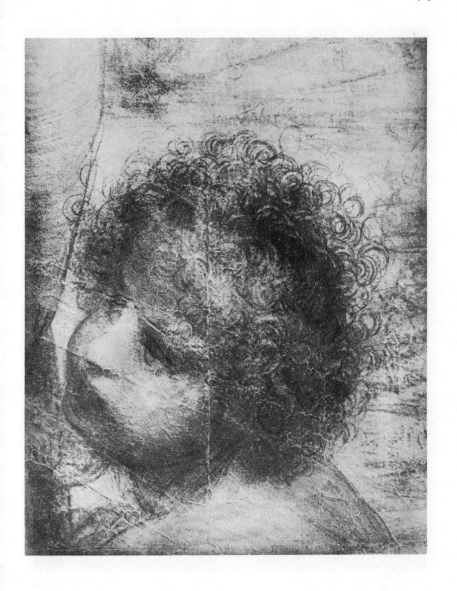

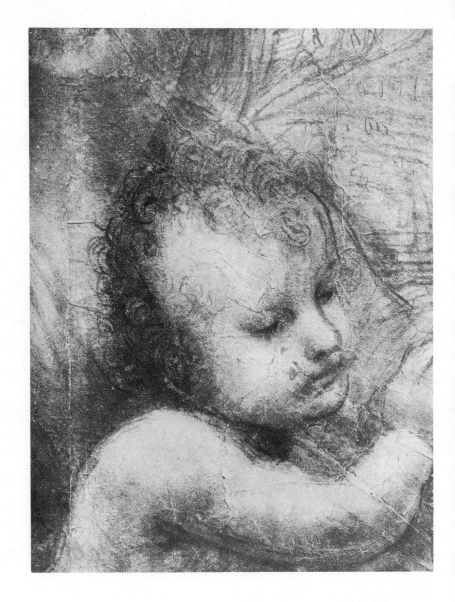

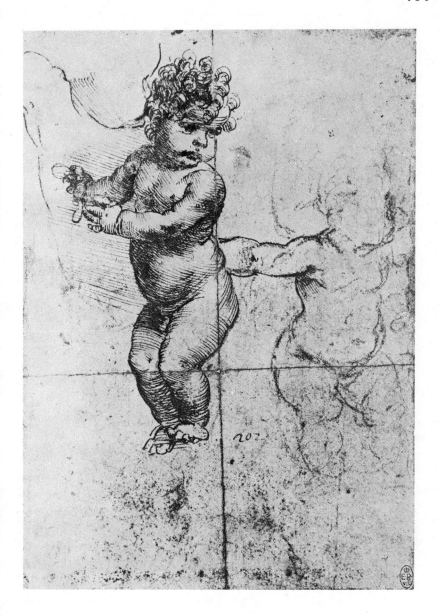

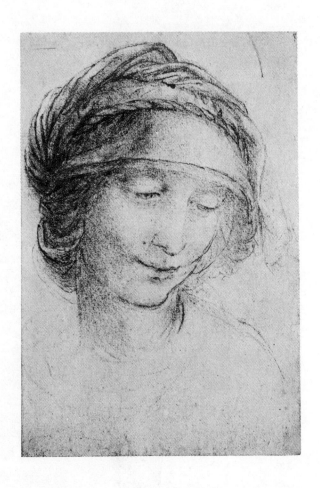

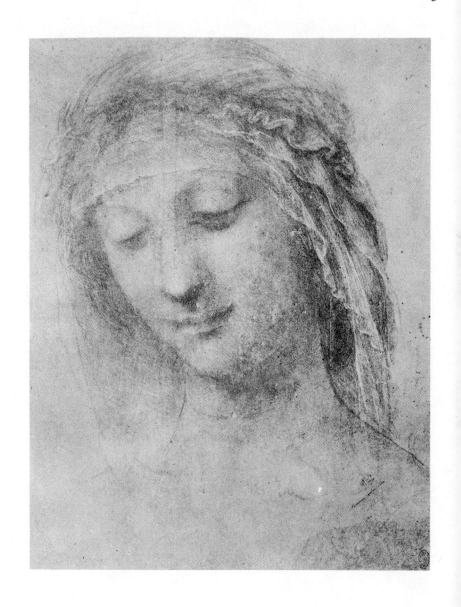

A

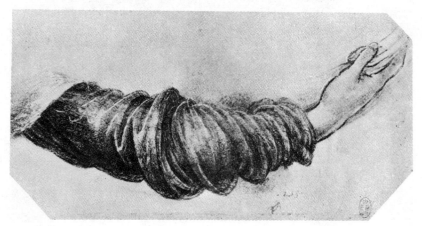

B

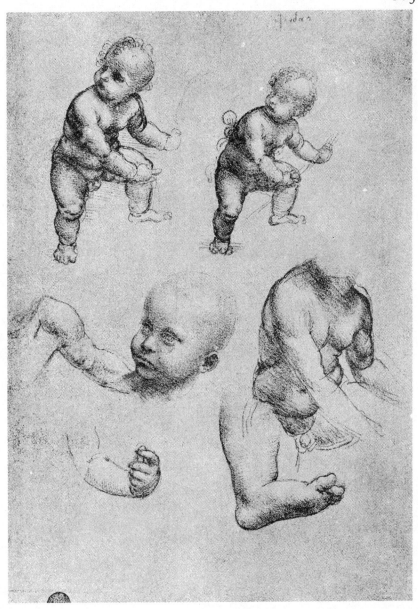

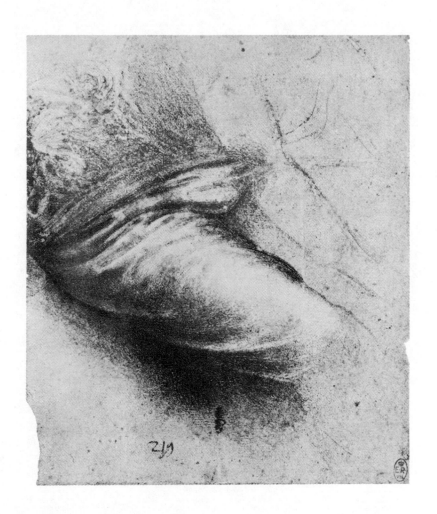

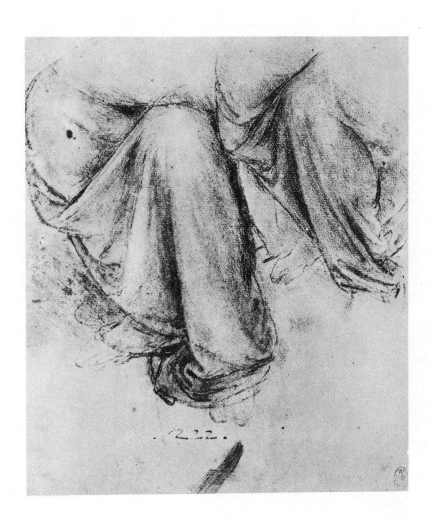

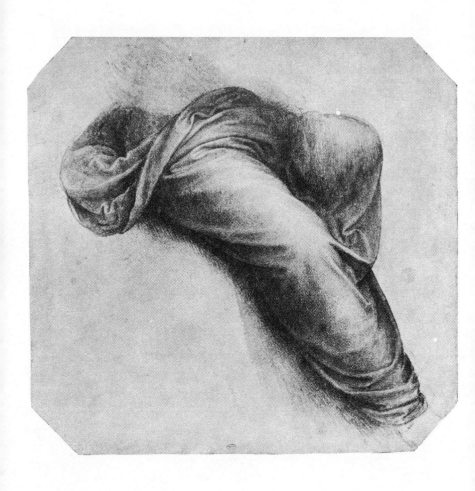

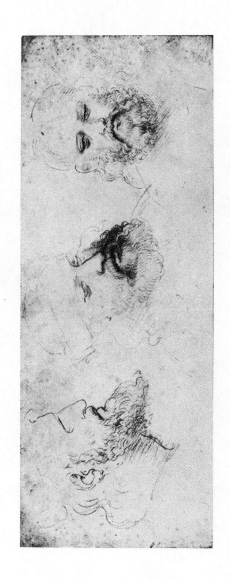

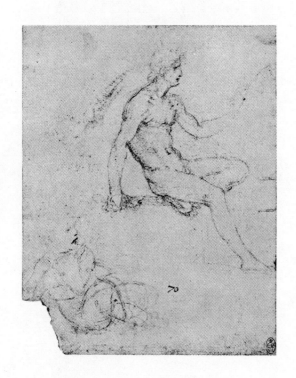

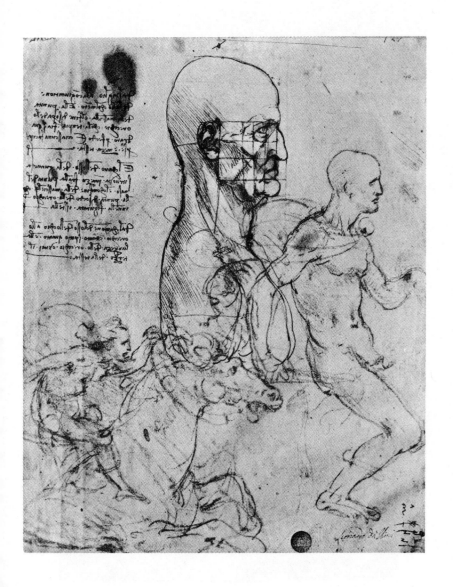

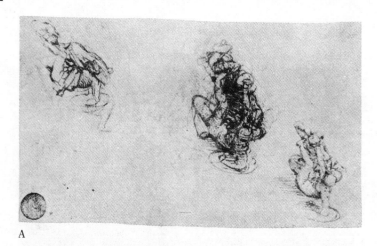

A

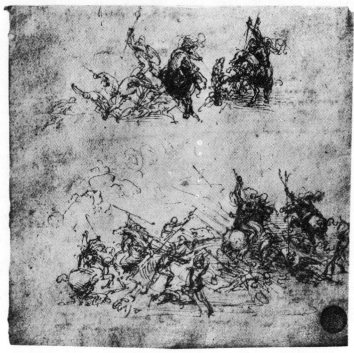

B

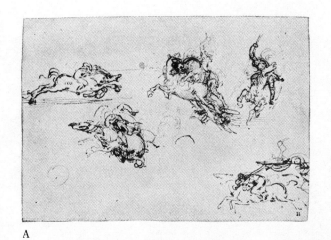

A

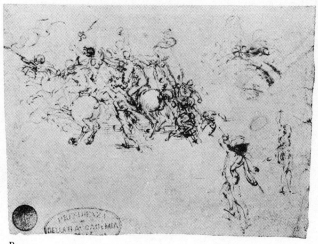

B

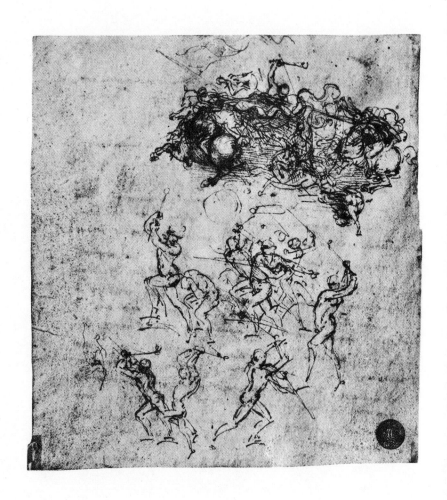

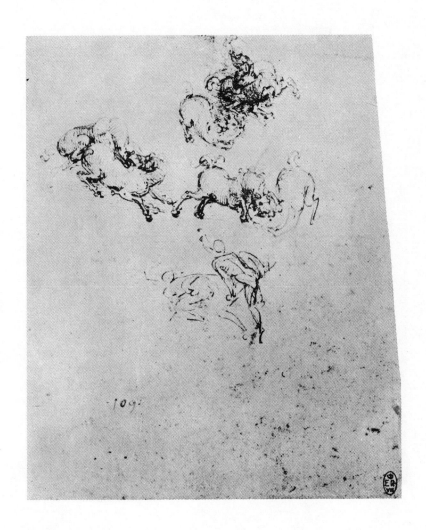

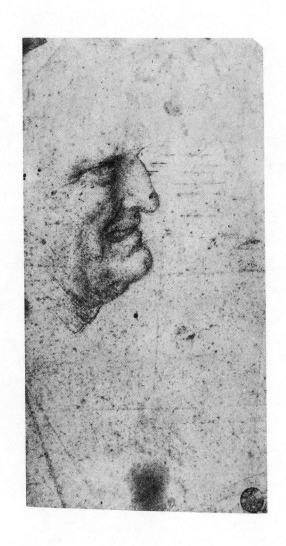

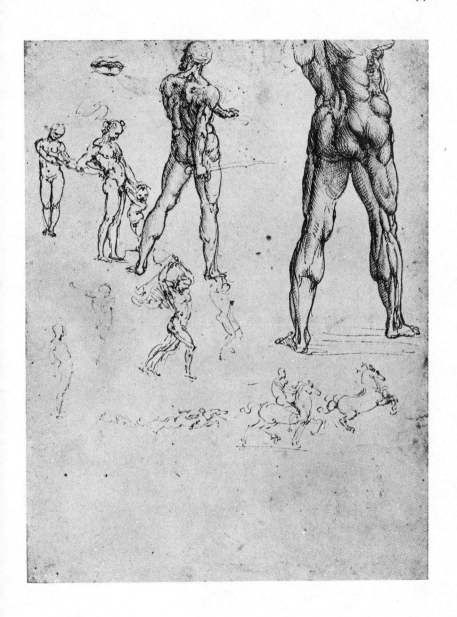

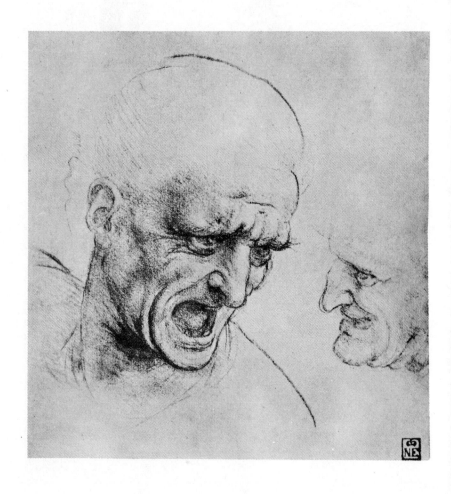

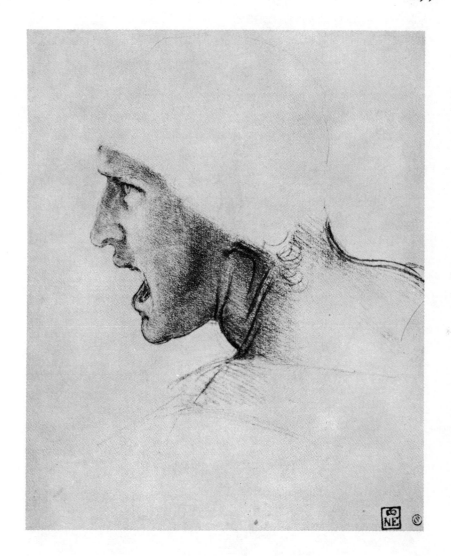

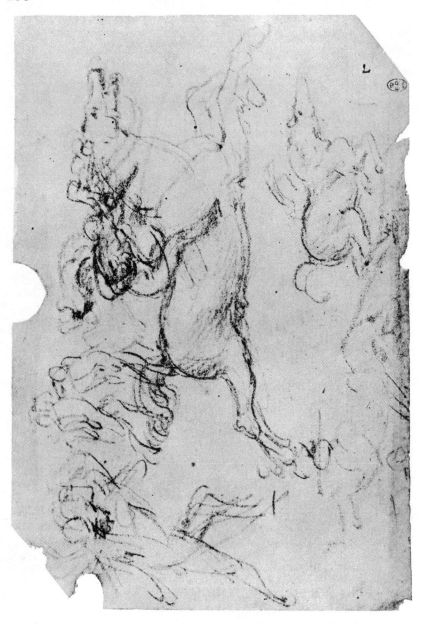

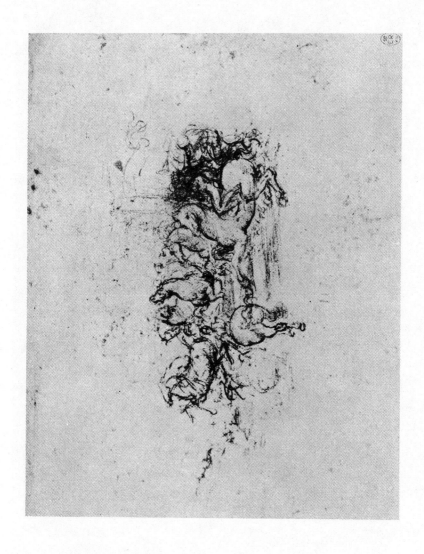

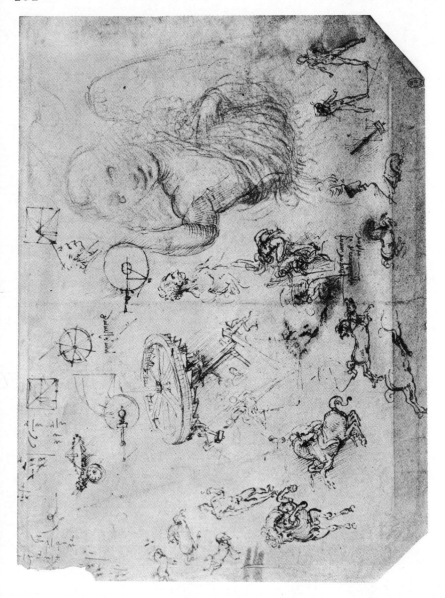

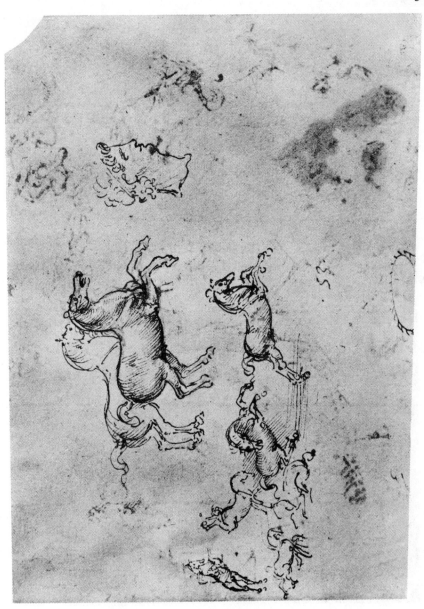

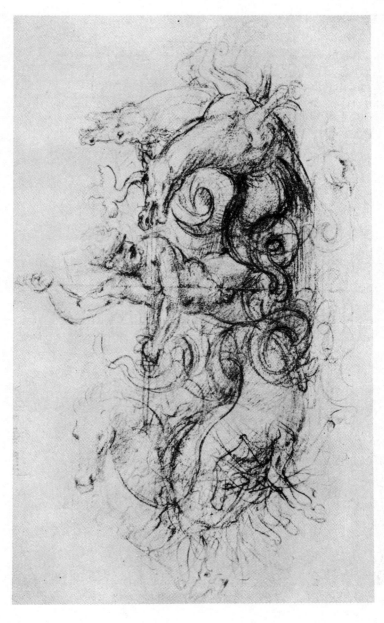

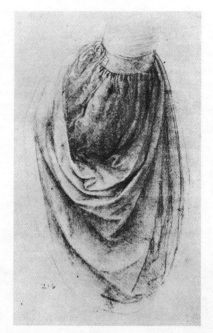

A

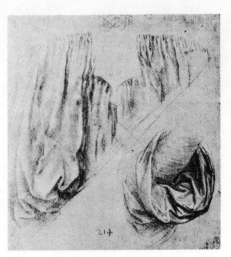

B

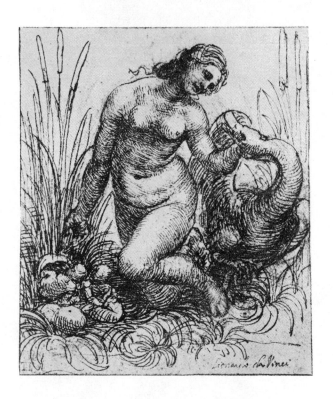

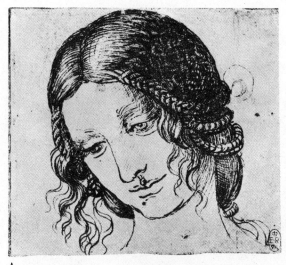

A

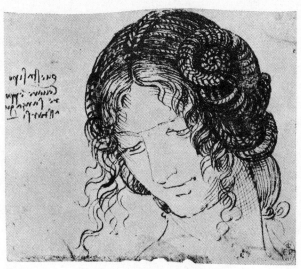

B

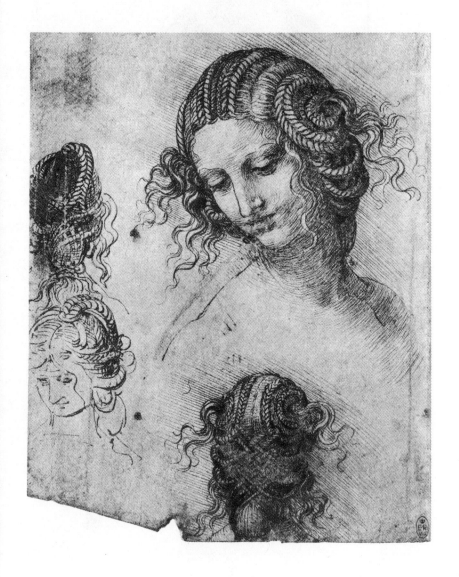

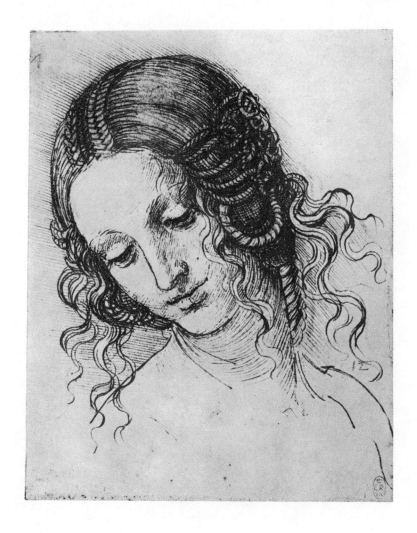

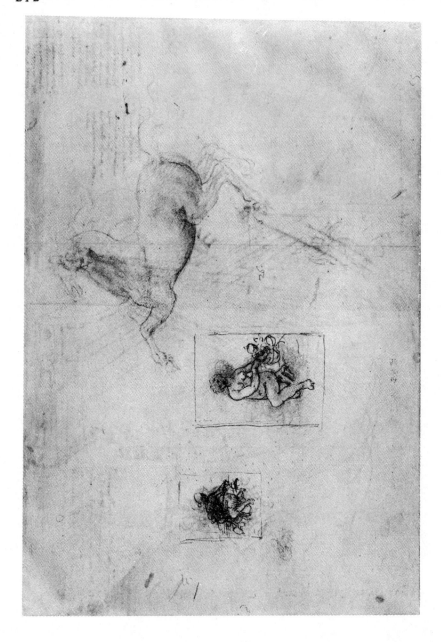

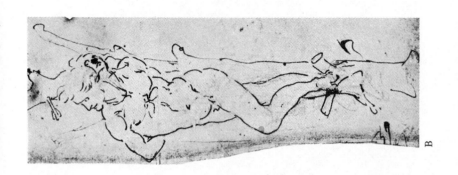

B

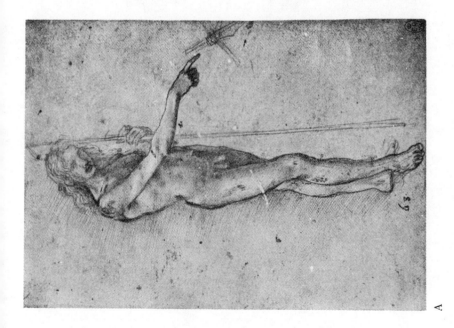

A

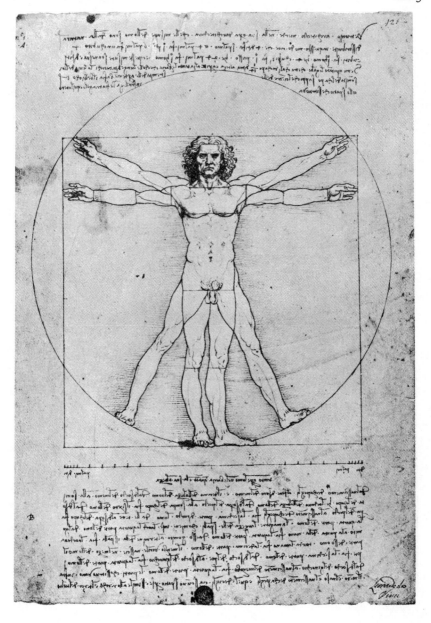

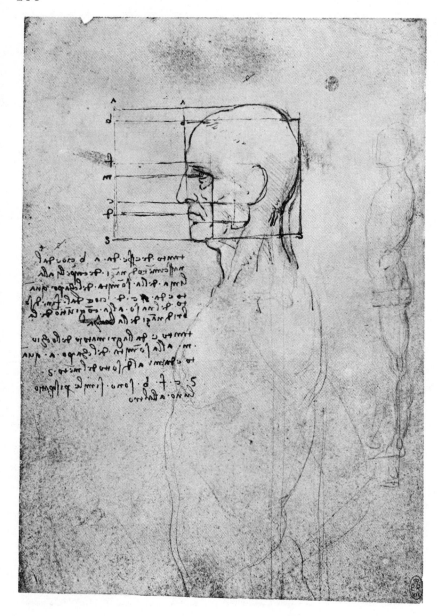

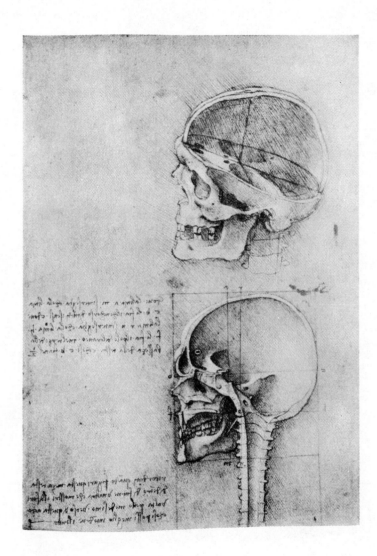

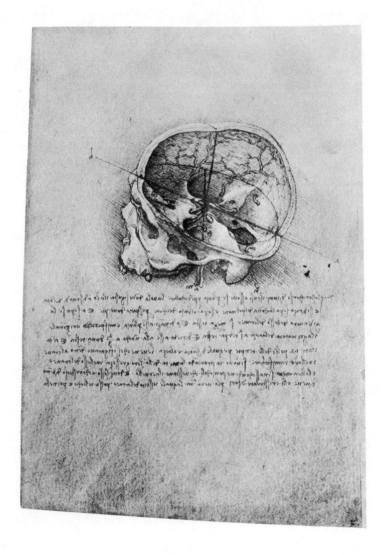

[Handwritten text in Leonardo da Vinci's mirror script, not legible for transcription]

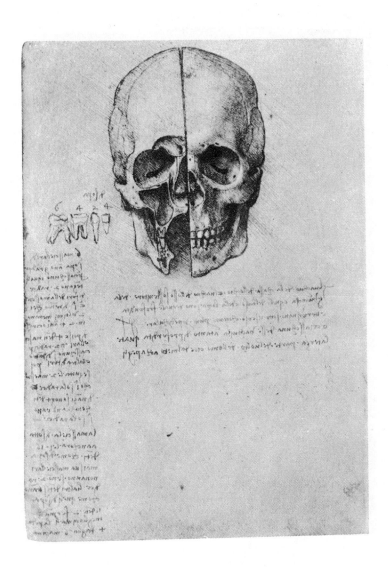

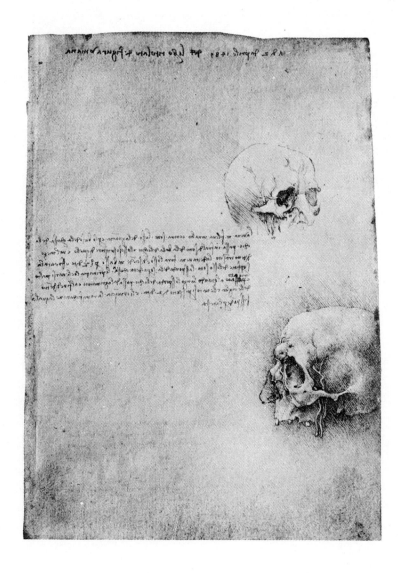

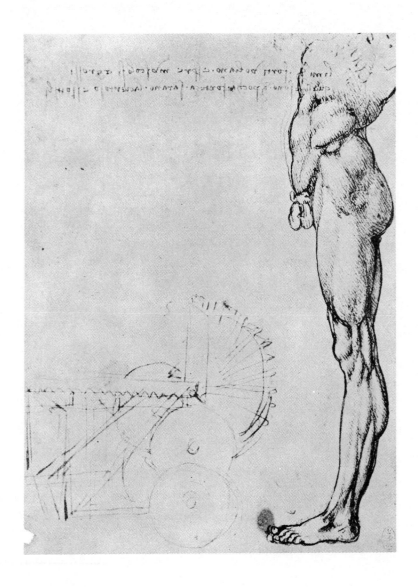

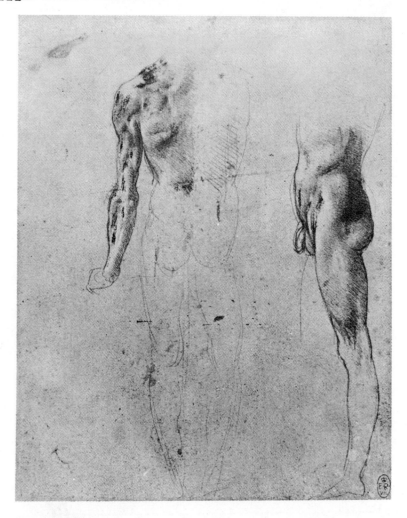

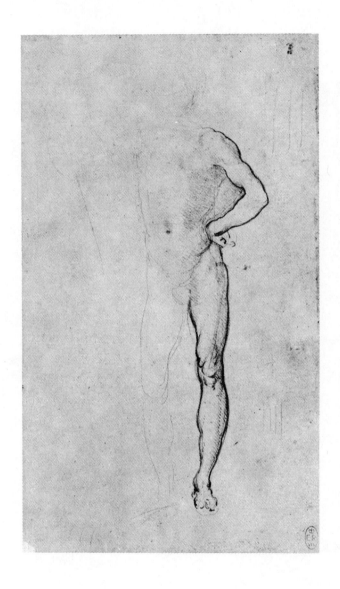

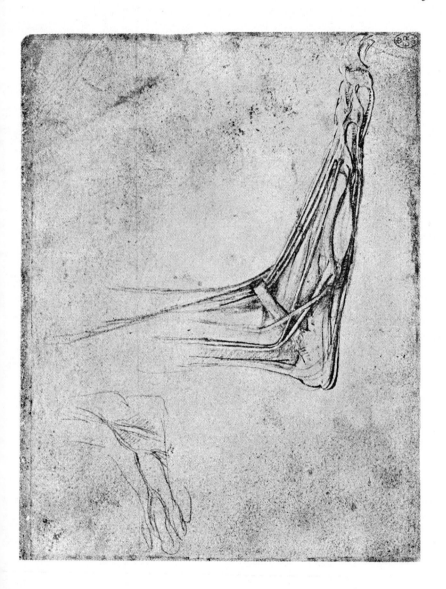

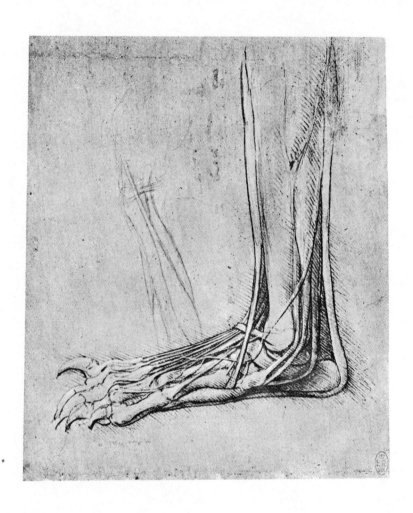

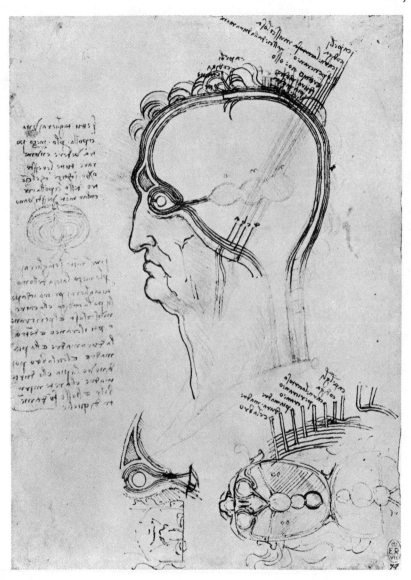

B

A

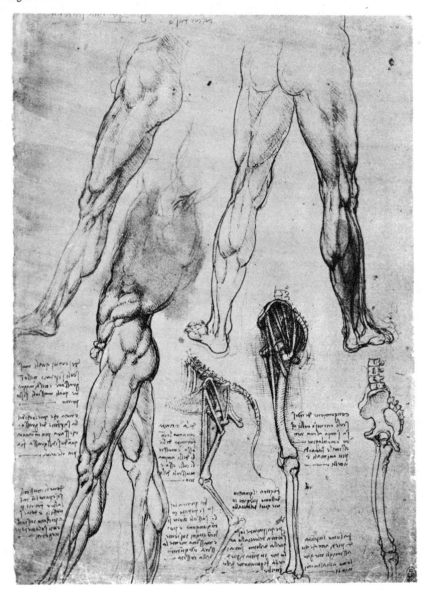

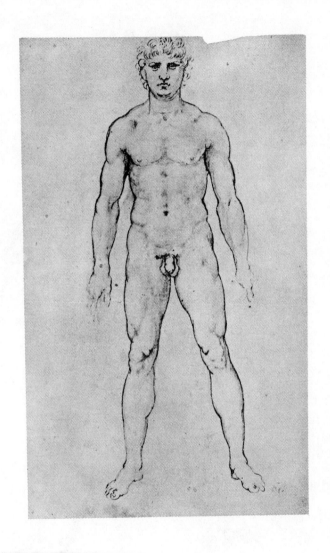

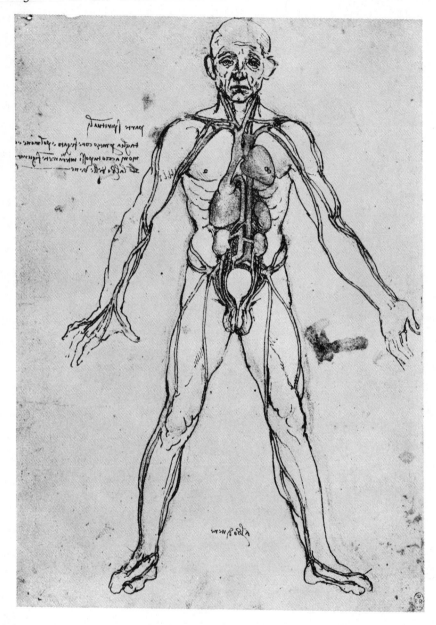

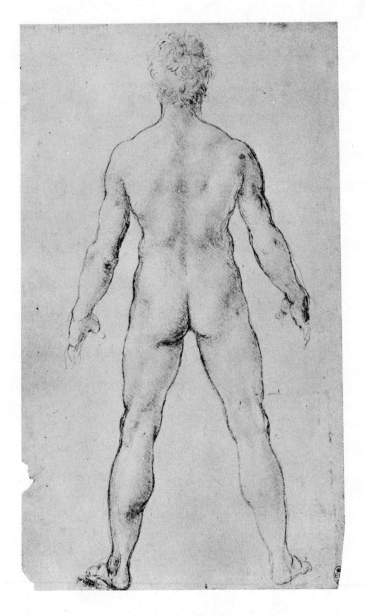

234

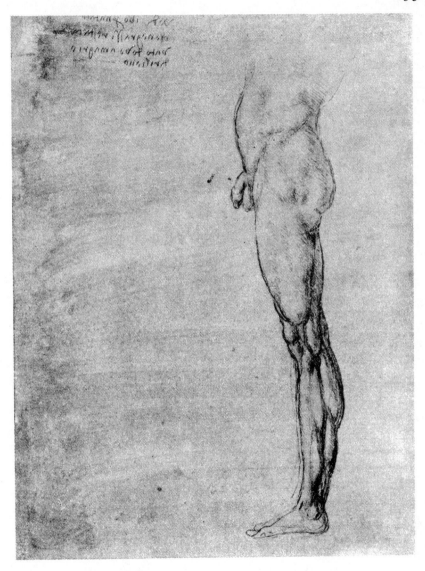

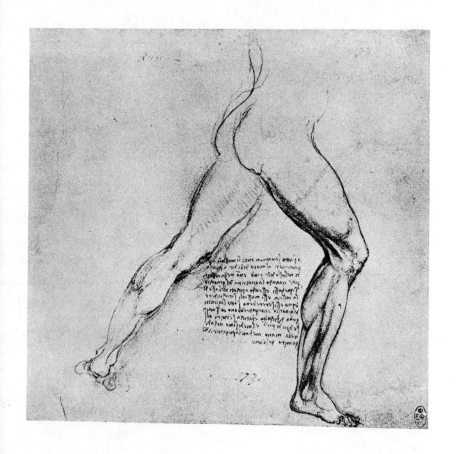

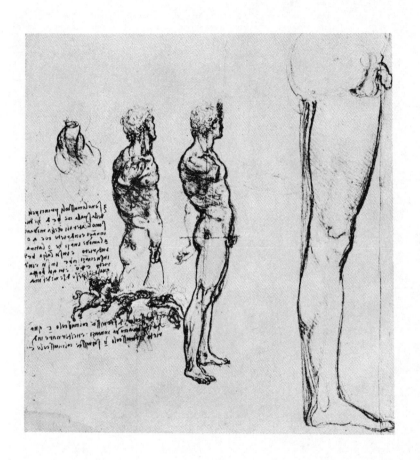

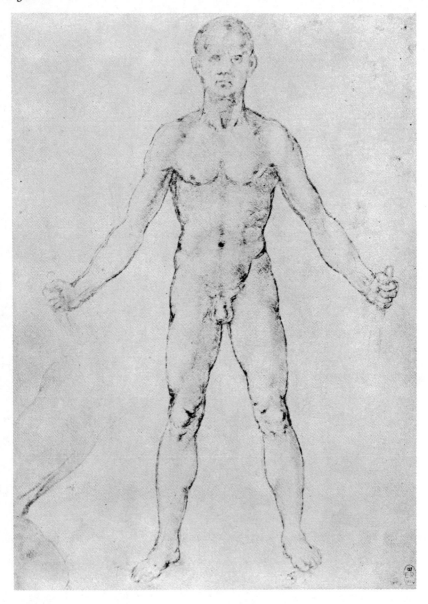

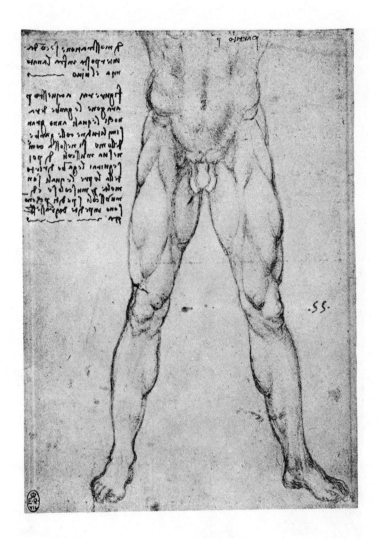

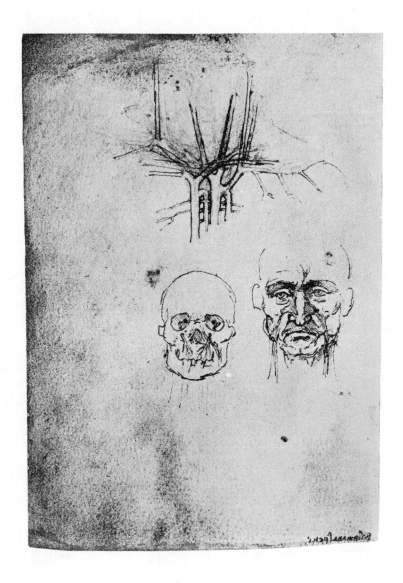

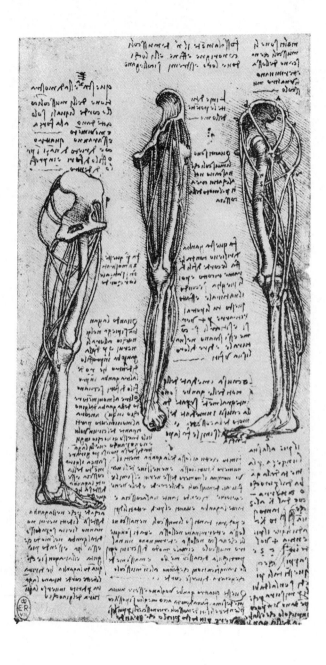

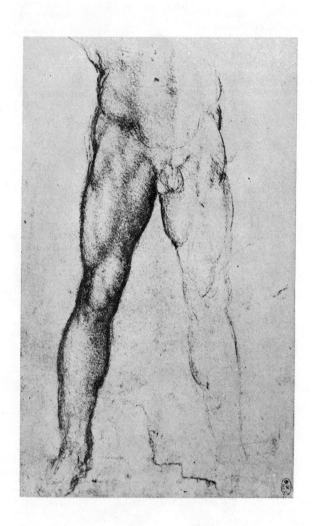

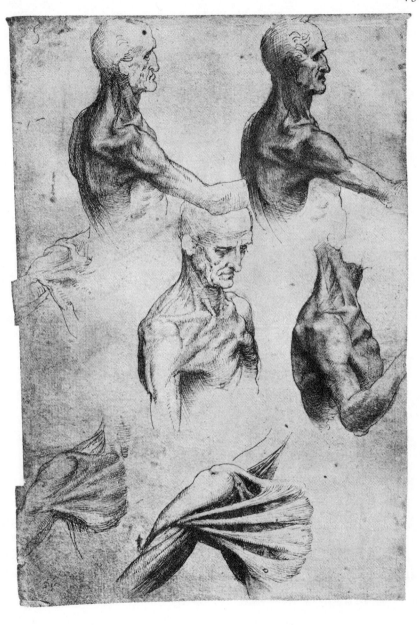

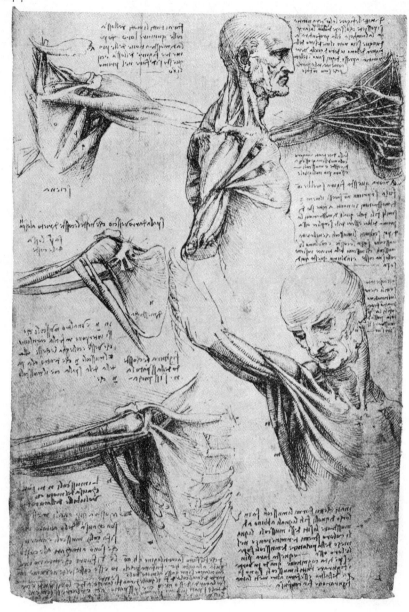

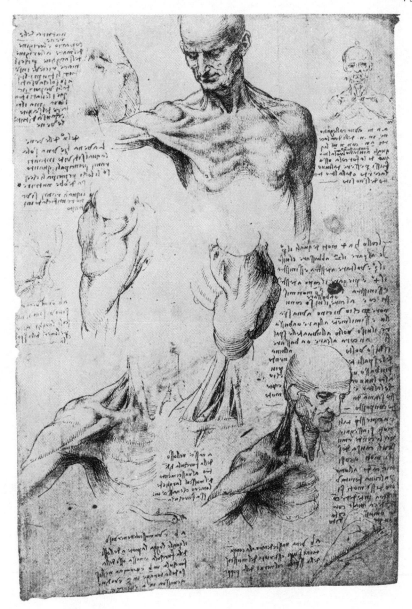

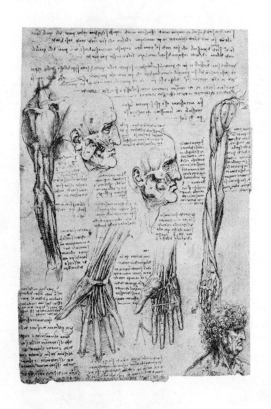

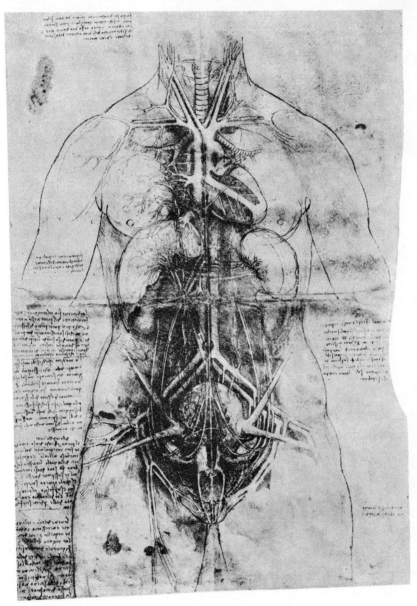

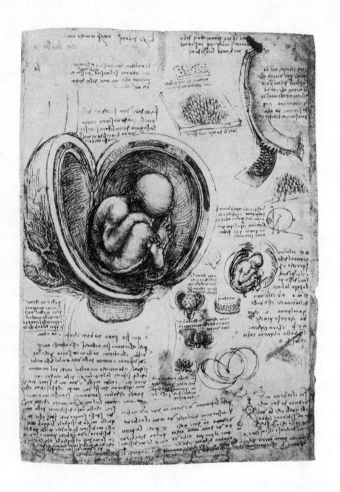

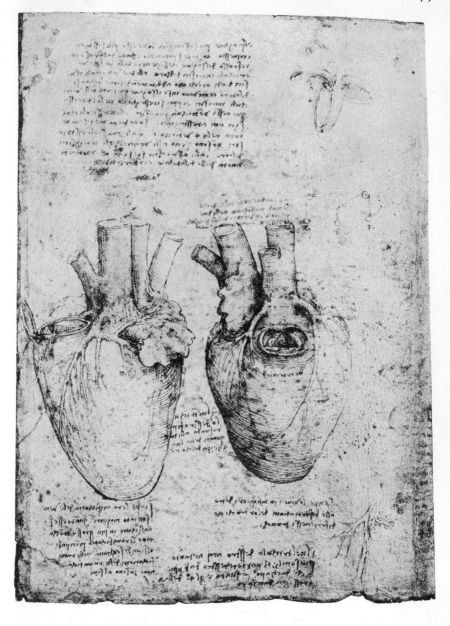

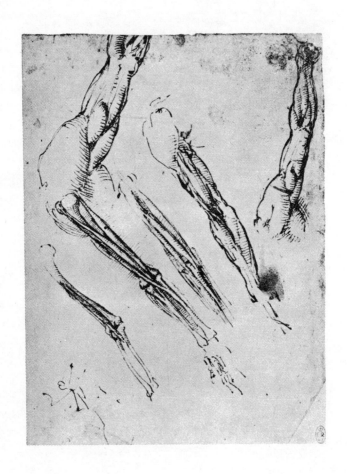

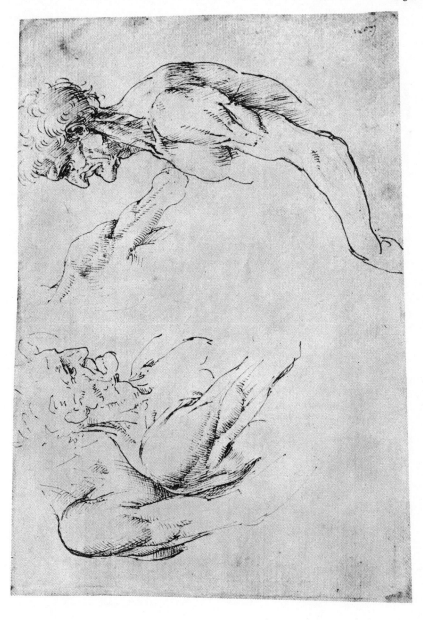

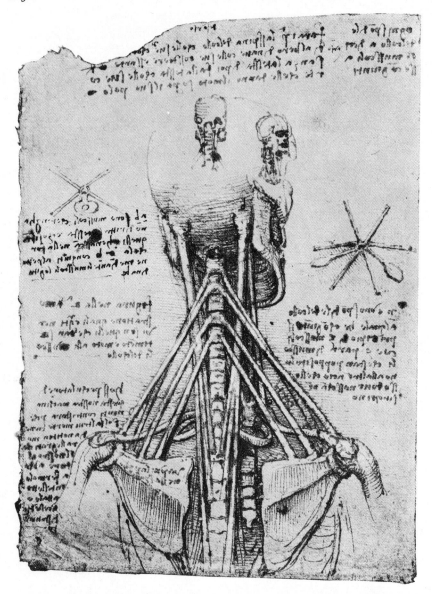

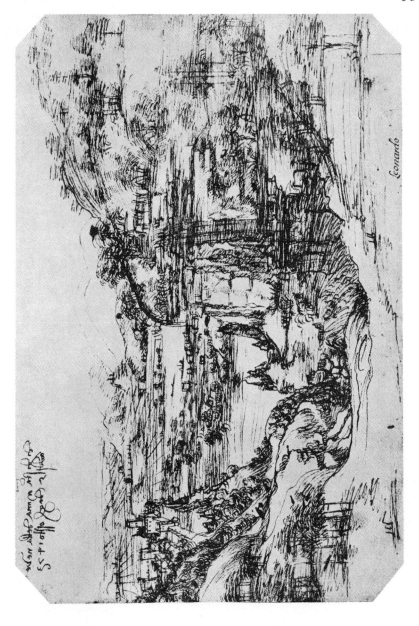

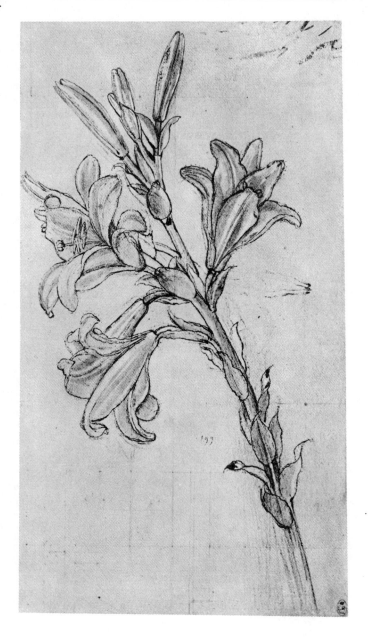

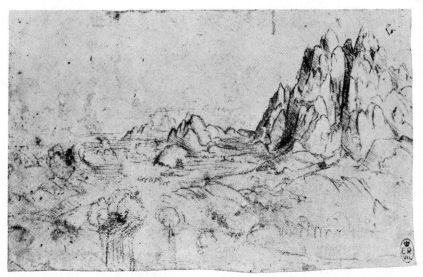

A

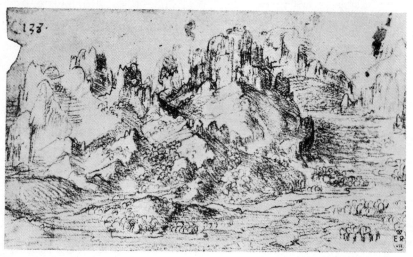

B

·137·

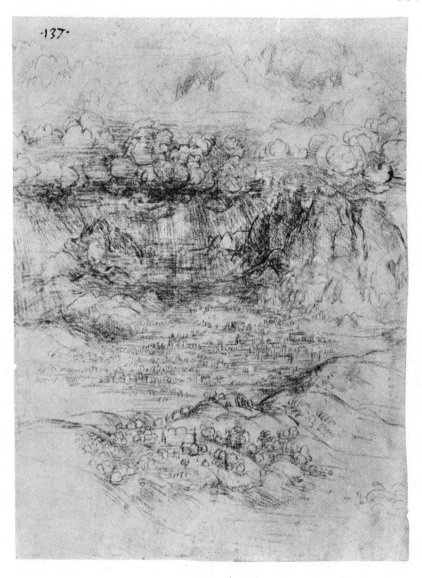

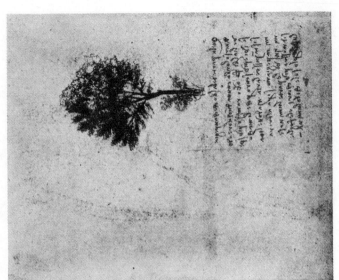

B

A

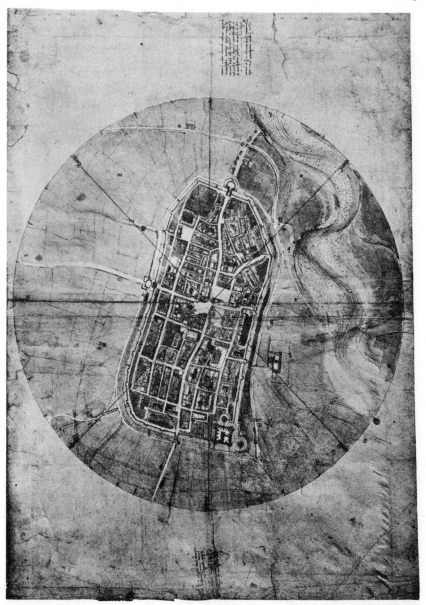

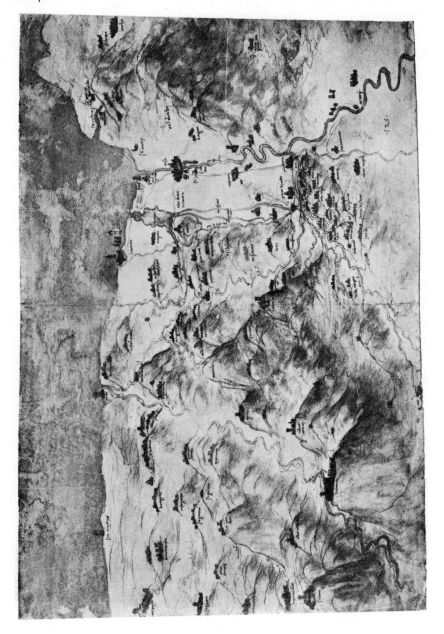

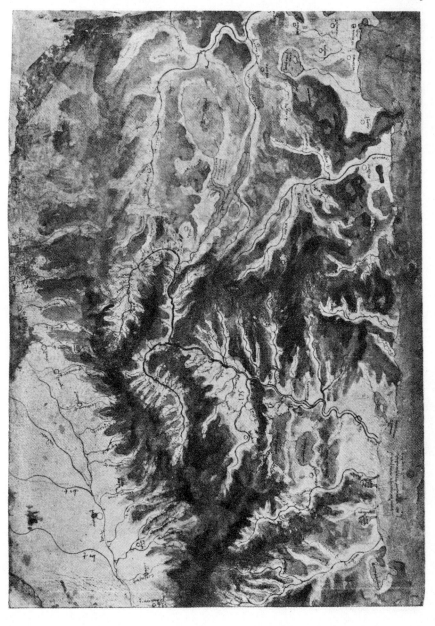

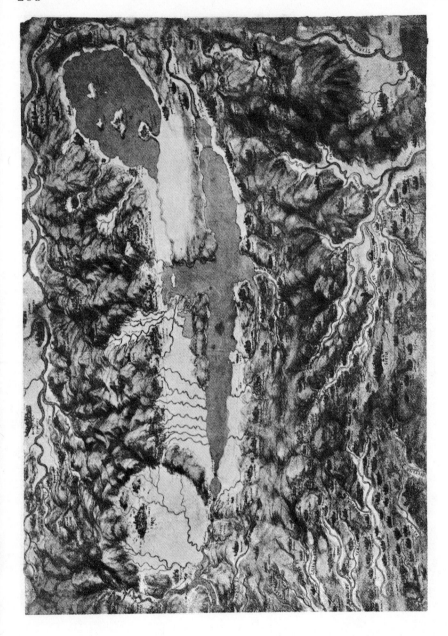

A

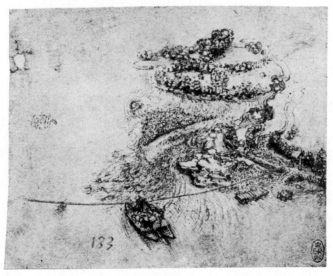

B

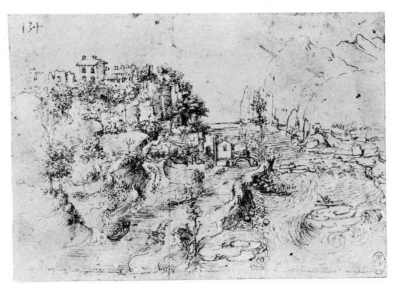

A

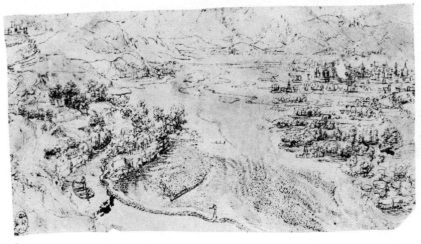

B

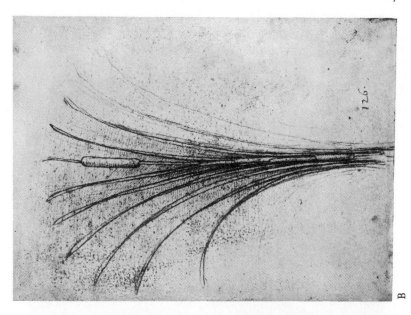

B

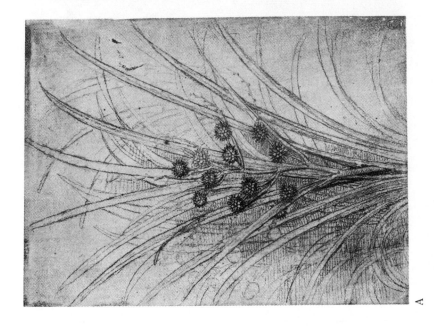

A

153

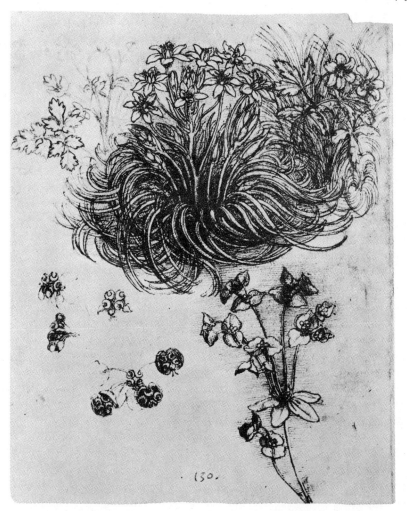

.130.

274

A

B

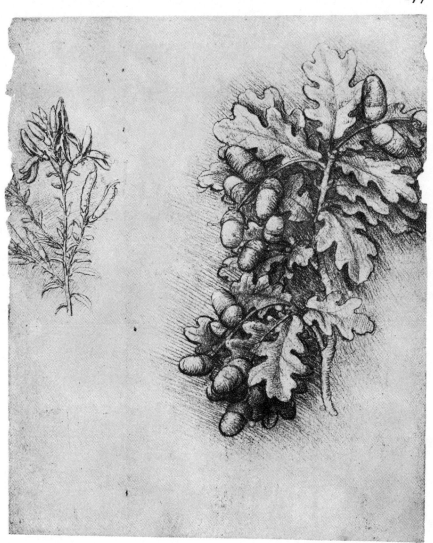

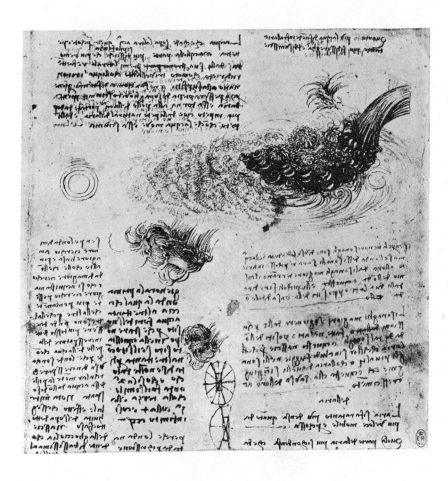

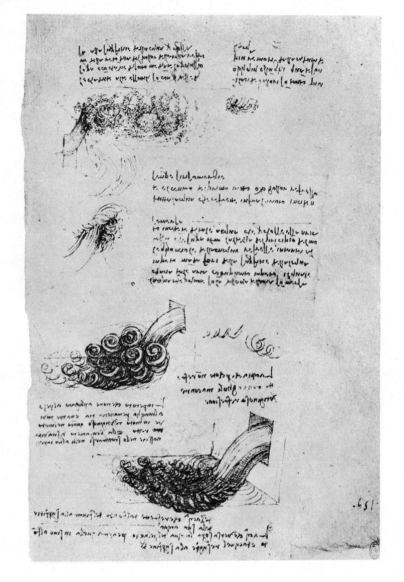

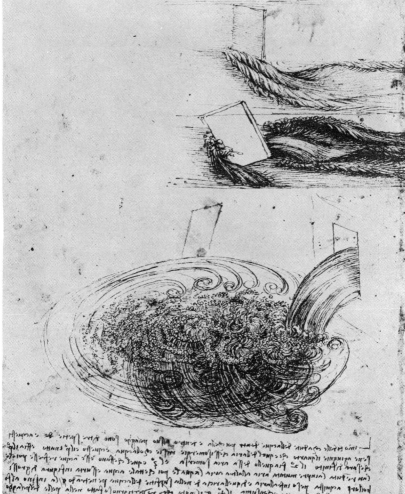

A

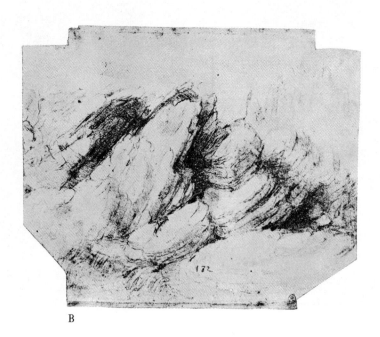

B

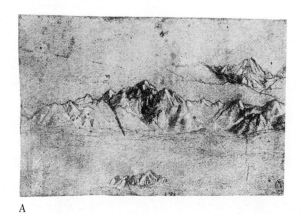

A

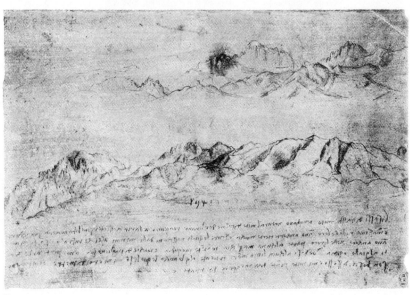

B

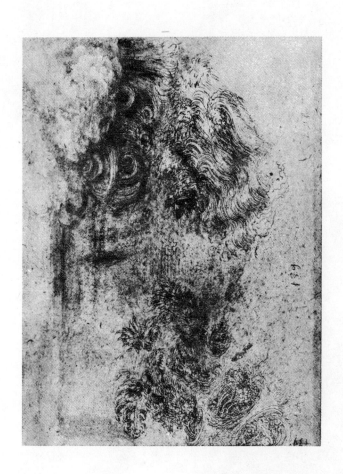

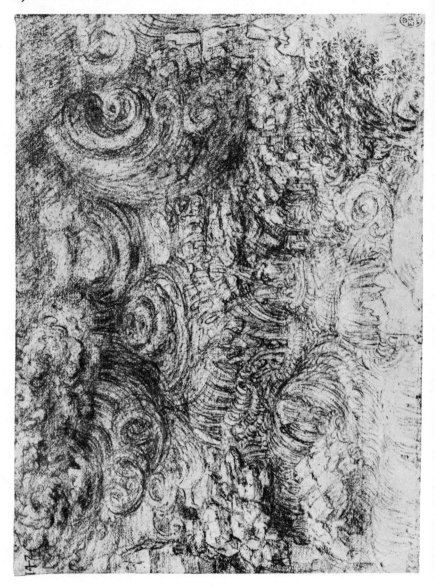

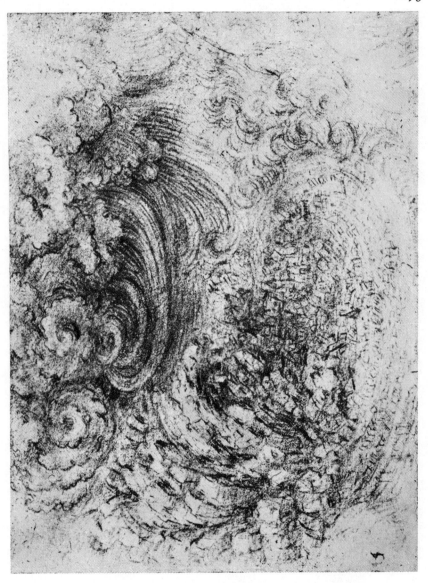

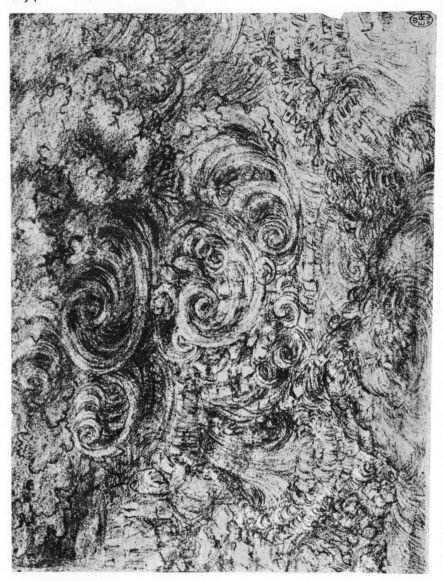

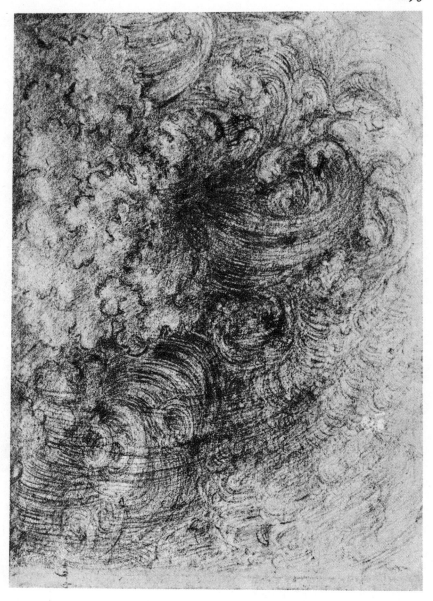

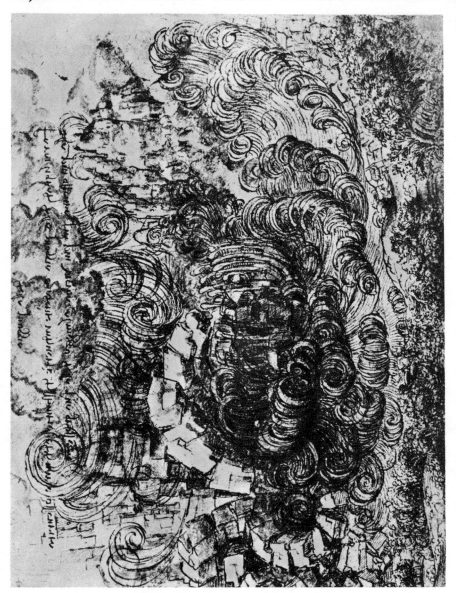

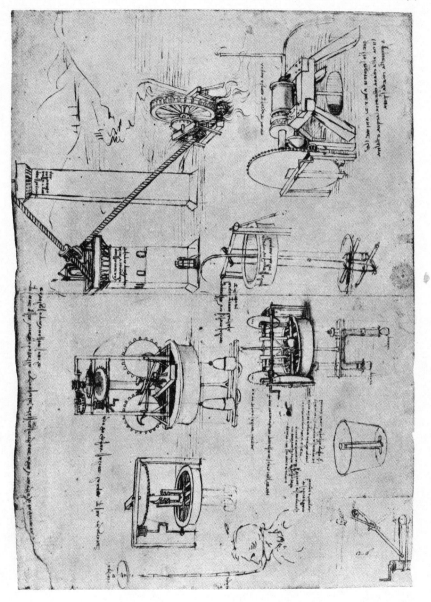

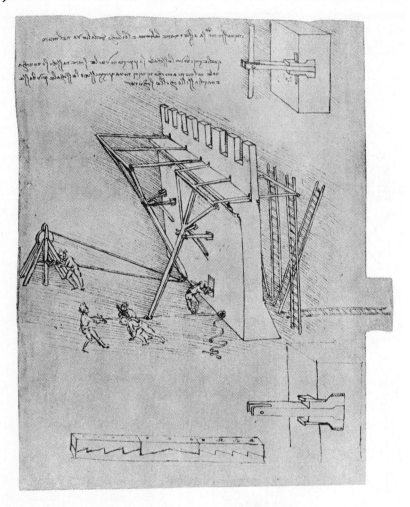

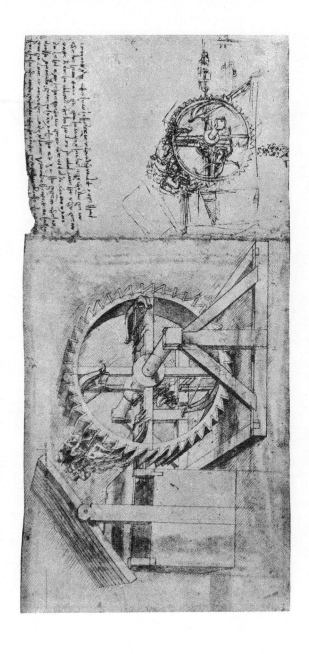

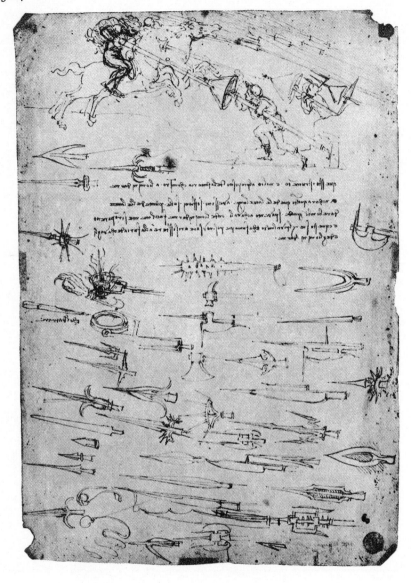

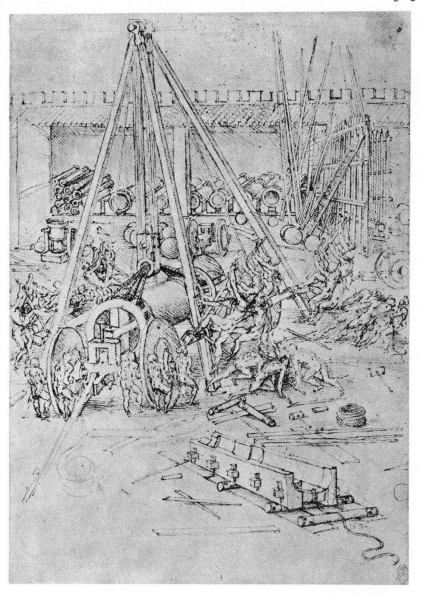

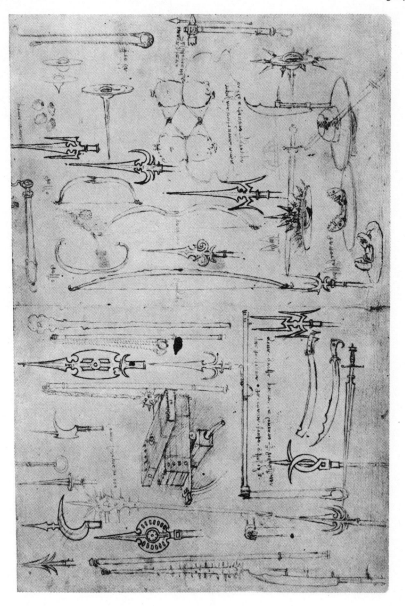

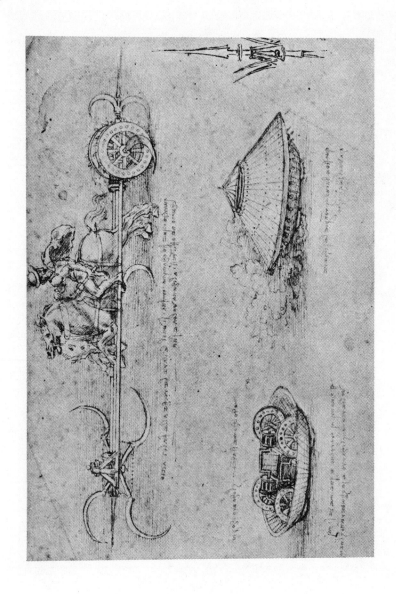

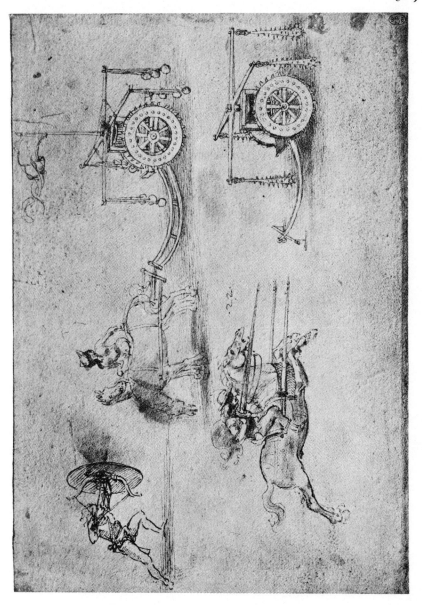

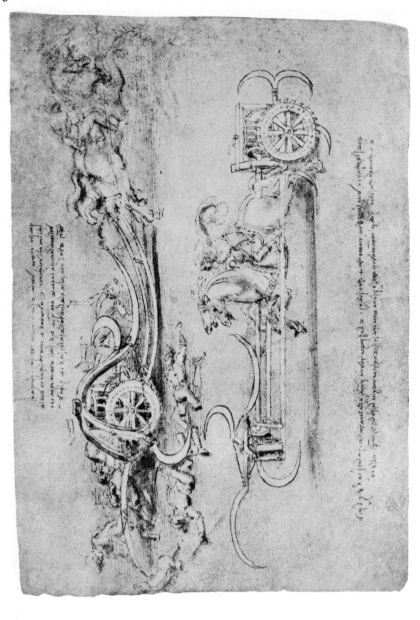

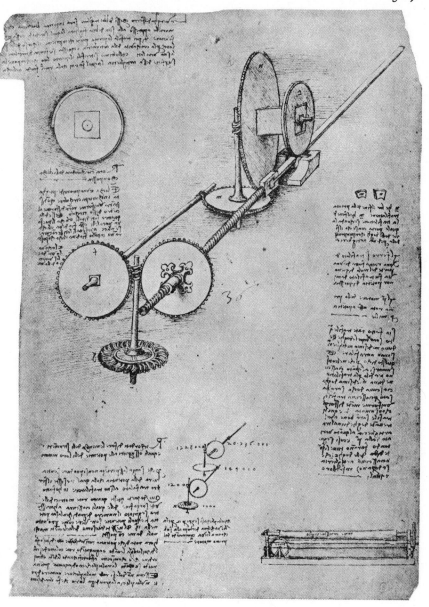